The Writer's and Photographer's Guide to Global Markets

Michael H. Sedge

ALLWORTH PRESS
NEW YORK

Published by Allworth Press
An imprint of Allworth Communications
10 East 23rd Street, New York NY 10010

Cover design by Douglas Design Associates, New York, NY

Page composition/typography by Sharp Des!gns, Inc., Lansing, MI

ISBN: 1-58115-002-4

Library of Congress Catalog Card Number: 98-72751

Printed in Canada

Contents

Acknowledgments

WHERE DOES ONE BEGIN THANKING PEOPLE? AS FAR BACK AS A JUNIOR high school English teacher? Or as recently as the freelance writer/photographer in Switzerland that sent you a tip on a new market? It's a difficult choice. All one can really do is brush the snow off the tip of the iceberg, and hope that those left out will understand that they too are part of every project a writer creates.

First and foremost, I would like to thank my father, Harry Sedge, who has been a silent business partner—perhaps slave laborer would be a better term—in my *Markets Abroad* newsletter project, which, ultimately, led to the writing of this book. Next, in no particular order, but of equal importance, my appreciation goes out to:

Joel Jacobs, who, from his Commerce, Texas, hideout, has been a colleague and a writing partner for many, many years. Beyond that, he has been a best friend. These—best friends—are very rare and precious. A best friend is someone you can call, though thousands of miles away, and say, "I need you to come here next week. I need your help." And you know that person will drop everything and be there. Joel is such a friend.

Skip Press, author of *Writer's Guide to Hollywood Producers, Directors, and Screenwriter's Agents*, was more of an inspiration than he realized.

Rohn Engh, perhaps the world's leading expert on selling photog-

raphy, who proved that one can be successful without living in a big city.

And, Ann Hattes, Fong Peng Khuan, Jill Dick, Debe Campbell, Andria Lazis-Valentini, Toni Lopopolo, Julian Block, and Linda Davis Kyle. Each of you had a part in making this project a reality.

Finally, every book project requires someone, besides the author, that believes in its worth. In this case that someone was Tad Crawford, publisher at Allworth Press. Not only did Tad have confidence in my idea and ability to realize it, but enhanced this idea with his own marketing skill and perception.

Thanks to you all.

Introduction

IN WRITING THIS BOOK, I HAVE TO MAKE SOME ASSUMPTIONS. I ASSUME, for example, that you are already a professional writer or photographer and have sold your work. Should this not be the case, I suggest you review the techniques of freelancing in one of the references listed in the following pages. In particular, for writers, *Making Money Freelance Writing* and, for photographers, *Sell and Re-Sell Your Photos*, both from Writer's Digest Books.

A Working Guide

When I was a youth, I attended public schools. City taxes paid for our textbooks and because of this, teachers were very rigid to ensure no one wrote in these so-called public property books.

It took me years to realize that there is nothing wrong with writing in a book. In some cases, in fact, it makes the education process easier and better. This is such a book, and I invite you to make notes in the borders, highlight text that holds special interest, and, above all, maintain the market information as current as possible.

Too often with market lists, freelancers fail to note the names of new editors and art directors, add a new fax number or e-mail address, or delete information as people change. Perhaps this stems from their own subconscious knowledge, gained during childhood, that one does

not write in books? Whatever the reason, you should strive to keep data current, make changes, delete, add, and make this a working text that is valuable to you and referred to often.

My Way

The methods discussed in this book are the way I do business. There are those—perhaps yourself—that may disagree with some of the techniques, information, and advice given. That's fine. Everyone, based on his or her personality and organization, does things in a slightly different manner. Editorial submissions are a good example.

Many writing schools and books will tell you that multiple submissions should be avoided. In the following pages, I'll tell you that they should be used extensively. At this very moment, in fact, I am trying to sell a novel and have fifty-three submissions out to editors in New York City and London. As one of my colleagues said, "That is the ultimate in multiple submissions!"

The point here is that you should alter your business style to fit your personality. If you are not comfortable using a method discussed herein, then change it to fit your needs. On the other hand, if you are into guerrilla marketing and want to attack the publishing industry head-on, take the advice offered in the following pages and let the battle begin.

It All Began . . .

I sat in the lobby of Hotel Inter-Continental enjoying the rich, air-conditioned environment—out of the hundred degree heat, 90 percent humidity, and ever-present smell of cooking rice filtering through the streets of Manila. Next to me was the noted New York travel writer and publisher of the *Travelwriter Marketletter*, Bob Milne.

It was the fall of 1987, Ferdinand Marcos had been removed from power and the renewed Philippine government, under Corazon Aquino, was looking to increase the flow of American tourists to the islands. I was one of thirty Travel Journalists Guild (TJG) members to receive a five-day press junket invitation. Unlike the others, though, I was unique. First, I had flown in from Europe, where I had lived and worked for the past fourteen years. Second, I would soon learn, due

to my unorthodox methods of marketing my freelance work—both articles and photographs.

"This is Mike Sedge from Italy," Milne said to a fellow TJG member.

"Oh," she said, "I read your article in *Mabuhay,* the in-flight magazine on the Philippine Airlines flight from Los Angeles. How did you ever sell a piece to them?"

"They're one of my regular clients," I replied, rather nonchalantly. "I sell to about fifty publications outside North America. The same article has already appeared in the United States, Germany, Italy, and the United Kingdom."

For a moment the entire lobby seemed to go still as vulturelike eyes of hungry freelancers fell upon me. One might have thought that I'd suddenly revealed the secret to stealing the crown jewels.

Then another writer asked, "You mean you sell the same article all over the world?"

"And photographs," I said. "Doesn't everyone?"

Needless to say, the following week was an education, for all of us.

My freelance career, unlike those of most American writers and photographers, began out of necessity. It also began in Europe. After six years of working for the Department of Defense in Naples, Italy, I suddenly found myself a victim of a new international hiring treaty. That is, I was laid off by the U.S. government.

I had two choices at that point: return to the United States or find another occupation. My Italian wife ruled out the first option and insisted on the second. So, armed with a year-old copy of *Writer's Digest* magazine and an Olympus OM1, I decided that I would become a writer and photographer. After all, didn't Hemingway's career blossom while in Italy? And what about Dickens, Shakespeare, Stevenson, and even Twain? Each of them had been inspired by this Mediterranean peninsula. Now, so would Sedge.

The date was August 19, 1980: my son had just turned two, my daughter three. And here I was using our savings to set up an office. Because there were no college writing courses, no major English-language libraries with how-to books on starting a writing career, I simply went about it the same way one would establish any home business—buying furniture, equipment, supplies, stationery, and a phone. Next, I did what Jay Conrad Levinson would preach three years later

in his bestselling book, *Guerrilla Marketing*. I went knocking on doors.

A year later, having used aggressive "business" tactics, I was a contributing editor to *R&R* magazine (Germany), Naples Bureau Chief for *International Daily News* (Rome), and a stringer, covering U.S. military and NATO affairs, for the Associated Press, *Newsweek*, and Time-Life. I was also submitting weekly queries to publications in Africa, Asia, North America, and Europe.

One of the first features I did for *R&R* magazine was on Venice's annual carnival celebration. I discovered early on that the publisher requested exclusive rights in its target market only—which is to say, the U.S. military in Europe. This left me free to sell my article to other publications that were outside this market.

A month later, Madeline Grimoldi, editor of *Going Places Doing Things* in Rome, bought first Italian-language serial rights to the Venice article. *Holiday*, in London, then purchased first U.K. serial rights. *Silver Kris*, Singapore Airlines's publication, paid $600 for exclusive in-flight magazine rights. A year later, *Mini-World,* the Japanese monthly, got first Japanese-language serial rights. And, eventually, the *Los Angeles Times* travel editor took first North American serial rights to the story.

Just as a baker cuts up a pie and sells it slice by slice, I was chopping up my articles, enhancing them with decorative images, and offering pieces to a global market. Articles and photographs were my products. I was a businessman. The more money I could make from each of them, the better my business became.

Little did I realize, at that point, that by using unorthodox business techniques and aggressive world marketing, my freelance career had soared to a level of success that most freelancers take years to achieve. I was no better a *writer* than thousands of others. Nor was I a match for top photographers. But I was a better *marketer*. I was, in fact, a global marketer. And that made the difference.

It was my marketing ability that awed the Travel Journalists Guild members in the lobby of Manila's Inter-Continental Hotel. To them, the thought of me, in far off Europe, tapping markets in Australia, Germany, Hong Kong, Italy, Japan, Philippines, Singapore, South Africa, and Kuwait was almost mind-boggling.

"Could I buy a list of your foreign markets?" one writer asked.

"I guess so," I replied.

Later that evening, Bob Milne took me aside, saying: "You know Mike, you should really give some thought to putting out a foreign markets newsletter. There are a lot of writers and photographers in the United States and Canada that would be interested in knowing not only what markets to sell to, but *how* to sell to them. It can't be all that easy to deal with editors in, say, Asia, or the Middle East."

I spent the entire week thinking over Bob's words, and upon my return to Italy, set out to produce the quarterly *Markets Abroad* newsletter. In the months that followed, subscriptions rolled in. *Writer's Digest* reviewed the newsletter saying, "Sedge offers practical advice on everything from rights to postage to cashing foreign checks."

My business eventually became a corporation, under the title Strawberry Media (a reflection of Afragola, the Italian city in which I live, that translates to "land of the strawberry"). In addition to my own freelance work and the *Markets Abroad* newsletter, I expanded into a stock photo agency, representing camera buffs like Norman Mosallem, one of New York's top model photographers; Bob Wickley, then an award-winning air force photojournalist who has since gone on to work with such agencies as Black Star; Rhonda Bishop, who freelanced for the likes of *National Geographic* and *Travel and Leisure*; and Bob Schwartz, perhaps the world's finest photographer of cats.

The newsletter's space restrictions ultimately required I stop providing advice and focus exclusively on market information. I was therefore thrilled when Allworth Press offered to publish the book you are now holding. In the pages that follow, you'll find not only a trove of markets around the world that purchase English-language articles, books, and images (no matter what the language), but eighteen-years of insight into dealing with and selling to foreign editors and art directors.

A lot has changed since I first began marketing my freelance work globally. Today's widespread use of fax machines and e-mail allows writers to transmit ideas and receive responses that once took months, in a matter of hours. Photographers can now scan their pictures into electronic images and transmit them to buyers in Asia, Africa, Europe, or the Middle East in minutes. In this respect, the world has certainly gotten smaller and the job of the international marketer easier.

In today's environment, there is no excuse for a freelance writer or photographer *not* to be working on a global scale. Granted, working

with editors and writing for non-American cultures requires some special knowledge, as does handling foreign checks, tracking international submissions, and maintaining detailed records of rights. All of this, however, is knowledge that can be acquired. The key to your global marketing education, in fact, is in your hands.

So go ahead, turn the page, and let's begin the journey that will take your freelance career beyond the North American borders.

Mechanics of Global Sales

A Successful Strategy

MY BYLINE HAS APPEARED ON MORE THAN 2,500 PUBLISHED ARTICLES AND perhaps 25,000 published images. Some people consider that an amazing feat. Believe me, it is not. What *is* amazing, however, is the fact that I have succeeded in *selling* 2,500 articles and 25,000 pictures.

Each article I write sells, on an average, three times. Accompanying each feature are from four to forty images. While some works may only sell to one or two markets, others might be scooped up by several magazines and newspapers. My all-time "bestseller" is a feature on a sunken city off the coast of Italy. To date, this single article of 2,300 words has appeared sixteen times, in nine different countries, and brought in $6,000. The illustrations have brought in another $6,400.

What's that? You say the photographs earned you more than the article? That's right. And therein lies your first lesson in freelancing, whether global or domestic. If you are a photographer, you should also be a writer. No talent in that area? Then find one, two, or more writers in your area and team up.

If you are a writer, get yourself a camera. You don't know how to operate a camera, you say. That's no excuse. Today's user-friendly, do-it-all picture boxes can turn anyone into a fair photographer in no time. And if you don't think you can produce publishable images without a high-priced SLR (single lens reflex) camera, listen to this.

In 1982, I was covering a press conference at the Allied Forces South-

ern Europe (NATO) Command for the Associated Press. Next to me was Mimmi Murphy, who worked in the Rome Bureau of Time-Life. Halfway through the conference, she reached into her purse and pulled out a tiny, $12, all-in-one camera (you know, the kind you can buy at any drugstore and turn in the entire camera for developing). Later I asked Mimmi what she was doing. "Taking pictures for *Time*," she replied. "Our regular photographer is on another assignment."

The moral of the story is to always have illustrations, and always have words. There is no better way to double your income than to provide a complete package.

Back to my greatest success—the sunken city article. The story first appeared in Italy in 1980. As the years passed, I continued to find new homes for the feature until, just last week, Nigel Eaton, editor of *Diver* magazine, published in Middlesex, England, wrote: "Thank you for sending through your article proposal concerning the sunken city in Italy's Bay of Pozzuoli. This may well be of interest to us."

This example reveals two very important aspects of my freelance marketing techniques that you may want to imitate: (1) trying to minimize my freelance efforts while maximizing my world sales, and (2) continuing to market article/photo packages months and even years after they are originally produced. If you take the 2,500 articles I have published, divide that figure by the average number of sales per article—three—you'll realize that, in effect, I have produced just over 830 features in eighteen years. That's forty-six a year, or less than one per week. So, you see, it is not as amazing as it may have originally seemed.

In addition to writing an original article each week, I also concentrate on sending out four new queries—not *different* queries, but *new* ones. To explain this further, let's imagine for a minute that today is the first day of your freelance career. What do you do? First, you must come up with an article topic. You've just vacationed in Hawaii, have some great images, and decide that you'd enjoy writing about volcano exploration. Next, you research potential markets and come up with *Adventure Travel*. The following day you prepare a query letter and send it off.

A month later, the editor contacts you saying that he loves the idea, so you begin writing. As you do this, you continue to think of new ideas and keep sending out a query a week.

Using the "international approach" to this same situation, I would

dig deeper into the markets, exploring not only publications in North America, but throughout the world. Then, I would submit multiple query letters to four publications. As rejection letters come in, I'd simply resend the idea to different markets of the same genre—e.g., inflight magazines, travel magazines, and men's magazines—until it eventually found a home.

This method of 4 queries a week will result in 16 letters a month, 192 a year. As editors accept your ideas and commission you to write articles, you'll find yourself with at least two or three new assignments each month. Once an article is done, it goes into your archive and the queries for that particular piece continue to circulate. Ultimately, this system will bring you increased sales and income from around the globe.

If you don't believe me, believe the facts. Not long ago, I sent a query to four editors in different parts of the world, and covering different markets, proposing a feature exactly like the one above. I called it "Hot Foot Adventures: Volcano Exploration." Less than a week passed before Arthur Hullett, then editor of Singapore Airlines's in-flight magazine, *Silver Kris*, gave me the green light to produce the article for them.

While I was writing the piece, other editors were turning down my offer. I continued to send new queries to global markets, however, replacing those "thanks, but no thanks" returns. Eventually, the article sold to *Mountain Living* (U.S.A.), *Going Places Doing Things* (Italy), *Tropi-Ties* (exclusive electronic—i.e., Internet—rights), and *Off Duty Europe* (Germany). And, naturally, it is still circulating.

Knowing the International Marketplace

THE FIRST STEP TOWARD SUCCESSFUL INTERNATIONAL SALES IS TO KNOW the markets. You've heard that, I am certain, over and over again. When I say "know" the markets, however, I am not referring only to the age, sex, and economic state of the readers. You must, in the global marketplace, also know and understand their habits, their religion, their environment, the television programs they watch, the languages they speak, and many more aspects of daily life that, in the United States and Canada, a freelancer need give little concern.

International marketing calls for knowledge of the various social, political, and cultural habits of the country in which you hope to sell your work. Lack of such insight can sometimes be the difference between a check in the mail or a rejection slip. A single cultural or political error in your query letter, article, or images can get you a quick "no thanks" from an editor, as well as plant doubt in his or her mind that may influence your credibility for future sales.

People living outside North America, in most cases, do not think like Americans and Canadians, and vice versa. There are hundreds of stories to exemplify this. One of the best, however, is Chevrolet's efforts to sell the Nova in Spain. As the marketing department prepared to launch the car, someone said, "Hey, doesn't anyone here speak Spanish? The words *no va* mean 'it doesn't go.' Who in their right mind

would buy a car that doesn't go?" On a similar vein, "Body by Fisher" translates as "Corpse by Fisher" in Japanese.

But language differences are only one aspect you, as an international freelancer, must keep in mind as your work travels abroad. More important are the cultural barriers. Corn on the cob, for instance, is an hors d'oeuvre in England. Vicks VapoRub is used in many tropical areas primarily as a mosquito repellent. It is a very good idea, in fact, to avoid using any brand names or products in your articles and images if at all possible.

Colors, too, have different meanings in different countries. In Brazil, purple is a death color, while in Hong Kong, white is for funerals. In Mexico, death is associated with yellow flowers and in France the same flora suggests infidelity. White lilies, while looking beautiful, are never given in England, unless you desire to give a death wish. Red is popular in all Chinese-speaking areas and in Italy. Red roses in the latter country could mean a special emotion if given to one of the opposite sex.

In the freelance guidelines for *Muhibah*, the in-flight magazine for Royal Brunei Airlines, editor Fong Peng Khuan warns, "Please be aware that as Brunei is an Islamic country, we cannot feature, mention, nor make reference to alcohol, religion (other than Islam), dogs, pigs, political commentary, human body parts, or women in revealing clothing."

There is no doubt that a writer or photographer submitting material that crosses these guidelines would seriously damage his or her chances of working with Khuan. Religion is a major influence on the value systems and the behavioral patterns of many nations. In Saudi Arabia, for instance, one would never think of giving a gift to another man's wife, or offering anything alcoholic. Such things are directly regulated by religious beliefs.

Other influences that you should be aware of are those brought about by educational and social environments. A few years back, a friend in New York wrote an article for a European publication informing readers that they could purchase all the materials mentioned at their local Kmart or Wal-Mart stores. The editor rejected the story, stating that "there are no Kmarts or Wal-Marts in France." In many parts of the world, in fact, one-stop shopping is unknown. In much of western Europe, individuals doing their weekly or daily shopping might

go to five or six different stores: one for meats, one for bread, one for cheeses, one for cleaning items, etc. While doing so, they mingle with friends and neighbors and have an opportunity to catch up on local gossip. Had the writer done her market research, she would have known better than to include the popular U.S. chain stores and may have made not only the first sale, but developed a long-term working relationship with the editor.

As you can see, knowing the habits and cultures of various foreign countries takes some effort. Being aware of the environment in which editors and art directors work and live, however, can make a difference in your international success. The best way to begin is to select a few prime countries for the work you hope to sell and study the lifestyles of those nations.

I was fortunate early on in my foreign marketing in that someone introduced me to the U.S. Government Printing Office's series of Background Notes. Updated by the State Department, these short, informative documents provide a quick education on a given country, its people, history, economy, and much more.

Each *Background Notes* costs $5 and can be ordered from the Superintendent of Documents, U.S. Government Printing Office, Washington, D.C. 20402. You can also call customer relations at (800) 274-4477 or (202) 783-3238. Internet users can obtain copies by addressing e-mail requests to: *order@bernan.com* or through the following Web page: *www.bernan.com/GPN_Search.html.* In this latter case, you go into the Government Printing Office database and search the library for the document number. The easiest way to do this is to use the name of the country you are interested in. Once you find the *Background Notes* you want, simply click on the order box.

A less expensive way to get a general background of a country is to consult an almanac or *The Book of Facts and Records,* found in most libraries. These contain complete listings of every country in the world with demographics, currency exchange rates, histories, political issues, and more. The key is to find the most current edition possible of these publications.

The foreign marketplace is huge, exciting, and often overwhelming. It's like being in a maze of unique and unfamiliar peoples and languages. Though you may not understand everyone and everything you encounter, try to understand the cultures from which they've come.

You will find it makes a world of difference in your international freelance success.

Afterthought

If you think you know international cultures and markets fairly well, you may be surprised—I certainly was—to read the following section from the annual "Quality of Life Index" published in *International Living*. (Available from Agora Inc., 105 West Monument Street, Baltimore, MD 21201 for $58.)

"We found that the number of newspapers per one thousand people is vastly higher in Russia (1,119) than in Italy (154). We found that Mongolia has the second highest annual museum visits per one thousand people (4,000) of all the countries we profiled. Meanwhile, Italy, a country full of museums, has only 410! And France has even fewer—210. The literacy rate in both Mongolia and the Ukraine is 98 percent, higher than in the United States, Singapore, Portugal, or Israel.

"These are just a few of the unexpected numbers we found. These statistics make it clear that we should be careful about our Western bias and about how seriously we take statistics. It's important to measure art and taste with numbers."

International Living is an excellent publication for freelancers who want to stay tuned to the cultures and lifestyles of foreign nations.

International Focus

Last week I received a letter from a freelancer asking the best way to begin her foreign marketing. My advice to her, and you, is to begin with articles and images you have already produced and perhaps sold in North America. There are three reasons, each of which follows my theory of minimum work for maximum profit.

Initially, you should consider overseas publications to be secondary markets. Rather than thinking up new ideas, you can quickly produce query letters based on completed articles and photos and send them to several editors. Your goal should be to get in the doors and build a relationship with editors that will eventually lead to new assignments. Once that happens, your writing business begins to work in reverse. That is, foreign publications become the prime markets and

you then resell the original articles done for them in North America.

Why, you may ask, don't you simply send the completed manuscript and images to the editor. After all, the editorial package is complete. Editors, no matter where they live, are busy people. It takes a few seconds to read a good query and know whether one wants an article/ photo package on a subject. A finished submission, on the other hand, takes up more time.

This is one reason not to send a completed article, from the editor's perspective. More important are the reasons that you, the writer/photographer, want to send a query letter first. International postage or courier service is not cheap. Once an article is packaged, it could easily cost you $15–$35 to send to, say, Singapore. However, an airmail letter, including envelope and stamp, can be sent for less than 50¢.

In addition, queries can also be sent easily by fax or e-mail to get quick attention from editors. Long, multipage article transmissions and stock photo listings are not only cumbersome, but discouraged by most buyers.

Once an article/photo package has been accepted, based on the initial query, editors may request a specific focus to target their readership. They may want a piece half the size of your original story, or twice the size. There may be individuals or information that they wish to be included. They could request sixty color slides or black-and-white prints. On the other hand, they may only want four or five.

Last year, for example, I wrote a feature for *Armed Forces Journal International*, in Washington, D.C. The topic was computer security. While the article focused on military computer systems, much of the information also applied to corporate electronics. I therefore considered this a good candidate for any international magazine covering business. Following my initial market research, off went four queries to different parts of the globe. A week later, Isabelle Lim, then editor of the Singapore Airport magazine *Changi*, informed me that the article would probably fit into the business section of the magazine. She preferred, however, some link to Singapore as well as a selection of general images of people using computers.

Reviewing my research, I found a quote by Lam Kwok Yan, a senior lecturer and spokesman for a group of researchers at the National University of Singapore. I inserted this information near the beginning of the article, giving it the exact slant Lim had requested. I also in-

cluded a selection of color slides. The result: a two-page article, with two images, which brought in $420.

Rewriting articles to give them a specific country or market focus will greatly increase your chances of an international sale. Inserting quotes or information from the periodical's home country, as I did in the above article, tells editors that you are tuned in to their readership. It adds credibility to you as a writer, and moves you one step closer to receiving future assignments. Similarly, when photographs reflect the "home country" of the publication, art directors tend to select those over other images they may be considering.

When an editor likes your work, take the required time and effort to focus on the article and images. Even though a full or partial rewrite, or even a new shoot, may not be necessary, take the time to do what is important for making the sale. Adopt the editor's or art director's point of view for a minute. Look at your text and images for possible reasons they could be rejected. For instance:

- Your work contains religious references, alcohol, drugs, modern women's fashions, dogs, pigs; includes quotes from clergy; or touches on military topics. EDITOR (Middle East): *Can't use it. These topics are taboo based on social and political beliefs.*
- Your work includes several quotes, all from North American sources. EDITOR (Hong Kong): *Would be a nice article for us if the writer had only quoted some Asian experts.*
- Your work highlights Oprah Winfrey, Howard Stern, Dave Barry, and Larry King. EDITOR (Italy): *Who are these people?*
- Your work includes measurements in inches and feet. EDITOR (South Africa): *Why didn't the writer use metrics? The United States is the only major country in the world that still uses inches and feet.*
- Your work uses words like "color," "theater," "organized," and "recognized." EDITOR (United Kingdom): *If the writer wanted to sell me this story, why didn't he or she take the time to spell these words correctly? (i.e., British-English spellings: "colour," "theatre," "organised," and "recognised").*

Fortunately, in the case of this last example, those working with computers (which should be everyone in this day and age) have the advantage of sophisticated word-processing programs such as Microsoft Word. These programs allow you to alter the dictionary and spell-check

features to apply to various languages and countries. If your original article was written in English (United States), you can change the configuration of your word processor's spell checker to, say, English (British), and then run a spell check, converting those *er*s to *re*s and *zed*s to *sed*s.

If you are unsure whether a word is spelled differently in the United Kingdom than in North America, and have Internet access, check the online British-American dictionary at *www.peak.org/~jeremy/dictionary/dict.html*.

Photographers should also examine their images to ensure that they are not slanted toward a market other than the one they are trying to sell to. For instance, if you are illustrating Russian fishing fleets, you certainly would not want to have Japanese fishermen in the picture. Similarly, for an article on French champagne, you would not want wine bottles labeled Chianti.

Given all these examples, it should now be clear why a query is the preferred method of approach. Basically, it saves money, time, and effort. No one said that becoming an international freelancer was easy. It often takes additional effort to make your work salable abroad— much less work, however, than creating a completely new feature or slide selection.

When selling abroad, you are self-syndicating your work. The world—not merely the United States or Canada—becomes your marketplace. What once was a onetime article or photo suddenly becomes a valuable product to be sold, resold, and sold again.

Unlike reprint sales, what you are offering to foreign editors are first rights in their country, readership, or genre. We'll discuss these and other rights in a later chapter. What is important at this point is that you realize the difference between a "reprint" and a "first right" offer.

When you sell a reprint, it basically means that another periodical in the same market area has already published the story. You may have, for instance, sold a story to *Travel and Leisure*, which bought first North American rights. A regional magazine may be interested in purchasing "second serial rights." Then, your local newspaper travel editor offers you $75 for the same story. He gets "reprint" rights. Normally, as the exclusivity of any article decreases, so does the price tag. The one exception is *Reader's Digest*, which pays top dollar for every reprint it publishes.

It has always amazed me that photographers, for the most part, do not have the rights problems that writers do. Just the same, if your images have already sold to a particular market—in-flight magazines, for example—it would not be wise to submit them to a competing publication without informing the editor first.

Selecting Subjects

Most of the same subjects that sell well in North America sell well around the world. Modern communications have shrunk the globe, and nearly everyone watches the United States closely. Foreign news broadcasts regularly cover Washington and U.S. affairs. As a result, U.S. business and politics are hot topics for most foreign weeklies and daily newspapers.

Many of the popular U.S. television series are aired in foreign countries one year later. Thus, celebrity articles and photographs are extremely popular, as are *National Enquirer*–type features. Anyone who is in the U.S. spotlight will sell abroad.

Many years ago, I visited the Frankfurt Book Fair and noticed several countries were releasing translated versions of works by author Stephen King. Since I had recently written a feature on King for a U.S. magazine, I began circulating the article abroad. It sold in Germany, Italy, Sweden, Spain, India, and Hong Kong. Most recently, I did an interview with Tom Clancy which, to date, has made print in Canada, England, Germany, Italy, and Singapore.

Foreign travel magazines, for the most part, cover North American destinations. In-flight magazines, one of the more lucrative markets for both writers and photographers (they do a lot of photo-essays), publish travel information about locations on the airlines' routes, as well as business, entertainment, personalities, environment, and an array of other topics.

I like working with in-flight publications. They are almost always slick, full color, and pay between $350 and $800 per feature. I've sold general-interest pieces ranging from jellyfish to microphotography to this market. I often correspond with editors in this sector, in fact, asking them where they could use coverage.

Arthur Hullett, longtime editor of Singapore Airlines's *Silver Kris* (the position is now held by Steve Thompson), informed me that his stock

of travel was overflowing. I therefore proposed an interview, and made the sale. I then tried entertainment—he was booked. I switched to environmental issues—two sales. This filled his archives in that category. Rather than move on, I suggested something on sports. As a result, I have sold him a feature/photo package on baseball and currently have an assignment on soccer. Anything that is popular at home—sports, medicine, military affairs, fashion, makeup, cooking—can also find a market abroad, if the piece is not too Americanized.

As I mentioned before, the United States is the only major country in the world that does not use the metric system. Therefore, when you send a query or article with measurements, they should be in metric units. When researching, look for sources outside North America. Quote experts from various nations, get the European viewpoint as well as that of Asia. And know the background of the country in which you are trying to sell. Do not, for example, try to sell a piece on world tobacco products in Sweden—law prohibits such articles there—or a piece on Western religions in Muslim countries. Such submissions merely alert an editor that you do not know the readership.

Finding Foreign Publications

ONE OF THE FIRST THINGS A FREELANCER LEARNS IS THAT THE BEST WAY to research a potential market is to obtain a copy of the publication. But how do you do this if you're four thousand miles away? Surprisingly, I've found that it is not all that difficult.

Your first stop should be the closest international airport. If you live, say, in Santa Monica, California, take a day and drive to the Los Angeles International Airport (LAX). Visit the newsstands. You'll find foreign language publications as well as newspapers and magazines from the United Kingdom and a number of other countries.

Be sure to also stop at the offices of foreign airlines—Air France, Alitalia, Air Jamaica, British Airways, Cathay Pacific, KLM, Gulf Air, Lufthansa, Philippine Airlines, SAS, Singapore Airlines, Royal Nepal Airlines, Qantas, etc. While there seem to be thousands of airlines and each with its own in-flight magazine, in reality there are probably fifty. Each a potential market for your work.

A few years back, I was looking for a particular magazine in South Africa. Now how was I ever going to get a copy? About that same time the directory of the International Food, Wine and Travel Writers Association (IFW&TWA)—one of several writers organizations to which I am a member—arrived. Going through the membership listing, I noticed an individual based in Johannesburg. I made contact with that person—using our mutual IFW&TWA affiliation as an introduction—

and asked if he could assist in getting me a copy of the magazine (at my expense, naturally). Two weeks later it arrived in the mail.

So don't overlook the power of networking when it comes to finding and obtaining foreign periodicals and markets. If all else fails, you can always write to the magazine. My experience is that most editors are too busy or too lazy to send sample copies to freelancers. Your chances are much better if you write to the advertising department and ask for a complete media kit.

The job of the advertising staff is to ensure such requests receive prompt replies. After all, advertising is what keeps most publications alive and you, in their eyes, are a potential client. There is no need for you to tell them that you are a writer or photographer seeking to sell articles and images to the magazine or newspaper.

Another advantage to requesting a media kit from the advertising department is that it frequently contains demographic information on readership, distribution figures, and other data that will help you target your sales. Not to mention the fact that the advertising folks *always* pay the postage, whereas editors have a habit of saying, "For a sample copy, send $5."

At this point, you may be saying, This is all great, but if I don't know a magazine or newspaper exists, how am I supposed to go seeking a sample copy? Good question.

You are now holding the first step to resolving this problem. The markets listed in this book provide an excellent base for your initial plunge into the world of foreign media. This is not the only reference for international publications, but I like to think it's the best. In all honesty, however, I would not be doing my job as a writer if I did not provide you with other options.

On my bookshelf is the *Willings Press Guide*, published in two heavy volumes and updated annually by Hollis Directories (see appendix B). Because the sales price is nearly $300, plus postage, I do not suggest you go rushing out to buy these books— rather, check their existence in your local library.

If the Willings guides are not available, there are other references that may be. These include the six-volume *International Media Guides*, *World Press Encyclopedia*, *Bacon's International Publicity Checker*, *Europa Yearbook*, and *Ulrich's International Periodicals Directory*. A good source book that the average freelancer can afford is the *Writers' and Artists'*

Yearbook, published in England by A and C Black (listed in appendix B). This book is released annually, with a cover price of about $20. While the publisher states that it is distributed in the United States, neither I nor any of my friends have been able to find it in bookstores.

Like any reference material, the information in these works is only as good as the publication date. It is therefore important to use the most recent editions possible and to ensure the market listings are not several years old.

Markets Abroad, my own quarterly newsletter, offers up-to-date information on publications around the world that buy articles in the English language for direct use or translation. A subscription is $27 a year by e-mail, or $31 for U.S. Postal Service delivery, from Michael Sedge Publications, 2733 Midland Road, Shelbyville, TN 37160. The information in *Markets Abroad* can be used to keep your references, including the foreign market listings in this book, as current as possible.

No matter where I am trying to sell an article—Africa, Asia, Europe, or North or South America—I have one rule of thumb that has always proved valuable: Never use market information that is older than eighteen months.

I know of no other industry—although telecommunications comes close—where individuals rotate so rapidly. In the fifteen years I have worked with *R&R* magazine in Germany, I have outlasted seven editors. This makes life as a freelancer very difficult, as you are required to constantly cultivate new people with new ideas and hope they will continue to use your services.

The ultimate for a writer or photographer is to find an editor that loves your work and who remains with a magazine for years and years. I can almost count the editors in this category on one hand. For the most part, editors in the United Kingdom seem to remain at their jobs much longer than, say, those in New York. This was also true, until recently, with many editors in Asia. Now, unfortunately, the editor-shuffle seems to be taking place there as well, with an increased number of publishing companies closing shop in Hong Kong.

Perhaps the only advantage to the editor-shuffle is that, if you are lucky, you can follow editors' careers as they jump from publication to publication and continue working with them. Also, if there is an editor you do not particularly like, the changes provide you with an opportunity to start fresh with a publication.

Just last week, a New Jersey–based writer sent me an e-mail saying, "I prepared a package and sent it to *Discover Europe*, only to have it returned with an 'Address No Longer Valid' stamp on the front. Could you tell me what is going on?"

First, I informed her to check the date of the reference from which she found the magazine. She replied that it was five years old. I then pulled out a current copy of the *Willings Press Guide* and found that the publisher of the *Discover* series had, in fact, changed. The new owner had also done away with *Discover Europe* and now focused on Eastern countries—e.g., *Discover Bulgaria*; *Discover Hungary*; *Discover Poland*; and *Discover Romania*.

This writer had lost time and money sending a package without doing her homework. Had she used the eighteen-month rule, this would not have happened. So, to ensure your work gets into the hands of the right person, whether it be a newspaper, magazine, or book editor, make sure market data is up-to-date and accurate.

If you have access to the Internet, there are other methods of locating foreign publications, such as online listings or, as they have been referred to, electronic newsstands. Here are a few sites that contain information on global publications.

- Ecola Newsstand: *www.ecola.com/news/magazines/world*
- Electronic Newsstand: *www.enews.com/channel/maglist/0,1041, 1,4,00.html*
- U.K. Travel: *www.travelconnections.com/Magazines/Unitedkingdom. htm*
- Media U.K.: *www.mediauk.com/directory/*
- News Sources: *www.uct.ac.za/depts/politics/intnew.htm*
- European/Latin America: *www.journlismnet.com/papers.htm*

Foreign Clubs and Associations

Joining foreign writers and photographers clubs and organizations is an excellent way to keep up with international markets. These groups also link you to others that can often provide greater detail into various publications. In fact, I have several colleagues based around the world with whom I regularly exchange marketing information. Such contacts can be invaluable. Appendix C lists some of the more popular English-language associations you might consider.

Depending on the group, there are numerous advantages to joining a foreign writers/photographers club, just as you would find with those in the United States or Canada. The Writers' Guild of Great Britain, for example, provides members with a variety of benefits, including the following:

- Negotiating collectively on writer's behalf—the guild has signed Minimum Terms Agreements with many U.K. media groups
- Writers' Guild Pension Fund
- Guild members automatically become members of the Authors' Licensing and Collecting Society—an organization that collects payments from foreign sources
- Guild members need not pay the joining fee if they become members of the American Writers' Guild
- Free access to guild events
- A bimonthly newsletter
- Free contractual advice

Additional information on the Writers' Guild of Great Britain can be obtained by sending a letter to its offices in London. Another valuable group is the National Union of Journalists, also in London. This organization is a driving force for the rights of writers and photographers in Great Britain. They have a bimonthly newsletter, *Freelance*, which provides updates on markets, a magazine, *Journalist*, an annual *Freelance Fees Guide*, and more. Addresses and contact information for these and other clubs and associations can be found in appendix C.

There is an organization for every area of freelance interest, or so it seems. If you do not find exactly what you are looking for in this book, check *The Directory of Writers' Circles*, which has been recently updated to include more than six hundred groups, meetings, and conferences. For more information, contact editor Jill Dick (see appendix B).

The Approach

FOR MYSELF, AND MOST OTHER SUCCESSFUL INTERNATIONAL FREELANCERS, the best initial approach is still a good query letter. Granted, once you have built a rapport with an editor, the wall of formalities begins to crumble and ideas can often be sent as one-paragraph proposals or, in some cases, a simple mention in an e-mail or during a telephone call.

After a few successful queries, during the early 1990s, to Janie Couch, editor of *Off Duty Europe*, in Frankfurt, I would make notes on article ideas and call her quarterly to go down my list. Knowing her editorial schedule and what "holes" she had to fill, Janie would say, "No. No. Got something similar. That one sounds good. No. Yes, I like that . . ." For every four or five negative replies, she would normally give me one yes.

Once you have rapport like this with several editors, you're in good shape. Until then, and when approaching new markets, however, stick with the query, even if you are selling photographs. As one editor from the MPH Magazines group in Singapore—which publishes, among others, Singapore Airlines's *Silver Kris* and Singapore Airport's *Changi*—pointed out: "It is always best to query. This saves time and energy on everyone's part. If something is sitting on my desk, it gets greater attention than a phone call or e-mail, both of which can easily be brushed aside. A letter is something tangible, something that requires action. I can't just push a button and delete it.

"Another advantage of the query is that they get filed and sometimes editors will reconsider or revert to them when they *do* need material."

This, in fact, happened to me recently with MPH Magazines. For many years I've been a regular contributor to *Silver Kris*. As with all editors, Arthur Hullett's space each month is limited and, therefore, he has to reject a certain percentage of my ideas. When the publisher won the contract to produce *Changi*, it suddenly found itself under a short deadline with no material for the first issue.

The group editorial director, Steve Thompson, mentioned this in a weekly meeting and Hullett immediately resurrected a few of my ideas. As a result, the premier issue of *Changi* carried two of my features— "Business Computers: Target of Corporate Terrorists" and "New Starlight Express, Fastest Show on Earth"—which brought me a check for $1,200.

The Package

Because I have a background in advertising, I take advantage of my stationery to promote myself and my various services. First, I created a company name—Strawberry Media—and logo. I then ran a one-and-a-half-inch-wide box along the left side of the company stationery. The box was divided into six sections, with each section indicating an aspect of my business, under the company logo: i.e., Strawberry Media Promotions, Strawberry Media Editorial, Strawberry Media Photos, and so on. The same logo design is used on my business cards as well as the cover of my presentation folders, which are used to send each completed editorial package.

Does this make a difference in the image-conscious markets around the world? Yes! For example, a few years ago James Kitfield, then editor of the now-defunct *Overseas!* magazine, asked me to do a story on Sicily. After I submitted the story, he wrote: "We'll be running your story in the July issue. The article itself was fair. You can chalk up this sale to your great packaging."

On another occasion, an editor receiving my article noted that I also offered photographic services and requested images not only for that story, but several others that he had been holding.

This is a good example of what I have said about writers being

photographers and vice versa. Like their American and Canadian coun-
terparts, editors and art directors around the world find it expensive
and time-consuming searching for artwork to illustrate a writer's work.
Writers that can also provide photographs are valuable to most over-
seas editors, as are photographers that can write. Receiving editorial
packages can decrease the editor's work by 50 percent. And if you make
their life easier, they'll find ways to repay you—e.g., additional money
for images, larger spreads in magazines (resulting in even *more* money),
and assignments that require articles and photographs.

You may have noticed that I mentioned sending "editorial pack-
ages." I always include illustrations with my articles. Depending on the
topic, they may be in the form of color slides, prints, graphs, charts,
maps, or even line drawings. The key is that I provide "visuals" that
the editor or art department of the publication can use to illustrate my
feature.

If you are not a photographer, or cannot find a collaborator, seek
out free picture sources. I discovered early on that somewhere, some-
one had photographs that they would provide free of charge for nearly
every topic—even if the magazine would eventually pay me for them.
I consider such payments as my fee for the time and research put into
locating images for the editor.

This morning, for instance, I called a regional archaeological direc-
tor in Southern Italy to request images. He agreed to have a selection
for me within two days as well as a letter of permission allowing me
to use them in any magazine in the world. In recent years I have ob-
tained pictures from tourist offices, nonprofit organizations, govern-
ment archives, corporations, and a host of other locations. The
possibilities are almost endless—and best of all, they are almost always
free. Of course, I am very careful to ensure credit is given to the source.

As life would have it, I just received a call from Mark Svenvold, spe-
cial projects editor at *Newsweek International* in New York. "We'd like
a thousand-word feature on the Italian fashion industry," he said. "And
it is *very* important that you obtain photographs from your various
sources. . . . We'll pay you $1,000 plus expenses."

See what I mean?

I've learned that working cooperatively with freelance photogra-
phers around the world is also helpful. Currently, I am waiting on a
selection of images of hunting from horseback from a photographer

in Holland, as well as pictures of Hawaii's volcanoes from another freelancer.

Such collaborations often open doors to photo-essays, which are so popular among the slick hotel magazines of Europe and Asia. A photographer in Switzerland, who had worked with me several times, mentioned that he had images of postage stamps from tiny countries like Andorra, Monaco, San Marino, and the Vatican. I suggested he send them to me. After looking over the quality, I wrote a five-hundred-word story called "Big Stamps from Little Countries." I sold it to four different publications, including Philippine Airlines's *Mabuhay*, which ran the story as a full-color photo-essay that was over six pages long.

During the past ten years I have sold perhaps fifty such photo features. Through collaborations, I've placed picture stories covering everything from Filipino jewelry to Italian architecture, jellyfish to chocolate, and historical war reenactments to antique-car races.

Putting together an image package that "tells a story" is often a simple matter of adding, say, five hundred words of text and presenting it to the right editor. In doing this, both the writer and the photographer can increase their sales at home and abroad. I, for example, always divide profits (minus expenses for courier, etc.) equally with the collaborator.

The bottom line is that images can help sell articles and text can often increase the sale of photographs.

Clips

Just how important are so-called clips or samples of previously published works to editors overseas? If you are using them to establish your credibility with a new contact, I would say very important. A few—no more than three—good-quality magazine clips will immediately set you apart from writers and photographers that merely say they've been published. The best clips are in full color, from noted publications, and contain topics of interest to the editor receiving them.

For example, you are trying to sell an idea to the editor of *Company*, which, despite its name, is a popular magazine for women in the United Kingdom. The magazine covers topics such as fashion, makeup, relationships, sex, and health. You've published several such articles,

or illustrated pieces for North American magazines like *Cosmopolitan*, *McCalls*, and *Redbook*. Clips from these periodicals to editor Fiona McIntosh would certainly be impressive and establish you as someone who can produce for the readership of *Company*. You might even go one step further and offer first U.K. serial rights to the articles you are sending as clips, or offer a similar selection of images.

I would avoid sending samples that appeared in newspapers or noncolor magazines unless they are from a well-known source such as *Reader's Digest*. Additionally, originals or color copies of your clips will have a greater impact on editors than will black-and-white reproductions.

SPOTLIGHT
Rohn Engh, Photographer/Publisher/Marketer

If you've ever explored the world of freelance photography, either as a primary or a secondary source of income, you have no doubt come across the name Rohn Engh. Over the past twenty years, Rohn has become the guru of global picture sales.

It began in the 1970s when Rohn, an active freelance photographer, published the first edition of the *Photoletter*, which provided advice on selling one's pictures to print media. As readership grew, he was asked by Writer's Digest Books to produce a work on freelance photography. The result was *Sell and Re-Sell Your Photos*, which became a bestseller for the publisher and has since gone into several printings.

Today, Engh's marketing advice and services have developed into PhotoSource International. With his wife, Jeri, and an extended staff, he now produces electronic and print versions of several newsletters for working photographers, including *Photo Daily, Photoletter, Photo Bulletin,* and the monthly *Photo Stock Notes*. Information on these publications can be found by visiting the PhotoSource International Web site at *www.photosource.com* or by e-mail at *psi2@photosource.com*. You can also call PhotoSource International at (800) 624-0266 or (715) 248-3800. Photo researchers can call (800) 223-3860 or fax at (800) PHOTO-FAX.

From his Osceola, Wisconsin, farm, Rohn took time out from his hectic schedule to answer a few questions and provide insight into the global marketplace.

Are North American photographers tapping the vast overseas markets? I've conducted surveys to inquire if individual photographers are selling to overseas clients. Only occasionally do I find someone who has made an overseas sale.

Why is this? Most overseas sales are made by major stock agencies who have satellite offices overseas. The problem, of course, for individual photographers is accountability: Will I ever get paid? Will my transparency be returned?

With more and more editors and photographers using the Internet, would it seem easier for one to find and work with foreign markets? Particularly since most communication is in English? There are several Usenet groups that discuss photography, and they often include participants who speak English and sometimes buy photography. However, most stock photographers are gun-shy about sending images to a person with no track record in the field, no history of publishing. The most popular group is Joel Day's STOCKPHOTO forum— it's out of Australia.

What would you suggest as a first approach with foreign markets? If the photographer is a specialist, say, in antique airplanes, and finds publishers worldwide who need such photos, it would be much better to deal directly with the foreign buyer to get 100 percent of the sale. [Otherwise] it's better to work through a foreign stock agency.

What advice would you give a photographer that wants to expand his or her sales abroad? My advice is to specialize. This way your list of photo buyers are accountable. They need you and you need them. This makes for good commerce and the problems of language, currency, time differences, customs, etc., go out the window.

We've touched on why a photographer should be a writer and vice versa. Are there reasons other than easier sales? Several reasons. The obvious, of course: payment is often doubled,

even tripled. An important reason: the photos that are used to illustrate an article can go into the file for future sales. Also, the sister shots. If the photographer/writer specialized, he or she can build up a file of additional related pictures for the stock file that can serve as current pictures, and later on as historical pictures.

Let's go back to the Internet for a moment. Aren't e-mail and Web pages opening new doors, new opportunities around the world?
Yes, they are—but slowly. We are finding that photographers who are listed on our PhotoSource bank [*www.photosource.com/psb*] are starting to get hits from Hong Kong, England, Japan, and other countries. Most of these photo buyers want to see digital images either on disc or e-mail. This makes it simpler to deal with overseas buyers.

The Return Envelope Illusion

"Everything I read says that I should include a self-addressed-stamped-envelope (SASE). Should I include those little international postage coupon things for foreign markets?"
Some of you may be laughing at the above line. If so, bear with me. This was an actual note sent to me by an aspiring writer looking to break into the international market.
First, those "little international postage things" are actually called international reply coupons (IRCs). They are sold at most post offices around the world and can be exchanged for international postage stamps in nearly any country in the world.
If you are one of those people who always include an SASE, good for you. Editors, I am certain, appreciate this. I know the publisher does, because it is paying the bills. I have always approached the writing business differently—and the word *business* is very important, because that *is* my approach.
Suppose you were trying to get a job in AT&T's media department, where hundreds of writers, editors, graphic artists, and advertising specialists work. What would be your first step? A résumé to the personnel department, of course. So you prepare a professional résumé, print it on quality paper, place it into a quality envelope, and mail it off. If AT&T executives decide they are interested, they will either call

or write you at their own expense. In fact, if they are not hiring, the personnel folks may even send you a letter—always at their own expense—to inform you of this.

The point is, they don't say, If you want to know if you've got a job, include an SASE. I know of no other business—none at all—that would dare ask a professional to include a postage stamp for a reply. What's going to happen in the future, when mail is obsolete? I see it now: If you would like us to contact you regarding your submission, please include a prepaid calling card.

Because I consider myself a *business* dealing with another business, I stopped sending SASEs fifteen years ago. Sure, an editor will send a "slap-your-hand" reply from time to time informing me that I "forgot" the SASE, but it's one in a thousand.

On the international front, I gave up including an SASE when the editor of *Off Duty Europe*, Bruce Thorstad, wrote: "There is no need to include international reply coupons, Mike. The time I spend going to the post office to cash them in is worth more than the price of a stamp." Now there was a professional.

There is, however, a downside to not including return postage and a self-addressed envelope. You have essentially provided editors with a valid—at least to them—reason for not replying. For instance, you send a query to Germany. After sixty days you have not heard a word. At the ninety-day mark, you send the editor an inquiry. She responds, "It is our policy to reply only to submissions that include a SASE."

Such replies, I can assure you, are very, very rare. More often than not, you will simply get no reply at all—unless, that is, the publication is interested in your story idea. On an average, I send out two hundred queries a year. I do not receive a reply on about 12 percent of these. Is it because I did not include an SASE?

I was curious to know this myself. So, last year I sent out fifty queries with SASEs and another fifty without. After 120 days, I had received ninety replies: forty-six in SASEs and forty-four in company envelopes.

Based on these results, I now allow a publication ninety days to reply to my query. After that time I assume I will never hear from them and send the idea to someone else in the same market. I can remember only five occasions when editors eventually replied after the ninety-day cutoff, saying they wanted the article. All of these, interestingly

enough, came from the United States—two just a few months ago: *Kiwanis* magazine and *Robb Report.*

There have been times when I've sold an article to a competing publication by the time I received a late reply. The editor of *Skin Diver* magazine, in fact, replied to a query after the ninety-day cutoff saying that he'd be able to use the story in his Christmas edition. I explained that due to the amount of time from my original query to his reply, the story had already been sold to *Dive Traveller*. I did, however, propose another article from the same geographical region that eventually appeared in the pages of *Skin Diver* magazine.

So, all's well that ends well—and two checks, in this case, are better than one.

Electronic Correspondence

Many years ago, fax machines revolutionized international communications. Suddenly, one could sit in Los Angeles or Owosso, Michigan, and instantly transmit a query letter to editors six thousand miles away, as long as they too had a fax machine. It was only a matter of months, in fact, that literally every business in the world—including publishers—had faxes.

After a "business study" on the cost of sending a fax to the Pacific, Europe, or Africa during the long-distance, low-rate hours, versus the price of envelopes and international postage, I found that it cost only pennies more to work electronically. Best of all, though, I knew that editors had my ideas "now" rather than seven to fourteen days later by standard airmail.

It wasn't long before I also learned something else. If an editor is queried by fax, he or she will often reply by this same means. Business became streamlined. To get an idea to England, and receive a reply, had been taking me nearly a month. Now I could achieve the same results in a matter of two to three days.

Fax machines, however, were just the beginning. For if the fax streamlined the international writer's business, the Internet launched it into a space-age world without borders, without paper, and without delay.

The E-mail Approach

Around 1995, there was a controversy taking place over e-mail queries. It seemed, at that time, that editors resisted electronic correspondence. Having been overwhelmed by as many as eighty e-mail messages in a single day, I can understand their dilemma and sympathize.

Fortunately, times have changed and, like the typewriter and computer before it, e-mail has become a tool used by more than 50 percent of today's editors. It was inevitable, if for no other reason than that of economy. The publisher—and the freelancer—saves on expensive letterhead paper and envelopes, postage, and, above all, time.

Last month, for instance, I sent out more than twenty-five electronic queries. Within three days I had received assignments from Marita Nuque, editor in chief of Philippine Airlines's in-flight magazine, *Mabuhay*; Judi Everitt, editor of *Holiday* magazine in the United Kingdom; the Germany-based publication *R&R* magazine, and a feature for *Writer's Digest*. After ten days, I had locked in three more assignments from London, Singapore, and Hong Kong.

It is easier and faster for an editor to answer an e-mail query—simply push the Reply button and type: "Thanks. It's not for use." Or better yet—from your point of view: "This is a great idea. We'll buy it!"

On the other hand, it is my experience that e-mail queries and article submissions also make it easier for an editor to *avoid* answering. It is simply a matter of pushing the Delete button and your idea, your query, your stock photo list disappears from the editor's screen and memory. What if you send a follow up inquiry? The editor quite simply pulls out the list of contemporary excuses that have developed with technology: (1) I never received it, (2) My computer crashed and I lost everything, (3) All e-mail goes to a general computer and not to me, or (4) We don't accept electronic submissions.

So, while e-mail submissions are the way of the future, you should also keep in mind that if you have not received a reply in, say, ten to fourteen days, it is best to scratch that publication and simply go elsewhere or present your idea through more traditional methods.

A very good reason to use e-mail queries is multiple submissions. I am a firm believer in sending the same ideas to markets around the world, as long as the rights one is offering do not conflict with one another. Electronic submissions make this *so* easy—just cut and paste. Let me give you an example.

I had come up with an idea to interview syndicated cartoonist Steve Moore, creator of *In the Bleachers*. I realized the subject was not right for many overseas markets, but I also knew there was enough exposure through Universal Press Syndicate, which handles Moore's work, to make this a good selling piece.

I made a list of ten primary markets where I might place the piece. In my word-processing program (Microsoft Word), I prepared a top-notched query letter and copied it to the clipboard. In my e-mail program (Microsoft Internet Mail), I sent the same query to ten different publications, at nearly every corner of the globe, in a matter of minutes by doing nothing more than creating a new message and clicking Paste.

What were the results of the multiple e-mail queries? Four positive replies (40 percent) within six days, coming from Australia, Germany, Japan, and South Africa; three "no thanks" letters (30 percent), and three left unanswered (30 percent). The key here is not the good return of acceptances, but the speed with which the replies came in and the cost involved in getting the idea to the buyer—nearly zero. This example highlights the effectiveness of using e-mail to market your work abroad whenever possible.

List Submissions

After I have sold a few article/photo packages to an editor, I often do as syndication agencies do: submit article lists. This is particularly true if I am trying to sell already completed features.

The "list" idea first began, for me, in 1990. I had sold a few articles to *Mini-World*, a magazine produced in Japan, which at that time, was edited by Naoko Yokoyama. Because its coverage included an array of subjects which I had written on, I decided to fax the editor an article list rather than individual queries. The list looked something like this:

- *The Art of Cameos from Shells* The art of handcrafting raised-design cameo jewelry from conch shells continues today, as it has for two hundred years, in the southern Italian town of Torre del Greco. This feature explains the step-by-step process of creating cameos, from the shell to the shine to the store. (800 words)
- *A Sea of Resources* Although mankind has used some ocean minerals and elements for centuries, extracting them in sufficient

quantities to meet today's needs would be an awesome task. Research is being carried out in many areas, however, in hopes of finding new and improved ways to harvest and utilize these resources. (1,500 words)

- *Master of Horror* If Edgar Allan Poe were alive today, he'd have some tough competition. With such works as *Carrie*, *Salem's Lot*, *The Shining*, and *Pet Sematary* to his credit, Stephen King is without a doubt the master of contemporary horror. (Interview—1,500 words)

- *Coffee: Italian Style* Hot or cold, topped with foamy milk, laced with liquor, or spiced, Italian coffee is a unique experience. Delve into the coffee-drinking culture of the Italian people, from its roots in the sixteenth century to its contemporary popularity. (1,200 words)

- *Square Dancing* Young people throughout Europe and Asia seem to be drawn like magnets to any trend that carries the "Made in USA" label. This holds true not only in fashion, film, and music, but dance as well. Almost overnight, in fact, a craze has developed for the fast-paced, American, barn-stomping do-si-do step known as square dancing. (1,200 words)

From this list, the cameo article and interview with Stephen King were purchased and appeared in *Mini-World* magazine. Yokoyama also took the Italian coffee piece to include as a chapter in *Italian Family Meals* released by Mini-World Books. Following this initial positive experience with lists, I continued this method of marketing, resulting in instances of both more and less success.

The key to benefitting from submitting article lists is that the editor knows you and your work. I would not attempt to sell features in this way until I had sold at least three articles through traditional query submissions, though I know other writers who have tried—some with limited success.

One of the disadvantages of this marketing technique is that you will rarely get an assignment. More often, an editor will agree to look at the completed manuscript(s) on speculation if he or she is interested in a particular topic. My personal view is that if I have already written the article, the only thing I lose is postage. And if the editor accepts e-mail submissions, I don't even lose that.

What's for Sale: Rights

PERHAPS THE BEST THING ABOUT INTERNATIONAL MARKETING IS THAT YOU are not restricted to individual submissions and the sale of first North American serial rights. Beyond U.S. and Canadian borders, you can send multiple submissions to your heart's content. The world is at your fingertips, and its wonderful.

This wonderful world, however, can quickly turn sour if you are not careful. There are vulturelike editors and publishers out there that will try to capture all rights to your articles, leaving you with dry bones, while they feast on the meat. This is particularly true in this age of electronic publishing.

Publishers have been known to pay minimal fees for all rights to articles, then use the features not only in their magazines, but in their Internet Web sites. Then, after this, they syndicate the features around the world and reap far more money than they originally paid the writer. Don't let this happen to you.

The key to rights is that you give each publication what it *needs*, within the legal boundaries of the sale. For example, if a newspaper published in New York State is going to publish your article, it has no *need* for all North American rights. In this same respect, a national publication has no *need* for world rights. If I am working with a periodical that insists on more rights than are necessary, I immediately up the price of the article accordingly. Granted, you might lose a sale by

doing this, but in the long run, you may end up making more money by being able to sell the piece again and again.

While there are certain established rights (e.g., first North American serial rights, second serial rights, and reprint rights), there are no rules that say you cannot make up your own rights. I do this all the time, based on a publication's readership. *Going Places Doing Things* is a bimonthly magazine published in Rome that is put out in English. I offer the publisher first English-language serial rights in Italy, which leaves me free to sell the same articles to an Italian-language publication. If that same article is sold to *Gente Viaggi*, also in Italy, what the publication is buying is first Italian-language serial rights. Similarly, *R&R*, in Germany, may purchase "exclusive rights in the military market," leaving me free to sell exclusive German-language rights.

You, and not the editor or publisher, should establish what rights are for sale. This is the only way to truly control what you own. I normally do not discuss rights when proposing an article. Some publications, but not most, will offer a written contract once they agree to assign you the story. These agreements spell out the rights the magazine desires. If you do not agree with them, simply inform the editor of the rights you are offering, change the contract, initial the change, and submit it. This is a common practice and most editors, if you give them the rights they *need*, will agree—though they will probably have to clear it with the publisher or legal department.

When a formal agreement is not provided, I place the rights offered in the upper-left-hand corner of the first page of the manuscript, under the copyright information and article length, like this:

© Copyright Michael H. Sedge
First Singapore Serial and Exclusive In-flight Magazine Rights
Approximately 2,500 words

Rarely have editors questioned what I offer. To provide myself with double security, however, when a check arrives for an article, I sign the back and, under the signature, write the exact wording as that which appeared on the manuscript. According to my international lawyer friends, if there is no written contract, the printed offering on the article, backed by the statement on the check, would make it very difficult for a publisher to prove he or she purchased more than you've offered.

This is as far as I go to protect my rights. In twenty years, I have never had any problems. If you wished to go one step further, though, you could print a second first page of your article, which contains the rights offered, rubber-stamp the date, and have two witnesses sign and date it as well. When the check arrives, make a copy of the back with your statement. Attach the two documents and file them in the event that you ever have to prove the rights purchased by a periodical. If you are really paranoid, you could even take the original page to the post office when you mail the manuscript and have the clerk place the date over the signatures with the official U.S. Postal Service stamp. Personally, I find that to be too much hassle.

To give you a better idea of some common and not-so-common rights you can offer publications, here is the listing I use (and frequently add to):

- *All Rights* (Frequently referred to as "work for hire") If you are writing under this agreement, forget all hopes of international marketing. The buyer, once you have turned over the article, owns it lock, stock, and barrel.
- *First North American Serial Rights* These rights are commonly purchased by the first publication, on a national level, that uses your article in North America.
- *Second North American Serial Rights* Smaller magazines, even regional ones, will often pay a lower price for quality articles knowing that they have appeared elsewhere. In this case, they are the second publication to use the article in North America. To reconfirm that you are selling only single-usage rights, you can also add "one-time use" to the rights line of these and any other nonexclusive offerings.
- *Reprint Rights* Newspapers frequently use reprinted material, as long as the articles have not appeared in a competing publication. The price is often much lower than you might get for first or second serial rights.
- *Regional Rights* There will be times when you may want to restrict the sale of rights to a particular city, county, region, or province. This would allow you to sell "first regional rights" throughout a country.
- *Exclusive Language Rights* Some articles cross the lines of culture, language, and nations. For these, you should consider selling

exclusive language rights (e.g., Spanish, German, Dutch, Italian, and English) when marketing internationally.

- *Exclusive Geographical Rights* Countrywide rights can also be negotiated for multiple-nation sales.
- *Language and Geographical Rights* This is one of my favorites as it limits not only the language, but also the geographical area. For instance, if you sell exclusive Spanish-language rights in Mexico, you cannot sell the article in Spain. By adding geographical restrictions, however, you are free to sell the same article in numerous countries that speak the same language, e.g., exclusive Spanish-language rights in Mexico, Puerto Rico, Spain, and Portugal.
- *Exclusive Market Rights* Throughout the world there are publishers that are only concerned that an article they run has not and will not appear in a competing magazine or newspaper. In these cases, offer exclusive market rights. In-flight publications are excellent examples. The publishers of these slick, color magazines all want exclusivity in the marketplace.

 You should also be careful to ensure that the type of usage you are offering is spelled out. That is, whether you are selling serial rights (for use in periodicals such as newspapers and magazines), book rights, audio rights, motion picture rights, video rights, etc. In your case, you will most often be dealing with serial rights. So, if you are selling an article in London, you may be offering first U.K. serial rights. On the other hand, if the story is appearing in a Japanese publication, you may be selling first Japan serial rights or exclusive Japanese-language rights. This latter would leave you open to also sell exclusive English-language rights in Japan.
- *Electronic Rights* In this age of the Internet, electronic rights must be aggressively protected. Many publications will purchase an article from you under the "assumption" that they can utilize it in both print and electronic media. If they wish to do so, you should negotiate an additional fee for the latter.

 Unlike geographical rights, which can sell over and over, electronic rights, for the most part, are one-time sales. An editor receives your piece and places it into the Internet magazine for anyone in the world to read. The only leverage you may have is

to limit the "language" rights. For instance, you can offer exclusive electronic rights in the English Language. This leaves you open to sell to Internet magazines in, say, French, Japanese, or German.

.

C H A P T E R S I X

In-flight Magazines

NEARLY EVERY AIRLINE IN THE WORLD HAS ITS OWN IN-FLIGHT PUBLICA-
tion, which is given out free to passengers. English is the primary
language for these magazines, though some also run text in dual lan-
guages. For writers, this means greater sales opportunities for original
as well as reprint articles—since editors of in-flight publications often
request exclusive rights in that market only.

In-flight magazines, because of their high-quality and extensive use
of color, are also excellent markets for photo-essays. As part of a sur-
vey of airline publications, a leading advertising agency in the United
Kingdom found that 79 percent of the magazines used photo features
in which pictures "told a story."

Like other markets, the best way to learn the needs of a particular
in-flight magazine is to study what is currently being used. Unfortu-
nately, airline publications are sometimes difficult to find. Walter
Glaser, past regional president to Australia and New Zealand for the
International Food, Wine and Travel Writers Association, suggests that
writers visit an airline's office in any major city to obtain publications.
"If you ask them for a copy of their in-flight magazine," says Glaser,
"editors' names, addresses, and fax numbers are usually on the inside,
front page."

In-flight publications typically pay from $400 to $1,000 for a text-
photo package, some slightly more, rarely less. It is generally the policy

of such magazines to pay in U.S. dollars if you request such payment; however, you should inquire about payment prior to agreeing to provide any editorial services.

One final note with regard to writing for in-flight publications outside North America: keep the reader in mind. Too often writers come up with good ideas, one European editor told me, then forget the international angle. They use quotes, examples, and anecdotes that are exclusively American—a segment that might make up only 7 percent of total readership.

SPOTLIGHT
Fong Peng Khuan, Editor, Muhibah

From the public relations department of Royal Brunei Airlines, in the tiny nation of Brunei, located on the northern tip of Malaysia, Fong Peng Khuan edits the bimonthly, English-language in-flight magazine *Muhibah*. Not long ago, I wrote Fong, asking specific questions about the publication. Here are her answers:

Do you work with freelancers?
The editorial panel of *Muhibah* values contributions by writers/photographers who can offer stories with photographs for publishing in our bimonthly magazine.

What type of material do you use?
We normally carry well-illustrated eight hundred–word features to our main destinations and other topics of general interest to the reader.

What are Royal Brunei's main destinations the freelancers should focus on?
Existing destinations include Beijing, Taipei, Manila, Hong Kong, Singapore, Bangkok, Kuala Lumpur, Jakarta, Bali, Abu Dhabi, Bahrain, Dubai, Darwin, Brisbane, Perth, and Osaka. Within Borneo, we fly from Bandar Seri Begawan to Kuching, Miri, Labuan, Kota Kinabalu, and Balikpapan. European stories on Zurich, Frankfurt, and London are also welcomed.

Occasionally, new routes to be opened like Cebu, Davao, Zamboanga and General Santos in the Philippines, Calcutta, Ho Chi Minh

City, Amsterdam, Brussels, Karachi, Paris, and Christchurch are given prominence when each of them comes online. U.S. destinations like Hawaii and Californian cities may be considered.

What does a normal issue of Muhibah *include?*
There is usually a selection of articles on the arts, lifestyle, motoring, innovations, entertainment, book reviews, and cuisine. These are easy to read and highlight subject matter that is current and topical. If you have a suitable story proposal, feel free to make a query.

Are there any restrictions in the writing style?
Please be aware that as Brunei is an Islamic country, we cannot feature, mention, or make reference to alcohol, religion (other than Islam), dogs, pigs, political commentary, human body parts, or women in revealing clothing.

What are the current payment rates?
Muhibah pays B$.50 per published word [the Brunei dollar (B$) is the same as the Singapore dollar]. One word is equivalent to seven characters on a Macintosh word processor. We reserve the right to edit any article to fit the space allotted to it, and to delete any items which, in our judgment, may offend local sensitivities.

And photographs?
Published photographs are paid B$90 each, irrespective of size printed, and we only accept high-quality original transparencies or prints of outstanding clarity. A cover picture earns B$200.

How do you prefer to be approached?
If you wish to contribute, we would appreciate a three-sentence synopsis before we accept any copy. Kindly fax your story ideas over to our direct line: 673-2-237-778.

Hong Kong Markets

ONCE A HAVEN FOR ENGLISH-LANGUAGE MAGAZINES SUCH AS *OFF DUTY Pacific*, *Emphasis*, *Regent*, and *Peak*, Hong Kong has experienced an upheaval in the publishing industry: as the Chinese government moved in, it seemed that publishers moved out.

"I don't think there's as much in English as there once was," explains Lawrence Gray of the Hong Kong Writers' Circle. "Travel pieces from exotic places like Watford and New York might sell here. . . . There are journals dedicated to various sports that are popular here—badminton, golf, and so on. Scuba diving is very big here due to the proximity of the Philippines, which is scuba-diving heaven. Considering I nearly drowned there in the care of their kamikaze dive masters, I now realize how close to heaven it really is."

According to Gray, who has lived in Hong Kong for many years, today's English-language market for nonfiction is largely for tourists or frequent traveller businesspeople. "There is also a market for *Gweilos* (ex-pats) who have actually settled here," he explains, "but the information is very localized. As an overseas market, it is most likely a tough nut to crack."

The Hong Kong government has a Web page at *www.info.govt.hk* with information on media outlets that Internet users can explore. Gray suggests writers also search for publications on the Net, since the

government site has dwindled some in recent months to cover only business publications.

"There are lots of Hong Kong directories around though," says the director of the Writers' Circle. "A quick search for Hong Kong media soon pulls up tons of stuff, mostly about movies and canto-pop, but there is other stuff buried in there."

There are also hotel groups and airlines that produce in-house publications and various English-language newspapers from Jakarta to Kyoto that buy material—some of them very well established.

With the downsizing of the market, Lawrence Gray has shifted his own efforts to TV scriptwriting. He discusses this and much more on the Hong Kong Writers' Circle Internet Web site at *home.netvigator.com/ ~lwgray.*

The United Kingdom

COMMON CHARACTERISTICS BETWEEN NORTH AMERICA AND THE UNITED Kingdom—English language, religions, products, movies—make this, by far, the best market for writers seeking to sell their work abroad. Frequently, with minor alterations, one can resell articles in the United Kingdom that have already been published in the United States or Canada. Just recently, for example, I received a call from the office of Fiona McIntosh, editor in chief of *Company*, the popular British magazine for women. They were interested in using an article I had originally written and sold to the U.S. magazine *Family*.

But exactly how large is the U.K. market? According to a recent edition of *Willings Press Guide*, there are more than 10,500 periodicals published in Britain. And this does not include newspapers! Everything from business to buffaloes and beauty to badminton is covered by the U.K. media—so there is certainly a place for your work.

One of the discouraging aspects of this market is that, generally, there are no cut-and-dried rates. There are some magazines, naturally, that have taken on the North American custom of establishing flat, per word, or per photo fees. For the most part though, periodicals simply stick with the traditional phrasing: "Rates are negotiated according to the job."

In some situations, the nonfixed rates can be beneficial to you. Let's say, for instance, that you are an expert on military affairs and have

access to high-ranking officials. You might query a publication regarding an interview with the U.S. Secretary of Defense (make sure that you spell it "Defence" for the British market). A popular weekly news publication such as *Sunday Magazine* might offer you $500 for the story. A week later, however, hostilities may break out in the Middle East, calling for NATO troops to once again deploy to that region. Suddenly, your interview is worth five times the amount offered during a "peace time" situation.

Something very similar to this happened to me a year ago. I had interviewed author Tom Clancy and sold the piece in the United States, Singapore, and Germany. By the time I got around to marketing it in the United Kingdom, Clancy's book *Executive Orders* was topping the country's bestseller list. As a result of the timeliness, I sold the article for three times the magazine's so-called standard publication rates.

Writers should be prepared to negotiate fees with British publications. As one U.K. writer points out, "Freelancers are constantly warned by the National Union of Journalists (NUJ) that the rates quoted by editors in their fees guidelines are the minimum acceptable. Often, editors will use the 'standard' or 'normal' rates as a shield."

The NUJ and Writers' Guild of Great Britain (WGGB) are two of the most powerful lobby groups for the protection of writers. To find out what rates they have negotiated with various media, you can contact them at the addresses listed in appendix C. You might also check the Internet Web sites for these organizations:

- NUJ: *www.gn.apc.org/media/nuj.html*
- WGGB: *www.writers.org.uk/guild/*

The NUJ also puts out an annual *Freelance Fees Guide* for writers and photographers. The latest issue divides British magazines into four pay categories ranging from £130 to £350 per one thousand words. Newspaper features, according to the report, should pay £200 per one thousand words. Photograph sales by NUJ members in the United Kingdom begin at £100 for a quarter page and increase with size, a full page bringing £485. These are the "minimum recommended rates" for images used in editorial content.

SPOTLIGHT
Jill Dick, Freelance Writer/Editor

Author of *The Directory of Writers' Circles* and contributor to the *Writers' and Artists' Yearbook* (see appendix B for details on these publications), Jill Dick has been an active member of the British writing community for over thirty-five years. When not working on books and how-to articles for writers, she divides her time between contributing to and editing for U.K. newspapers as well as writing about two of her passions, books and albums.

From her Derbyshire home, here are some of the comments and advice Jill gives to writers hoping to break into the British markets.

What is the best way for North American writers to approach the U.K. markets?

First essential step: obtain and study recent editions of chosen markets and keep at it until you get to know the "reader." They, not the editors, are the people you are writing for.

How should one contact newspaper editors in Britain?

By letter or fax, but still take note (of my previous answer). If you are not talking their language, you won't get far.

Should a writer try contacting editors by e-mail?
No.

What are some obstacles non-British writers might encounter?

Maybe not being able to drop into the British idiom, particularly in newspapers, but if "obstacles" means barriers put up to keep non-Brits out, absolutely nothing like that exists. If you can write the right copy we don't mind who you are or where you come from! In fact, in some ways non-Brits could have an advantage, looking at British concerns with fresh eyes from a distance. Welcome all!

What topics are popular right now in the U.K. magazine market?

Again, study the markets. Some U.S. writers think it's okay to pass on ideas and themes to little old-fashioned U.K. but I am sure your readers would not make this mistake! At the moment, anything on politics, royalty, and government issues are received with boredom. It

is easier to tell you what is *not* wanted than what *is*. There really is no answer but to study the markets, put your thinking hat on, and write. Apart from that, my advice to budding journalists is: if you have a good idea to work on, don't talk about it or someone will pinch it, probably me.

What is the average pay a writer might expect from U.K. newspapers and magazines?
Impossible to give averages, as the variation is wide. But the *Writers' and Artists' Yearbook* will help, as will the National Union of Journalists *Freelance Fees Guide* (see appendix C).

What would you suggest a visiting writer do to enhance his or her knowledge of the U.K. marketplace?
A first-class residential course often gives overseas writers an invaluable eye-opener into what goes on here in the writing world in every sense. The best is the annual Writers' Summer School, which meets for a week in August in Derbyshire and attracts top speakers in every field. It also runs courses in poetry, nonfiction for magazines, novel writing, playwriting, writing for newspapers, short stories, and countless other topics. Not all these will be offered every year, but there are always seven or eight courses running at any one time during the week, together with dozens of workshops, discussion groups, etc. More information is obtainable from Brenda Courtie, The New Vicarage, Parsons Street, Woodford Halse, Daventry, Northants NN1 3RE, United Kingdom.

Can you suggest any publications American and Canadian writers might consider subscribing to for assistance in reaching the British markets?
[In addition to those mentioned above] *Freelance Writing for Newspapers* and *Writing for Magazines . . .* There is also *Writers' News*, a monthly magazine for writers, published in Scotland (see appendix B).

Anything else you feel North American writers should know, seek, or consider?
Remember that fresh outlook I mentioned earlier? This is the very best approach, for all editors welcome something new in spirit as well as in the writing. Better than a tea break.

Sex, News, Interviews, and Travel

WE, AS WRITERS AND PHOTOGRAPHERS, ARE ONLY HUMAN. AS SUCH, WE fall into the same pits as others, e.g., overexcitement, a desire to get fast results, and laziness. Without going back to count, I would say that I and others from the previous pages have advised you to "study the publication" at least twenty times, perhaps more. And yet, I found myself recently overlooking my own advice.

I had heard that the best paying markets in the United Kingdom were the magazines targeting women readers (and there are a *lot*). In a rush to make a few sales and bring my bank account up to minimum wage, I sent out a series of query letters covering such topics as spa vacations, gardening, home computer businesses, and celebrities. These were all popular topics in U.S. women's publications, and besides, these types of magazines are all the same, right? Wrong!

After numerous rejections, I found myself in London and collected current issues of several publications for women. Among them was a copy of *Company*, published by National Magazine Company. Without even opening the magazine, I realized why I had missed the boat with this one. Had I studied a recent copy, as I preach to others, I would have known that my ideas were not on target. The glossy, four-color cover carried titles like "Make Him Beg for You!" "The Night I Slept with My Bridesmaid," "The Only Sex Trick You'll Ever Need," and "Rugby Strip."

No gardening in this monthly! I had been trying to sell them on ideas which *I* thought were for women when, all the time, I should have been pushing what the readers wanted—for example, sex.

Upon my return to Italy, I sat in the Leonardo da Vinci Airport, waiting for my bags. I watched as an Italian man talked to two British girls and was amazed that by the time their luggage had arrived, he had succeeded in getting their names and the name of the hotel where they were staying. I suddenly had my first idea for *Company*—Italy's Latin lovers.

A few days later, a fine-tuned query went out to the magazine. The phone rang on a Wednesday, nearly ten days later. It was Rachel Loos, deputy editor of *Company*. She wanted to use the article, which, ultimately, would carry the title: "Sex Italian Style: Ten Ways to Turn Your Man into a Latin Lover."

While the moral of this tale is that you should definitely study a publication prior to submitting ideas, it also illustrates that top-paying European markets are eager to work with writers that have the right ideas. The women's magazines pay excellent rates and should be explored by all writers.

Another area that pays well—when compared to their counterparts in North America—is foreign newspapers. Naturally, this does not hold true for *all* newspapers, but definitely the major ones. The recommended rates of England's National Union of Journalists for a national newspaper, in fact, is £200–£300 ($340–$510) per article. At the same time, leading newspapers in the United States continue to pay $75–$200 for articles.

Anything that is a hot topic in the news or related to a subject covered by, say, CNN, will go over well with foreign newspapers. The key is to have a unique angle or an aspect of a story that is not being explored by other media.

While researching this book, I set out to find the most profitable area of writing for those interested in selling abroad. To do this, I contacted twenty-five international syndicates from Asia to Europe, asking each of them the same question: In which category of writing are most of your sales? Of those that replied—seventeen—the answer was always the same: celebrity pieces.

Not everyone has access to Tom Cruise or Demi Moore. There are many of us—including myself—that wish we did. And while film stars

are by far the most noted personalities among foreign populations, they are certainly not the only celebrities that interest editors and readers.

Early in my writing career I noted how many periodicals were using personality profiles. And since my other areas of writing were not moving as fast as I would have liked, I decided to delve into the celebrity field. But I was in Italy, far from the glitter of Hollywood and the bright lights of Broadway. It did not take long to realize, however, that world-known personalities were all around me.

I first explored the local area and found Admiral William Crowe was the commander in chief of the Allied Forces Southern Europe (NATO) Command. Soon after I interviewed him, he became the chairman of the Joint Chiefs of Staff at the Pentagon, exposing him to more world media and increasing the salability of my article. I next sought out radio personalities such as Father Harry, whose program *The God Squad* was broadcast to U.S. military around the world. I succeeded in selling his interview to *Off Duty Europe*, *Stars and Stripes*, and the *Times Journal*.

While attending the Frankfurt Book Fair, I ran into Stephen King (all right, I made a specific effort to see him). There was no time for an on-the-spot interview, but I did get him to answer twenty questions in a follow-up letter. I then obtained photos from his publisher and sold the article in Germany, South Africa, the Philippines, and the United Kingdom. This success stimulated me to do further interviews with such authors as Alex Haley, Tom Clancy, and Lawrence Block.

Combining popular categories like business and celebrities, I was able to open more doors. A story on Italian designer Fendi and the jeweler Buccelatti sold well throughout the Middle East, Europe, and Asia, as did a feature on entrepreneur John Hendricks, founder of the Discovery Channel.

There are two points to be made here: (1) to be successful, there are times when you must alter your area of writing to fit the market and (2) don't be fooled by the "celebrity" title when seeking out individuals for your interview stories. Look first in your own backyard. A women's magazine in South Africa might be interested in a local black, female involved in business, while an art magazine in England may be thrilled to receive a feature on a local wax artist (I've already done this one, so you may want to pass).

In one form or another, we are all celebrities. I have, in fact, sold a number of stories about myself to the editors of *Business Opportunities, Entrepreneur, Panorama,* the *Stars and Stripes,* and *Writer's Digest.* Today I use the Internet to do most of my interviews, making it easier to reach out and find unique personalities that will be welcomed by markets abroad.

One of the more enjoyable writing categories—at least as far as research is concerned—is travel. It is also an area that overseas editors seem to thrive upon. In-flight magazines, hotel and airport publications, newspapers, regional journals, and general-interest periodicals all buy good travel stories.

Here too, however, you must come up with something unique. At the onset of 1997, I reviewed my foreign sales for the past year. I was happy to see that I had placed an increasing number of interviews, but concerned that my travel feature sales had dramatically declined.

Not long thereafter, I was corresponding with Arthur Hullett, editor of Singapore Airlines's *Silver Kris.* Try covering travel with a new slant, he suggested. About this same time, off the coast of Alexandria, Egypt, divers had discovered what they considered the lost palace of Cleopatra. I quickly sent a query to several editors, including Hullett. Not only did he buy it for *Silver Kris,* but so did Jim Randall, editor of Mobil Oil's the *Compass,* and several other editors around the world. Why? Because it was (1) unique, (2) exotic travel, and (3) newsworthy.

Because I am well linked to such groups as Earthwatch, the United Nation's Food and Agriculture Organization, and the World Wildlife Fund, I've been very successful in placing travel articles that have environmental slants. Topics such as volcano exploration in Italy, iceberg research in Switzerland, insect eradication in Libya, and ocean farming in Asia are all subjects that have sold in popular travel magazines around the world.

No matter where your interests lie, there are ways to slant your story to fit into the popular writing styles and categories. Combining the elements of two or more styles will enhance your sales potential greatly. Let's say, for instance, you were able to get an interview with Hillary Rodham Clinton, on vacation at an Italian beauty farm. You suddenly have a celebrity piece, a travel feature, and a beauty slant that would fit the format of a number of publications.

Be creative, be innovative. Don't get trapped into the traditional

mold of "travel writer" or "news reporter." Let the markets be your guide and your overseas success will blossom into an attractive end-of-the-year bottom line.

SPOTLIGHT
Debe Campbell, Editor/Freelance Writer

From her base in Bali, Indonesia, Debe Campbell edits the monthly magazine *Kem Chick's World,* which targets the expatriate residents in that country. In addition, she operates a successful freelance writing and photography business, selling her work to editors around the world. Beginning as a hobby in 1979, Campbell's freelance efforts became serious around 1985. Today she specializes in travel, covering industry news, and focused destination and consumer features.

When I decided to include spotlight features in this book, Debe immediately came to mind. What better person to provide advice and insight into the international marketplace than an American writer/photographer living overseas, who also edits a magazine that pays for English-language material? Fortunately, for me, Debe also thought it was a good idea.

If you were talking to a group of freelancers that wanted to begin selling overseas, what would be your advice?

Do your homework before you query. Don't waste an editor's time by proposing things that would never be used by a particular magazine. Study the market and the publications. Know what magazines publish and the style they use. Try to match that style and content with what you are proposing to an editor. This applies to any market, domestic or overseas.

Anything else?

If you can't sell it more than once, you've wasted your time. Market to as many different, noncompetitive magazines in different, nonoverlapping distributions/regions/countries as possible. Again, this applies to domestic or international markets, but is easier to do internationally because there is less overlap and editors seem less threatened by this than perhaps in the U.S.

Have you ever tried to market a book abroad?
Yes, without much success because of the focused, cultural interest to a limited population.

You are also a photographer, correct?
Yes.

Do you submit photographs with your work?
Yes. I always make photo-word packages available. I cannot recall a word-only sale. If I do not have the correct or quality photos available, I have a good relationship with professional photographers in the region from whom I can use stock shots or usually ask to shoot, to back up the text, on spec. Or, on occasion, we will collaborate on pieces. I have [also] had photographers and editors contact me to write [a piece] to [go with] photos available.

What are some of your better sales?
This depends on how you look at it—highest income or most satisfaction. Some of the greatest rewards are seeing stories that I care about appear in a market where they make a difference, rather than make the highest income. Among these was recent placement of a story in a South African magazine, revealing an overlooked segment of the history and culture—something in their own backyard that had been overlooked. Developing the story, knowing that I was onto something special, made it exciting. Seeing it come to print and having an editor recognize the value of the piece was satisfying. So the pay, while fair, was secondary.

Another satisfying sale was an advertorial piece in the *International Herald Tribune*. While it lacked journalistic integrity, it was nice to have a placement and a byline in a global newspaper. And it probably paid better than a news sale would have.

What about a horror story?
Can't think of any real disasters. Spent a lot of time chasing money around the world and that can be an expensive horror. I've seen my work reproduced without permission, without a byline, and without payment. That was not appreciated. And it does happen in countries where copyright laws are not strongly enforced.

Who would you vote the best overseas editor?

Stephen Forster of *Winds*, the in-flight magazine for Japan Airlines, gets my vote hands down.

Why so?

In giving an assignment, he tells you exactly what he wants and exactly what he doesn't want. He is the only editor who has ever followed up by forwarding me the edited text for correction and approval before it went to press—and this was critical to clarify some cultural aspects when the text had been pared down in editing. And, he is the only editor who has ever followed up months later with a sample of a similar story published, later, in a rival magazine as an example of exactly what he didn't want in his magazine, saying what we had accomplished was far superior. That is a rare editor!

You specialize in travel?

Yes.

What overseas markets do you find best suited for your work?

As a travel writer, my work is very segmented and focused, so I target my market carefully. I know where to look for what I am trying to place and have, over the years, developed a base of editors to work with on a more intimate level so I don't have to do the formal query process with everyone. My focus is on Asia and Australia, where I know I can sell without much effort. I've never tackled the European market and marginally the U.S., simply due to time constraints.

Writing for International TV and Film

VERY FEW WRITERS BEGIN THEIR CAREERS WITH AN INTENT TO WRITE FOR the screen. Most follow the path from newspapers to magazines to books to multimedia and, eventually, wind up on a television or film project.

"When I arrived in Hong Kong," explains writer Lawrence Gray, "I set out on a quest to make some fast bucks writing in glossy magazines. [Eventually] I lost interest in the whole enterprise and slipped back into writing TV scripts, which is much more lucrative, and I gave up on the so-called local [print media] market entirely."

There are numerous opportunities for English-language writers in the visual media business. In the United Kingdom alone, there are more than ninety international, national, and regional television companies—including BBC, GMTV, Sky, ITN, and ITV. There are a similar number of independent production companies, as well as the visual markets in Australia, Ireland, New Zealand, South Africa, and other foreign countries.

Currently, the standard fees for a sixty-minute television script range from $8,000 to $12,000 for an established writer. What that means is you will have to either demonstrate a track record in the industry or have the required skills to produce material in the proper format and style.

Before leaping into this market, however, I suggest you first write

to the Writers' Guild of Great Britain, which oversees this industry like a watchdog. The address, telephone number, and e-mail of this group can be found in appendix C. Their Internet Web site is: *www.writers.org.uk/guild/*.

I would also recommend, if you are a newcomer, investing in the *Writer's Guide to Hollywood Producers, Directors, and Screenwriter's Agents,* by Skip Press (see appendix B). The book offers contacts, both at home and abroad, and a wealth of tips and insight into making a career in the scriptwriting business.

SPOTLIGHT
Skip Press, Author/Scriptwriter

A Hollywood veteran, Skip Press has written numerous books, screenplays, and television scripts. I first encountered this enterprising writer over the Internet. It didn't take long to realize, however, that I was dealing with a pro.

During the past two years Press has expanded his business to an international level. Here is what he had to say about the global marketplace for the TV and film writers during a recent over-the-Net interview.

Would you say it is easier to sell a script in, say, the United Kingdom than in Hollywood?

That depends. If you're involved with the right group, yes, because the BBC has programs and it's a smaller "town" over there.

Is there a benefit in writing scripts in the English-language with regard to foreign sales?

Let's face it: all roads lead to Hollywood, where everyone speaks English except the household help of the executives. Even then, English is the language of business around the world. One friend of mine, Terry Borst, has a friend who has sold three scripts this year to production companies in Germany. He writes them in English, they translate them, then shoot them in German.

What, in your view, is the greatest hurdle in selling scripts abroad?

Knowing where the production companies are. Periodically, South Africans come to Hollywood looking for talent and scripts to be shot over there. . . . Once I was in negotiations with some South Africans over a script I later sold and I was asked if I would take payment in diamonds and a Mercedes. Recently, a friend of a friend got a three-movie deal in South Africa, but all the main talent, the producer, etc., came from southern California. So the greatest hurdle is finding the production companies and people who want to invest. I don't think there's a shortage of them, but how do you find them? The Internet is helping that greatly.

Talking about the Internet, do you have any popular Web sites that might help writers exploring the foreign marketplace?

The best one is the Web site of the London Screenwriters' Group at *www.lsw.org.uk.* [More details on this group are in appendix C.]

You obviously feel the Internet can help writers in their quest to reach producers and other buyers overseas.

Without question, it is the greatest thing that ever happened for writers of *anything.* An unqualified yes to this one.

What should be the first approach for scriptwriters wishing to market their work around the world?

Read Hollywood Reporter online each workday at *www.hollywood reporter.com.* Visit the Hollywood Network at *www.hollywoodnetwork. com.* Visit the site from the writers of *Aladdin* and other top movies, Terry Rossio and Ted Elliot at *www.wordplayer.com.* And keep doing Web searches for "movie producer" every chance you get. Don't forget the Mandy site, which originates from England, *www.mandy.com.* On that one you'll find résumés of people it wouldn't hurt to know—including myself.

What are some of the dangers a scriptwriter must be aware of when dealing with countries outside North America?

Different laws, period. If you don't have a good lawyer, you'd better get one.

Any tips for scriptwriters that would make their work more attractive to foreign producers?

If you're American, lose any "America is king of the world" attitude. Car chases might bore the hell out of a foreign audience. Study foreign films. [When you find a potential buyer] see if you can look up that producer's track record on Mandy's or the Internet Movie Database at *www.imdb.com.* And don't overlook the importance of international filmmakers. Recently, films from Iran—of all places—have been making a big splash at festivals.

Author's Note: I would suggest scriptwriters looking to extend their sales abroad also check the following Internet Web site and the links it provides: *www.mclink.it/mclink/cinema/scripts.html.*

Foreign Language Sales

IF YOU'VE NEVER SEEN YOUR BYLINE ON AN ARTICLE PRINTED IN A FOR-
eign language, you are missing one of life's little pleasures. It's almost
as nice as seeing your work published for the first time.

Recently, while attending a writer's conference in New York City, a
colleague said, "It has never occurred to me that foreign publications
would go to the expense of translating anything but major stories of
national importance by widely known authors."

Well, quite the opposite is true. I have had articles about soccer and
coffee sold and translated into Arabic, a travel story published in Japa-
nese, several features on U.S. military affairs in Italian, and an inter-
view translated from English for use in a German publication.

Many of the more popular foreign language weekly and monthly
publications use a great deal of translated material. While much of it
deals with international celebrities, politics, social issues, science, and
medicine, there are a number of periodicals that also translate general-
interest features. Not too long ago, for example, I sold an article on
diving that was translated and used in a magazine distributed in Swe-
den and Norway. It earned me $1,600.

The simple fact that a magazine is produced in a language unfamiliar
to you does not necessarily mean that editors of that publication are
not interested in your work. Too many freelancers feel that language
is a barrier. You can, however, do business in English.

Unlike Americans, most foreigners, particularly in northern Europe and Asia, speak a second, and often a third, language. Ninety percent of the time, that second language will be English. I was amazed during my first trip to Germany, that in travelling to seven cities, I met only one person that did not speak English. The same was true in Belgium.

If you are trying to sell exclusive language rights (and that is what you are selling, not reprint rights) to an article you have already sold in North America, you go about it the same way you would in, say, the United States. That is, you send a query. You need not tell the editor the article has appeared in English. It is not important, unless it sold to a publication like *Newsweek* or *Time*, which has a large world circulation. Be sure that you indicate in your query what language rights you are offering—for example, exclusive Spanish-language rights.

Keep in mind that the key to success is knowing the publication. This does not necessarily mean that you can read the text, since it is probably in a language unfamiliar to you. Just the same, you can study the editorial content, the use of images, the advertisers. This will provide insight into the readership as well as the editor's and publisher's tastes.

One thing that I discourage is sending a résumé to an editor—no matter what language the publication is printed in—and waiting for him or her to pass you an assignment. It rarely, if ever works. Submit ideas. Submit clips. This is the way to get your foot into the foreign language markets.

Translators

A unique opportunity came across the Internet recently that has opened some new doors for me. A notice I posted in a newsgroup for writers, promoting the *Markets Abroad* newsletter, was answered by an individual that worked as a translator in France. I had worked with Italian translators in selling articles to Editoriale Pucci Publications, which publishes *Aviazione, Difesa Oggi*, and *Force Sicurezza*. But the thought of contacting translators for sales in other countries had never occurred to me.

What the individual in France proposed is that he translate a few

of my articles and provide me with copies of popular magazines. Together we would market the stories and split the profits. It was an interesting—and unique—proposition, and one to which I gave a lot of consideration before moving forward.

Some of the major concerns in such a relationship are, Who is this person? Why should I trust him or her with my work? Who collects from the client? I first requested a résumé, in English, along with references and memberships of professional organizations. Most reputable translators belong to at least one association. Of interest was also the person's academic record and licenses (many countries require professional translators to obtain a license to do business).

Researching even further, I found that embassies and consulates in most foreign countries keep a list of accredited translators. These lists can be obtained by writing to the business and economic development office of each country. With such a list, a writer can contact translators around the world, proposing a cooperative relationship, whereby you provide the articles and marketing skill, and the translator transforms your work into the local language and supplies publications or potential markets.

By contacting the magazines and newspapers directly—my partner also translates my letters, which I send via e-mail—I am ensured that all payments and future assignments go directly to me. This provides me with a security buffer. As articles appear and payments are made, I pass on half the earnings to the translator.

Perhaps the easiest way to find translators, and avoid some of the headaches in working with unknowns, is to pick up the local telephone book. The Dallas yellow pages, for instance, has two pages of translators from Danish to Russian, Serbo-Croat to Hungarian, Germany to Japanese, and Chinese to Vietnamese. In short, it lists individuals for nearly every need you'll ever have.

Another plus to using local translators is that you can meet them face-to-face and build a good working relationship. Naturally, not every translator is going to want to spend his or her time working on an "if it gets published" pay agreement. But, certainly, there are two or three hungry translators out there that would jump at the opportunity. To add a bit of glamour to my offer, I also ensure that a "translated by" credit line is included in the article.

Users of the Internet also have another option: translations by

e-mail. Globalinks is a company that offers translations in most of the popular languages of the world. One merely submits his or her article, it is translated, and a fee is exchanged. For more details on this service, visit Globalinks Web site at *www.globalink.com.*

Agencies

THERE ARE SYNDICATION, NEWS, AND PRESS AGENCIES AROUND THE world that will, for a percentage, handle your international marketing for you. There are advantages as well as disadvantages to using these organizations, and depending on your ability, desire to put effort into foreign marketing, and available time, you can judge whether an agency is for you.

One of the advantages of marketing agencies is that, for the most part, they cultivate both foreign and English-language buyers. The better agencies also have cooperative agreements with similar operations around the world, thereby obtaining global exposure and sales opportunities for your work.

I sometimes provide features, for example, to Articles International, a world syndication agency in Canada. The director, Andria Lazis-Valentini, is responsible for marketing client's articles in North America. She also has sister agencies that handle cooperative world-wide sales: IFA for Austria, Denmark, Belgium, France, Germany, Ireland, Italy, the Netherlands, Sweden, Switzerland, and the United Kingdom; Sjoberg Byldebra in Norway; Lehtikuva Oy in Finland; Radial Press for Spain and Portugal; Orion Press in Japan; INPRA in South Africa; and others for sales in Australia, Brazil, New Zealand, and various regions of the Pacific. Each week Valentini puts together a list of new features, with a one-paragraph blurb of the story. This is sent

either by e-mail, fax, or postal service to her clients. At the same time, the list is distributed among the sister agencies where it is combined with their own offerings and submitted to their customers.

An article submitted to, and accepted by, Articles International therefore goes to more than one hundred potential buyers in twenty or more countries, and their stable of clients is constantly growing.

Another advantage to working with these groups is that they maintain all the overhead costs in getting material to the buyer. When you imagine the expenses you would incur to submit an idea to more than one hundred editors and, subsequently, to send the completed article to those who requested it, it becomes easy to realize the financial benefit of a syndication house.

A good agency will also obtain work for its writers. I recently did a feature for *Jack* magazine, in Santa Fe, New Mexico, based on a lead from Articles International. The editor, Rick Maslow, was looking for something offbeat that would help boost his European distribution and sales. I proposed a feature on Italy's TV home shopping—which included personalities that jumped, screamed, and even wore erotic attire after midnight, in an effort to sell products to viewers. Maslow loved the idea and ultimately paid $900 for a 1,500-word article and three photos.

In this particular case—an assignment for an original article— Valentini took only a 15 percent commission, rather than the standard cut of 50 percent. The high commissions international syndicates demand is one of the drawbacks of working with these organizations.

Some of the other disadvantages include loss of control of your work and your inability, in most cases, to establish rapport with editors. Once you submit a work to a syndication outfit, and it agrees to handle it, you have, for all sellable purposes, given away full control of the article. That is, of course, unless you find a small, personal organization that is willing to work with you. Unfortunately, there are not many of these types of operations around.

I have been able to come up with a happy working relationship with Articles International. If I feel I can sell an article to one of my customers in, say, Hong Kong or Germany, I will exclude these countries from the agency's circulation for that particular story. This leaves me free to sell the piece in these countries myself. Additionally, if the agency fails to sell the article in a given nation, and I later find a po-

tential buyer, I advise Articles International and ask to have the marketing rights for that country reassigned. I have yet to be turned down. One of the best ways to ensure that you do not miss sales opportunities is to try to market a story first. Then, after you've exhausted your efforts, or simply become bored with pushing it, send it to a syndication house.

Personally, the biggest negative to working with world press agencies is that you rarely get to know editors—those people that buy your work, those people that can provide you with future assignments, those people to whom you can send an e-mail, fax, or letter and say, "Jim, how about this for your summer edition?"

As a businessman, my goal—and yours—should be to make money. To do this, we must operate like a business. We have a product—we must have a market plan. We must network and establish clients. Turning our products over to agencies and giving up half our income may very well be a good, cost-effective business decision. We must weigh the results—i.e., income gained—with the effort and expense the same return would have cost us. If we find we could have made the same sales at a cost of, say, 30 percent of the total profit, then we'd be better off selling the articles ourselves. On the other hand, if it would have cost us over 50 percent of the total profit, then we're better off staying with an agency. Keep in mind, too, that when handling your own work, you are constructing future business through personal contact with editors. This is a factor that is hard to put a dollar figure on, but very valuable just the same.

For those who are interested in working with international press agencies, I have included a list of some of the more reliable and respected organizations of this type in appendix D.

SPOTLIGHT
Andria Lazis-Valentini, Syndication Agent

Over the past five years, Andria Lazis-Valentini has run Articles International, a syndication service in Canada. Working with various subagents, features by writers she represents circulate the global market each week. In order to give you an idea of how an agent works, as well as provide insight into the best way to approach a foreign syndication, I sat down with Andria to pose specific questions. She offers some good

THE WRITER'S AND PHOTOGRAPHER'S GUIDE TO GLOBAL MARKETS

advice, whether you plan to submit your work to an overseas agency or market it yourself.

How did you become an agent?
I worked as an editorial administrator for a major daily newspaper. I had to juggle a staff of over one hundred writers and photographers and monitor an annual budget of seven magazines and a weekly newspaper. Writers that I previously worked with wanted an agent to represent their work. Why not? There are numerous photo agencies that represent photographers and most writers don't have the time to market themselves.

What is the best way to approach an agency?
Send a letter explaining what your area of expertise is. Most agencies are very selective about the type of material they handle. Stories have to be unique and very well written. Avoid sending travel articles to agencies, since all papers and magazines are already inundated with travel. We, in particular, look for stories that an international audience can relate to or personalities that very rarely speak to the media.

What are a few things to avoid when approaching an agency?
Don't send outdated material; be unique and honest. Don't send sloppy samples or copy with spelling mistakes. Treat an agent as you would treat an editor. Don't harass an agent since their time is very limited. Don't approach more than one agent at a time.

What is the best way to impress an agency?
All the answers above apply. Query before sending anything. Do your homework. Ensure that you have fact-checked your article. Be particularly vigilant about spellings of names of people you have interviewed, places, and organizations. Provide a dynamite synopsis, then leave the agent to do their job.

What type of material sells best outside North America?
The question-and-answer formats of celebrity and business tycoon profiles. Package deals that include text and photography. Foreign magazines or papers don't want the aggravation of chasing down visuals to match the text.

What is the average commission an agent takes?
On reprints, it's 50 percent per sale, but fresh assignments are negotiated on an individual basis.

How do you prefer to receive material?
An outline of the story, followed by the full text. Tell where the story was previously published. If the story never sold, include a date when it was written. Also, a statement that the writer owns copyright to the work, a résumé [and a one- or two-paragraph synopsis of the article].

How does your agency work?
If we think a story is worthwhile—dynamic, newsworthy, record-breaking, or of interest to various publications—we farm out the details to all of our client publications and agencies worldwide. Client publications view the list of synopses and choose the text for preview purposes and to determine suitability. Obviously, it is in the best interest of the writer to provide as succinct and eye-catching a synopsis as possible. If the client likes the story, we start negotiating the best rates possible. There are no guarantees that a story will sell.

Do you prefer original or reprint material?
We prefer to work with original material only from our team of journalists. We will accept reprints from other writers. This protects us from any libel action.

How many partner agencies, outside North America, do you work with?
It varies, from one agency to three, depending on the story, country, etc.

Why would an editor prefer an agency over a freelance submission?
An agency provides a diversity of available material that working with freelance submission does not. There is also timeliness, as often freelancers tend not to respect deadlines as they should. Price is also a factor, as an agency may be able to provide volume discounts that are not available when negotiating with individual freelancers.
On the other side of the coin [the writer's side], an agent can expose a writer's work to hundreds of client publications that may otherwise incur a writer time and money. Also, some editors don't like to

deal with fielding calls from numerous freelancers, and prefer to deal with an agent. Editors like variety and the freedom to be able to use different writers who are experts in various fields. An agent works as a mediator between a writer and editor.

Writers tend to take a rejection more personally from an editor. A good agent moves on to the next editor and refrains from passing negative remarks back to the writer. To an agent, it's simply a reflection of an editor's personal style and taste.

What would be your advice to writers wishing to sell overseas?
Be careful of the countries you choose. There are publications that choose to ignore copyright laws. Do not send original negatives. Do not send a complete story; send samples of your previously published material along with an outline of your proposed piece. If the client/ agencies like it, they have to come back to you. This enables writers to protect their own material.

Stock Photo Agencies

Just as there are editorial agencies around the world to handle a writer's work, there are also stock photo agencies, constantly in search of new photographic talent. Some of these are one in the same, handling both images and articles. I owned such a company, based in Italy, for several years.

I had never intended to get into the stock image or, as the Brits call it, the photo-library business. As my writing career blossomed, however, images played an ever-increasing role in sales. Soon I was seeking illustrations from a variety of photographers, next I was selling their work separately; and before I even realized it, I had collected, catalogued, and stored over 250,000 images.

There are several advantages to working with overseas stock agencies. First, their sales often go far beyond the monthly periodicals and newspapers.

Their clients include advertising agencies, book publishers, designers, and printers. These, for the most part, are customers that you would never have access to. In addition, good stock agencies have sales representatives that circulate among hundreds of potential clients each week to fulfill their needs.

The key factors in working with foreign agencies are having confidence in their ability to sell your work and having patience. When you sign an agreement of representation with a stock house, you're in it for the long term. When I signed on New York advertising photographer Norman Mosallem, he told me that I would be getting his "reject" images—i.e., those that his U.S. clients refused. Fortunately, his quality was so superior to that of most photographers that even his "second best" brought in a good, regular income for both of us.

American Bob Schwartz, based in Milan, began working with me as a travel photographer. Ultimately, he became the finest "cat photographer" in Europe, and perhaps the world. As his interests changed, so did our sales techniques and markets. I recall one occasion when Bobby called to ask if I'd ever heard of the Cat Museum in Switzerland. I had not, but luckily he *had.* He provided me with sixty slides, and I wrote an article to accompany them. We ultimately sold this story to a number of cat publications around the globe.

Like Schwartz, you should maintain close contact with your agency and, hopefully, build rapport with one of the representatives. This will allow you to propose new ideas or inform the agency of your latest work. Eventually, my stock photo agency sold more than twenty photo-essays for Bob Schwartz, as well as numerous single images.

The more you read about the marketing of photography, the more you will realize that each stock agency seems to have its own policy for submissions. I can tell you how I, as a former stock-house owner, liked to be approached. Then it is up to you to decide the best method for you.

While all agencies want original slides, it is more cost effective—and safer—to make your initial approach with a query letter and duplicates. Today's laser copy processing accurately captures the original quality an image, so I suggest you use this method exclusively. Another option would be to have print sheets made of a selection of images that best represent your work.

Above all, be professional. Send your proposal by courier. It may cost more, but you can easily track it to ensure it arrives. Using a courier service is also impressive. Provide twenty to eighty images. Give a brief biography of your professional activities in the letter/query, and state how many and what type of images you plan to contribute to the agency's stock each year. This is an important factor. Agencies in gen-

eral do not want to spend time cultivating new talent that will be providing fewer than five hundred images a year to their stock. They much prefer a photographer that will inundate them with photos.

Try to put together an initial proposal that will not have to be returned. If an agency decides to handle your work, it will place this material in your file. If not, it will be trashed.

If you have a fax or e-mail, you will probably get a reply by one of these means, as overseas agencies are keeping up with technology. Some are even accepting electronic submissions. While this will no doubt be the wave of the future, at present, it is rare. If, after two months, you have not heard back from the agency then assume that it does not want to represent you and that you will not get a reply. There are thousands of stock photo agencies around the world to choose from. If one does not take the time, nor spend the money, to answer your query, you do not want to work for that agency anyway. To get you started, contact some of the agencies listed in appendix E.

What's It Worth?

ONCE YOU'VE SOLD AN ARTICLE OR IMAGES TO AN OVERSEAS MARKET, what can you expect to be paid? I've made hundreds of sales abroad and, as in North America, the pay scales run the gamut from as little as $25 for a local newspaper reprint to $3,000-plus for a feature in a national or international periodical. I have a rule, however: If someone offers $3,000, I take it. If someone offers $25, I take that too. This is particularly true when selling articles originally written for North American markets that I have already collected from. The reason I accept even low pay, in some cases, is that—like any good businessperson—I am looking at the long-term results.

Seven years ago, a magazine in Italy bought a piece—it had already sold in the United States for $425—for $35. Today, this publication purchases two to four articles an issue from me, plus an average of five photographs. It now pays $120 for the articles and $35 for each image. So, by offering my services at lower rates while the magazine was struggling, I essentially worked myself into a position that increases my annual income by $4,800–$6,500. And all from already published articles. As the editor told me, "You were one of the few that would work with us during our early years; now we're happy to repay you."

Most of the foreign weeklies are excellent payers, ranging from $600 to $2,000. On the average, though, you can expect to earn $450 for a good 1,500–2,000-word article. A survey of the readers of *Markets*

Abroad revealed the best overseas buyers/payers are Sweden, Norway, Finland, Denmark, the United Kingdom, Iceland, Belgium, France, Germany, and Italy. Following these are Spain, Switzerland, Australia, Japan, South Korea, Singapore, India, and Hong Kong.

As discussed earlier in chapter 8, European periodicals are famous for saying "payment by arrangement." Many writers, including myself, ask What does this mean? According to Britain's National Union of Journalists, when editors quote their "standard" or "normal" rates, what they are actually offering are their low-end fees. From there a writer should negotiate upwards. So, when you read "rates negotiable," you should do exactly that: negotiate.

Keep in mind, when deciding which publications and countries to deal with, that payment rates are based on local currency. What sometimes seems an overwhelming amount, to the uninformed writer, may turn out to be minimum wage. Italy, where I reside, is an excellent example. Last July, the exchange rate of the Italian lira was 1.400 for one U.S. dollar. Today, one year later, it is 1.835. What does that mean with regard to potential sales in this country? Let's imagine that a magazine pays Lit.600.000 for an article. Looks like a lot doesn't it? At last year's rate of exchange, that is $428.57. Now, however, it is only $326.98. You've made the same amount, in lira, but lost $101.59 in exchange rate fluctuation.

Unfortunately for you—and most foreign countries—the U.S. dollar is one of the strongest and widely used moneys in international trade. As such, foreign currencies are often weak when the U.S. economy is strong. During those periods, I would attempt to sell more to the United Kingdom, Germany, Singapore, Hong Kong, or Japan. When the U.S. economy goes flat, it's time to increase sales in Italy, France, Spain, Greece, South Africa, and New Zealand.

To find out what a foreign currency is worth, you can check the business section of any major newspaper, or, if you have access to the Internet, one of the many online currency converters. The one I frequently use is *www.xe.net/currency/.*

Some foreign publications will pay in U.S. dollars, if you request it (although they still base payments on local currency). Several Asian magazines regularly provide checks according to one's mailing address—e.g., Montreal residents will receive a check in Canadian dollars; New York residents, payment in U.S. dollars. If you are working

with a publication that does not follow this practice, it may be easier for both parties to have payments made by wire transfer, directly from the client's bank into yours. This often saves time and keeps you from paying high fees for foreign check cashing. There is, of course, a transfer charge, but it rarely amounts to fees for international check cashing.

Photographs, like words, bring a wide variety of prices. Editors and art directors in Asia, Africa, the Middle East, and most of Europe have fixed rates for images, based on size and usage. In the United Kingdom, however, there seems to be a fear to release their prices. Such terms as "negotiable," "based on work involved," or "paid according to timeliness" are common.

To keep up on U.K. pricing, photographers as well as writers may want to write to the National Union of Journalists (see appendix C), requesting the *Freelance Fees Guide,* which is updated every other year. The latest edition provided fourteen pages of recommended rates for photo usage, covering everything from magazines and newspapers to theatrical and commercial use.

For example, the recommended minimum rate for books is £77–£400 per image; for public relations and commercial use, £100–£420. Single-image, magazine and newspaper rates are divided into categories based on circulation. At the low end of the scale, one can expect £40–£200, while the upscale markets bring £80–£480 per picture.

CHAPTER FOURTEEN

Using the Net

NOTHING HAS DONE MORE IN RECENT YEARS TO ENHANCE INTERNATIONAL marketing, and the freelance business in general, than the Internet. Apart from the financial benefits of not having to utilize postal or courier services, the speed and ease of accessing editors around the world is amazing. In addition, many newspapers, magazines, and book publishers have Web pages. If you are considering selling an article to the *Times,* the United Kingdom's daily newspaper, and want to review a copy to see if your topic fits its style, you simple get on the Net and type *www.the-times.co.uk/.* You could also check out the *Scottish Herald* at *www.cims.co.uk/herald,* or Britain's *Car World* magazine at *www.erack. com/.*

The possibilities are nearly endless, with more and more publications coming online each day. Further on I list a few popular Web sites for writers. Most of these offer thousands of links to additional pages. One of the best sites I have found for foreign market information is the Journalism U.K. homepage at *www.octopod.demon.co.uk/journ_uk. html.*

This is, according to its authors, "aimed at print journalists writing for U.K. magazines." And, indeed, it provides links to newspapers throughout the country, as well as magazines, e-zines (that's electronic magazines on the Internet for those who are not yet into the world of the information superhighway), news sources, jobs for writers, and more.

Another benefit of Internet pages for writers is that many provide updated market information. For instance, from the Canadian *Inklings* newsletter at *www.inkspot.com/inklings/* I found the Australian Science Fiction, Horror, and Fantasy Writers' Web site *www.ozramp.net.au/~aplank/Writers.html.* This led me to *Altair* at *www.oz.com.au/~robsteph/altair.html,* an international magazine published in Australia.

At this time in the development of electronic communications, there seems to be a vast gap among editors. On the left, we'll say, are the old-school editors who are comfortable with hard-copy queries and articles. On the right are the techno-age editors, who have learned the ease of working with e-mail. One of the keys to your success as an international writer is to discover which working method the editor you are trying to sell to uses. The simple fact that a publication has an e-mail address does not necessarily mean that correspondence goes to the editor. One editor at a popular in-flight magazine, for example, responds immediately to my letter or fax queries. Once, I tried sending him an e-mail and waited three weeks for a reply.

For those, like myself, who have become addicted to electronic communications, I've included a substantial list of e-mail addresses from world publications in appendix A. Both market research and correspondence can be enhanced by using the Net. I have made many sales through data received from Internet sites. In fact, the publisher of this book, Allworth Press, was found on a Web page listing.

If you are on the Internet, use it to increase your knowledge of, and sales to, the foreign marketplace. If you are not yet up to speed on Net communications, you should make it a priority to become so. Otherwise, you may find yourself light-years behind.

Web Resources for Freelancers

The following are Internet Web pages that I have found helpful. This is by no means a comprehensive listing of sites that offer special value to writers and photographers looking to expand their foreign sales—that would take an entire book in itself. If you find other sites that are helpful, please send them to me by e-mail (*pp10013@cybernet.it*) to be included in future editions of this book.

- **@Writers:** *www.geocities.com.* An array of information for writers.
- **Australian Science Fiction, Horror, and Fantasy Writers:** *www.ozramp.net.au/~aplank/Writers.html.* This site provides tips and market information on Australian publications, as well as contests.
- **Authorlink:** *www.authorlink.com/.* A site offering a variety of services, information, and tips for writers of books and articles.
- **Authors' Licensing and Collecting Society:** *www.alcs.co.uk.* A group that protects the rights of authors and ensures they receive all payments due.
- **Committee to Protect Journalists:** *www.cpj.org/.* A group established in 1981 to protect the rights of journalists.
- **European Journalism Page:** *www.demon.co.uk/eurojournalism/.* This site provides a link to European newspapers, magazines, and related organizations. An excellent resource.
- **Inkspot:** *www.inkspot.com.* Offers the markets newsletter (free), *Inklings,* as well as interviews, tips, market information, and other useful information for writers and photographers.
- **Inner Circle Writers Club:** *www.mosquito.com/~fictech* Exchange of information, research assistance, and free advice for all types of writing.
- **International Foundation of Journalists:** *www.ifj.org/.* Anyone working in the news sector should check out this site.
- **Internet Communications:** *www.intercom.com.au/intercom/newsprs/.* If you are looking for a comprehensive list of online newspapers, this is an excellent place to start.
- **Journalism U.K.:** *www.octopod.demon.co.uk/journ_uk.html.* Links to and data on newspapers, magazines, and organizations for writers in the British marketplace.
- **National Union of Journalists:** *www.gn.apc.org/media/nuj.html.* U.K. organization for the protection of journalists. Covers a great deal of general information.
- **Photo Insider:** *www.uniquephoto.com.* A magazine with general tips and information on freelance photography as a business, published by Unique Photo, a wholesale photographic supplier. Includes editors, contacts, and updates.

- **PhotoSource International:** *www.photosource.com.* Worldwide marketing information, buyer requests, and daily updates for photographers.
- **PR Newswire:** *www.prnewswire.com/.* For press releases from corporations around the globe, this is the spot.
- **Pure Fiction:** *www.purefiction.com/.* Based in the United Kingdom, this site holds an enormous amount of information and links to great Web sites for freelancers worldwide. Despite its name, this is the site I would begin with because of the volume of data it contains.
- **Spotlight:** *www.eclectics.com.* A good site for writers for everything from self-promotion to markets.
- **World Wide Web Virtual Library (Journalism):** *www.cais.com/ makulow/vlj.html.* A comprehensive collection of links to journalism Web sites around the world.
- **Writers' Guild of Great Britain:** *www.writers.org.uk/guild/.* Information on membership, benefits, publications, links, and the state of the markets in the United Kingdom.
- **Writers Write:** *www.writerswrite.com.* Provides an online database of guidelines for publications, as well as other information.
- **Writing Now:** *www.mindspring.com/~daviskyle/.* Market news, links, tips, and articles for writers.

Photographers on the Net

If you're a photographer using the Internet, you may want to check out Picture Search, a United Kingdom–based organization that lists photo needs from picture researchers throughout the country. Go to: *www.picture-search.demon.co.uk.* You can also find information on various aspects of photo marketing and updates on stock agencies from the British Association of Picture Libraries and Agencies at *www.bapla.org.uk.*

The monthly magazine *VOICE: of the Specialist Libraries* also provides insight into the picture-buying market. A subscription costs £30 a year. You can contact the magazine by e-mail at: *lupe.cunha@btinternet.com.*

If you get heavily involved in the European markets, I suggest that you look into the following two organizations: the Association of Photographers and the Picture Research Association (see appendix C for contact information).

Free International Publicity for Travelling Photographers

If you are about to travel abroad and want editors to consider you for photo assignments that correspond with your ventures, be sure to contact PhotoSource International. You can contact the organization by e-mail at: *info@photosource.com,* or call toll-free at (800) 624-0266, extension 21.

Travel details should be provided at least two months in advance. "We broadcast your foreign destinations along with your phone/fax number, departure date, and length of stay, in our monthly *Photo Stock Notes,*" says the editor.

PhotoSource International also features over 6,000 photographers who have listed detailed descriptions of their photo collection on the PhotoSource bank. With a total of more than 600,000 photo descriptions to work with, a photo researcher can go into the PhotoSource bank—it's a free service—and find obscure pictures such as "South Mountain State Park," "Inner Mongolia," and "tiger swallowtail."

SPOTLIGHT
Linda Davis Kyle, Writer/Internet Publisher

A common name to many writers and photographers who frequent cyberspace is Linda Davis Kyle. Though she is a highly professional general-interest and health and fitness writer, it was Linda's Internet publishing activities that brought her into the spotlight of international journalism.

From her home in Austin, Texas, Linda produces features that appear not only in the United States and Canada, but also in the Netherlands, Antilles, Ireland, the United Kingdom, South Africa, Bangladesh, and Japan. Since 1996, she has been a columnist for *Balance Fitness*, published in London. The editor of *Caritas*, in Ireland, said that, "The excellent quality of [Linda's] feature articles . . . contributed in no small way to maintaining the high standard of reading content presented and enjoyed by our readers."

Today, however, she set aside her domestic and international assignments to offer her insights on the Internet and provide advice to other freelancers.

How has the Internet changed the job of the writer?
The basics of etiquette for writers remain the same. One still should familiarize oneself with the subjects covered, the tone, and the essence of online publications and abide by the plans outlined by the publishers and editors. Before submitting, one always should study writer's guidelines, if available, to know precisely what editors prefer. Submit letters, queries, and typescripts by e-mail only if they are welcomed.

Currently, in some ways, the Internet still seems to be its own entity, separate from the print world. As more and more editors realize the user-friendliness of the Internet and feel familiar with it enough to harness its power and its tremendous potential to save them time, effort, and money, they will embrace it and integrate it into their systems. Some still are not comfortable with the intangible and fluid nature of the Internet. Still, the immediacy afforded by e-mail submissions perhaps seems daunting to some.

Proper protocol should be practiced with regard to submitting by e-mail to print publications, as well.

Do you feel English-language writers have more opportunities to reach markets around the globe as a result of the Internet?
Always there have been many opportunities for English-language writers. In the distant past, one merely had to ferret out those opportunities from dusty newspaper, magazine, and publishing house directories housed in overstuffed library stacks. Now, sparkling new opportunities for assignments lie before writers like a vast open sky to a parachutist. Still, one must organize and focus and fine-tune research efforts to find new markets.

Where are a few good Web sites for writers to start their search for world markets on the Net?
To start a search for international markets on the Internet, I would focus my energies to using one of the many fine search engines: Alta Vista, Beaucoup!, Search Engines, Excite, Infoseek, Magellan, and Savvy Search—which coordinates results from numerous search engines and presents the data—and Yahoo! [These are all good] to locate world markets.

Have you ever tried selling articles through e-mail submissions?

Since May of 1996, I have written a health and fitness column for Howard Jardine, editor of *Balance Fitness,* based in the United Kingdom. In addition, I have sold work to Glenn Saunders in Shizuoka, Japan, and I have sold work to Dr. Joseph Sherman, editor of *Jewish Affairs,* based at the University of Witwatersrand in Johannesburg, South Africa. Currently, an interested publisher in Australia is considering my work. All of these submissions were sent with ease through e-mail.

Does one need to be more cautious when selling to foreign publications, with regard to rights?

I can speak only about the editors with whom I have worked—the particular online editors whom I have mentioned. [They all] show appreciation for carefully prepared e-mail submissions and have been exemplary in every way. One could not wish for better editors. From all indications, the Australian editor will be equally gracious.

I encourage writers to sell either first-print rights, one-time rights, simultaneous rights, or reprint rights. Writers should keep in mind the prudent advice of the American Society of Journalists and Authors [ASJA] that "All uses beyond first-print publication must be separately licensed and separately compensated." Likewise, writers should be cognizant of ASJA's sober guidance that "It is not acceptable to take a higher overall fee to surrender electronic rights with print rights."

What other information can ASJA provide?

For definitions of rights, writers should check out the indispensable information on magazine and newspaper publishers available at [the] Contracts Watch [Web site]: *www.asja.org/cwpage.htm* and the ASJA Web site: *www.asja.org,* which includes a full, searchable archive of past editions of Contracts Watch as well as tips on freelance contracts, electronic rights, and copyright.

To receive each edition of ASJA Contracts Watch automatically—and at no charge—by e-mail, send the following message:

To: ASJA-MANAGER@SILVERQUICK.COM
Subject: CONTRACTS WATCH
Complete text: JOIN ASJACW-LIST

A writer recently asked me how to find U.K. publishers on the Net. What would be your answer to such a question?

I would suggest using one of the many useful search engines [mentioned earlier]. Keep in mind that it is important not only to give good solid keywords [when doing an Internet search], but also it is necessary to narrow your keywords enough to focus your search.

How has the Internet changed your life as a writer?

The Internet gives writers access to some publishers and editors who prefer e-mail communications. Many of these opportunities allow writers and editors to establish business relationships in an atmosphere that can support and nurture a cooperative spirit. Even while maintaining proper protocol and following established patterns of etiquette, a refreshing air of informality coupled with the immediacy of e-mail fosters an editor-writer bond of camaraderie that long has been stifled by a climate of stuffiness and distance so seemingly prevalent in the world of print publications.

What do you think the future holds for writers and electronic media?

As e-mail transmission incompatibilities and other submission difficulties subside, greater numbers of writers and editors will embrace the new technology. As more and more writers throw off the shackles that bind them to hard copies of queries and typescripts, they can share in a dynamic revolution of writing and publishing in an electronic age.

It's a Business

SELLING WHAT YOU HAVE ALREADY SOLD IS WHAT FOREIGN MARKETING is all about. Once you start, you'll discover, as I have, that you can decrease your workload and increase your profits. Selling abroad opens your eyes to new ideas and techniques in the writing business. But you should never forget that it *is* a business, requiring special attention in the areas of recordkeeping, communications, and banking.

I receive a great deal of assignments from editors in Europe and Asia not only because I am a fair writer and photographer, but because I am almost always available for spur-of-the-moment, tight-deadline work. More than that, however, I make it easy for editors to contact me. On my extended desk, where I am writing these words, is a dedicated fax machine. I have two computers—one exclusively dedicated to e-mail. I also have a printer, standard telephone, and a cellular phone. So there is no excuse for an editor not being able to reach me, night or day, in any time zone of the world.

As a "business," I was able to write off the expense of all my equipment at tax time. When I have an exceptionally good year—and need tax deductions—I will review my office equipment to see if additions (like a photocopy machine) are necessary or if an upgrade in hardware is justified. For this reason, and the fact that online editors were asking for digital image submissions, I added a scanner last December.

Such decisions are all part of the "business" of being an international

writer. When I produce an editorial package—i.e., not merely text that can be transmitted by fax or e-mail—for a client, I always send it by courier. For one thing, using Federal Express, UPS, or DHL, I can track my packaging through their Internet systems. This has come in handy several times when editors said they did not receive the materials. I simply look up the waybill number, do a search on the carrier's Web page, and come up with the date and time delivered as well as the person that signed for the package. With this information, editors have always "found" the "lost" shipment. Using a courier service also gives the client a good feeling about doing business with you. It shows professionalism and a business attitude toward your freelance work.

If you are working with a computer, but have yet to get connected to the Internet, you may want to find a friend who is online and visit the Juno Web page at: *www.juno.com.* Here you can establish a free— yes, *free*—e-mail account. You will receive the software, one e-mail account, and no bills. What more could you ask for, and what a cost-effective way to get online.

Invoicing

If you are to be successful businessperson, the first thing you must understand is that the world operates on invoices. In recent years, in fact, I have seen a growing trend among publications, even those that I have worked with for over a decade, of requiring bills for freelance services.

If you want to be paid, you must often forget your dealings with the editor and think about the requirements of the accounting office. The annual *Freelance Fees Guide,* published by Britain's National Union of Journalists, suggests that "unless the client you work for operates a system of self-billing, you should invoice promptly for work done: without an invoice, a client may not even know that payment is due."

This happened to me recently with *Holiday* magazine. I produced an article and it was accepted. I waited for payment. The article came out, I waited for payment. Thirty days passed, I waited for payment. After sixty days I called the editor. "Oh, Mike. I'm sorry. We must have lost your invoice. If you fax me a copy, I'll get the payment sent out immediately."

I now include an invoice with all editorial packages I send out, unless I know for certain that one is not required for payment.

Banking

When you begin selling overseas, you will want to review the check-cashing policies of your bank. In twenty years I have had eleven bank accounts in various countries and for different reasons. One reason I changed financial institutions was because the First National Bank of Tennessee insisted on charging me exaggerated rates for cashing Canadian checks. Opening an account in New York resolved this problem. I'm told this is because the state borders Canada.

What you will want is a bank that charges a minimal fee to cash foreign checks. Because some publications abroad will offer you the option of payment by bank transfer, you may want to ask the charges, if any, for such operations.

Last year I received a $100 transfer from Germany and the U.S. bank took a $25 fee. In the same respect, I transferred $12,000 from my U.S. bank account into my Italian account. On the U.S. side, a $120 fee was charged, and when the money got to Italy, another $90 was subtracted.

Bank fees are one consideration. Naturally, you want the lowest fee possible for foreign check cashing and incoming wire transfers. Another issue will be taxes on foreign-earned income.

Taxes

Tax issues for money earned as a freelancer are far too complex to get into here. I do, however, want to touch on a couple of items. First, the Internal Revenue Service (IRS) issues an official foreign currency conversion rate each year which one can use to calculate exactly how much those German mark, Japanese yen, and British sterling checks are worth in U.S. dollars.

Officially, this is the chart you should use to calculate your foreign earnings. Unless it is an overwhelming amount, however, I have found it just as easy to simply have the bank exchange checks and credit my account—and my income statement—with its figure. After all, *that* is the actual amount you received from your transactions.

For free help, suggests Julian Block, noted expert and author of several bestselling tax books, there are IRS publications, particularly, Publication 17, *Your Federal Income Tax.* It covers how to fill out Form 1040. Publication 334, *Tax Guide for Small Business,* covers how to fill out Schedule C. Also, Publication 910, *Guide to Tax Services,* lists the various IRS booklets that are available. You can obtain these publications from any local IRS office, or by calling (800) TAX-FORM.

I also suggest reading Julian Block's *Tax Avoidance Secrets,* a 560-page book available for $19.95 if you write to the author (that's $10 off the bookstore prices), at 3 Washington Square, Larchmont, NY 10538-2032.

As a final note, Block suggests that writers and photographers doing business overseas also get a copy of IRS Publication 901, which covers international tax treaties. This publication provides measures that will ensure you are not subject to dual taxation by selling your work in certain foreign countries.

Freelancers can also get one-on-one help from writer and licensed tax professional Joseph Anthony. In fact, he will do your taxes for you.

"While I live in Oregon, in my tax business, I handle tax returns for writers and other professionals living everywhere from Maine to California, as well as overseas," says Anthony.

He can be reached by e-mail (*josephanthony@compuserve.com*) or by phone at (503) 281-4401. There is no charge for an initial half-hour consultation.

More information and tips on taxes for freelance businesspeople can be found at the following Internet Web sites:

- *www.irs.ustreas.gov*
- *www.dtonline.com*
- *www.hrblock.com/tax/refnd*
- *www.uni.edu/schmidt/tax.html*
- *www.1040.com*

Communications

The telephone and fax are two tools most writers and photographers cannot live without. They are also two of the most costly items in any office.

Last year, my bills for communications exceeded $600 a month,

which prompted me to begin shopping for a discount deal for freelancers. Having spent six years as European director for MCI Communications military marketing, I realized that it would be difficult to negotiate a savings with telecommunications giants like AT&T and MCI. I therefore searched for a smaller, growing company that provided quality, dedicated customer service, and a willingness to give freelancers a break. After more than one year, I discovered Rapid Link Telecommunications.

An Atlanta-based company, Rapid Link's marketing department rolled out its long-distance, state-to-state, 10¢-a-minute, twenty-four-hours-a-day, seven-days-a-week, Rapid Connect plan for me to review. In addition, it agreed to toss in a $15 cash rebate for freelancers that sign up for the Freelance Saver Calling plan.

I thought this was very similar to the Sprint "dime deal," until I looked further and discovered that most other companies offered this rate only after 8:00 P.M. and before 8:00 A.M. Who works those hours?

For writers and photographers based overseas, Rapid Link offered its callback service—whereby a special number is assigned and, when dialed from overseas, one pays the low U.S. rates rather than those of the local telephone company. For example, writers and photographers in Germany can call the United States for only 19¢ a minute. The callback plan provides savings of 50–70 percent over local rates. Rapid Link also agreed that freelancers would get the $15 rebate here in Italy. That sold me—and I have been using their service since.

For more information on the Freelance Saver Calling Plan, inquire via e-mail (*pp10013@cybernet.it*) or fax (011-39-81-851-2210). If you prefer to correspond by letter, write to Strawberry Media at 2733 Midland Road, Shelbyville, TN 37160.

PART TWO

Periodicals

Keep It Current

LIKE ALL GOOD AUTHORS, IN THE FOLLOWING MARKET LISTINGS, I HAVE attempted to provide the most up-to-date information possible. In a perfect world, editors would love their jobs and stay put forever, publishers would find no reason to move to new locations, telephone and fax numbers would never change, and e-mail addresses would remain constant. I somehow doubt that we will ever live in a perfect world, however. Consequently, things will continue to change—including the information listed within these pages.

As I mentioned at the beginning of this book, you should attempt to keep the listings as accurate and current as possible. When you discover an editor change, cross out the old and insert the new. By maintaining the information, this can be a valuable working list for many years to come, and not merely an outdated reference like so many other market directories. It's up to you.

Aberdeen Evening Express
Aberdeen Journal Ltd.
P.O. Box 43
Lang Stracht, Mastrick
Aberdeen AB9 8AF
United Kingdom
Tel. 44-1224-690222
Fax 44-1224-699575
Editor: Moreen Simpson
　　Daily newspaper distributed in the evening. Uses lifestyle as well as news features, illustrated with both color and black-and-white images. Payments are by arrangement with the editor.

Achievement
World Trade Magazines Ltd.
World Trade House
49 Dartford Road
Sevenoaks
Kent TN13 3TE
United Kingdom
Tel. 44-1732-458144
Fax 44-1732-456295
Send submissions to the managing editor.
　　Articles dealing with British business personalities who are making achievements in the international sector. Quality color photography is used throughout. Payments are arranged with writer/photographer based on assignment.

Active Life
Aspen Specialists Media
Christ Church
Cosway Street
London NW1 5NJ
United Kingdom
Tel. 44-171-2622622
Editor: Helene Hodge
　　A Christian magazine covering travel, health, finances, hobbies, personalities, food, and general lifestyle for the over-fifty crowd. Also uses some fiction. Query first. Article length: 500–1,200 words. Payment is £1 per word. Color photography is used; slides preferred. Images are paid for separately.

Adventure Travel
P.O. Box 6254
Alcester
Warwickshire B49 6PF

United Kingdom
Tel. 44-1789-488166
Editor: Rebecca Pugh

This bimonthly targets the eighteen- to forty-year-old outdoors person. Articles run 1,200–4,000 words. Color photographs are used. First person and travelog styles are frequently used. Some destinations recently covered: Burma, Ethiopia, Israel, and Slovakia. All payments—articles and photos—are negotiated prior to purchase or assignment.

Aeromodeller
Nexus Special Interests
Nexus House
Azalea Drive
Swanley, Kent BR8 8HU
United Kingdom
Tel. 44-1322-660070
Fax 44-1322-667633/615636
Editor: John Stroud

Monthly magazine dedicated to model aircraft. Articles running 750–2,000 words are used with top-quality images. Payment is negotiated with the editor prior to assigning article. Query first. Photographers with photo-essays should submit complete package.

Aeroplane Monthly
IPC Magazines Ltd.
King's Reach Tower
Stamford Street
London SE1 9LS
United Kingdom
Tel. 44-171-261-5551
Fax 44-171-261-7851
Editor: Richard T. Riding

Historical aviation is the topic of this monthly. Articles up to 3,000 words are used and bring £45 per 1,000 words. Photos bring £10 each or £80 per page. All payments are made upon publication.

Africa Business
IC Publications Ltd.
7 Coldbath Square
London EC1R 4LQ
United Kingdom
Tel. 44-171-713-7711
Fax 44-171-713-7970
Editor: Anver Versi

Monthly periodical with a readership of businesspeople, officials, and clergy interested in African affairs. Topics include personality interviews, business and economic developments, and related subjects. Most articles are short: 400–750 words. Illustrations are black-and-white and color. Payment: £70 per 1,000 words; £1 per column centimeter for images.

Africa Confidential
Blackwell Publishing Ltd.
73 Farringdon Road
London EC1M 3JB
United Kingdom
Tel. 44-171-831-3511
Fax 44-171-831-6778
Editor: Patrick Smith

News and political features dealing with Africa, including international relations and economic development are used here. The editor prefers first world rights—no reprints—for articles of 1,200 words. Payment is £200 per 1,000 words. There are no illustrations.

Afrika Mosaik
PO Box 7031
Bryanston 2021
South Africa
Tel. 27-11-706-1210
Fax 27-11-463-3001
Publisher: Thomas Reprich

Travel articles dealing with all aspects of Africa are used in this publication. Destination features, news, tours, outfitters, airlines; if it is African, it is in *Afrika Mosaik*. Readership is primarily German. Articles run 700–1,700 words. Color photos are used. Payment: negotiated based on topic and illustrations.

Agenda
5 Cranbourne Court
Albert Bridge Road
London SW11 4PE
United Kingdom
Tel./Fax 44-171-228-0700
Editor: William Cookson

A quarterly small-press magazine dedicated to poetry. Payment ranges from £10 to £15 per printed page. Upon request the editor will provide a list of special theme editions.

Air International
Key Publishing Ltd.

P.O. Box 100
Stamford, Lines PE9 1XQ
United Kingdom
Tel. 44-1780-55131
Fax 44-1780-57261
Editor: Malcolm English

This monthly covers commercial and military aspects of aviation, including history, technical, and personalities. Articles can be as long as 5,000 words, with illustrations of all types: color photos, black-and-white prints, line drawings, cartoons. Payment is £50 per 1,000 words; £25 for color images; £10 for black and white.

Air Pictorial International
HPC Publishing
Drury Lane
St. Leonards-on-Sea
East Sussex TN38 9BJ
United Kingdom
Tel. 44-1424-720477
Fax 44-1424-443693
Editor: Berry C. Wheeler

Covering all aspects of aviation, this monthly assigns most of its articles based on queries. General interest as well as technical features are used and well illustrated with color transparencies and black-and-white prints. Payments are negotiated with the editor.

Alpha Traveller
Neville House
55 Eden Street
Kingston-on-Thames
Surrey KT1 1BW
United Kingdom
Editor: Marshall Lightfoot

Distributed free at fourteen airports in Britain, this monthly covers travel to all destinations in the world as well as products, fashions, and travel advice. Advertising is primarily duty-free products. Query the editor; he negotiates all fees for articles and photos.

Altair Speculative Fiction Magazine
P.O. Box 475, Blackwood
South Australia 5051
Australia
Tel. 61-8-8278-5585
E-mail *altair@senet.com.au*
Web site *www.oz.com.au/~robsteph/altair.html*

Editor: Robert Stephenson

International publication of fiction. Length: 2,000–6,000 words. Payment is 3¢ a word.

Amateur Gardening

IPC Magazines Ltd.
Westover House
West Quay Road, Pool
Dorset BH15 1JG
United Kingdom
Tel. 44-1202-680586
Fax 44-1202-674335
Editor: Graham Clark

All aspects of gardening, from soil preparation to seeds and crops to cultivation, are used. Most articles run 500–700 words. Color slides are used to illustrate text. Payment is £12 per 100 words. Photos bring £20 each.

Amateur Photographer

IPC Magazines Ltd.
King's Reach Tower
Stamford Street
London SE1 9LS
United Kingdom
Tel. 44-171-261-5100
Fax 44-171-261-5404
Editor: Keith Wilson

A weekly how-to publication for amateur and professional photographers. Articles cover techniques, pictorials, and advice. Short pieces of 400–800 words are used without illustration, while features up to 1,500 words run 2–4 pages with images. Payment is by arrangement with the editor.

The Antique Collector

Orpheus Publications Ltd.
7 St. John's Road
Harrow-on-the-Hill
Middlesex HA1 2EE
United Kingdom
Tel. 44-181-863-2020
Fax 44-181-863-2444
Editor: Susan Morris

Published six times a year, the *Antique Collector* seeks authoritative and timely articles with good illustrations. Interior design and art topics are used, in addition to all aspects of antiques. Both black-and-white and color images are used. Payment: £250 per article; photos are paid based on quality, size, and whether color or black and white.

Antique Dealer and Collector
P.O. Box 805
Greenwich
London SE10 8TD
United Kingdom
Tel. 44-181-691-4820
Editor: Philip Bartlam

All aspects of historical art and antique collecting are used here. Length: 1,500–2,000 words. Payment: £76 per 1,000 words. Images, both black and white and color, are purchased according to size/use.

Apollo
1–2 Castle Lane
London SW1E 6DR
United Kingdom
Tel. 44-171-233-6640
Fax 44-171-630-7791
Editor: Robin Smith

Established in 1925, *Apollo* is a monthly magazine covering art, architecture, furniture, ceramics, glass, sculpture, and all topics relating to collecting. Writers should have in-depth knowledge of their subjects, or have interviewed experts in the various fields. Length: 2,500 words. Color photography is used. Payment is by arrangement. Query first.

The Aquarist and Pondkeeper
M and J Publications Ltd.
Caxton House
Wellesley Road
Ashford
Kent TN24 8ET
United Kingdom
Tel. 44-1233-636349
Fax 44-1233-631239
Editor: Dick Mills

A monthly, illustrated publication for more than seventy years, the editor uses articles dealing with life in and around water. Conservation topics are also considered. Writers should always keep in mind that their work is being read by professional and amateur biologists, naturalists, and those interested in aquariums. Style should, therefore, be semi-scientific. Length: 1,500 words. Color images are used. Payments are negotiated. Query first.

Architectural Design
Academy Group Ltd.
42 Leinster Gardens
London W2 3AN

United Kingdom
Tel. 44-171-402-2141
Fax 44-171-723-9540
Editor: Maggie Toy
 Since 1930, *Architectural Design* has been published six times a year. This international magazine uses highly illustrated features of historical, innovative, and contemporary architectural design. All articles are by assignment only—so query first. Illustrations—slides, black-and-white prints, or line drawings—a must. Payment is arranged based on the assignment.

Architectural Review
EMAP Construct
151 Rosebery Avenue
London EC1R 4QX
United Kingdom
Tel. 44-171-505-6725
Fax 44-171-505-6701
Editor: Peter Davey
 A monthly dedicated to all topics of historical and contemporary architecture. Articles, up to 3,000 words, are assigned based on initial queries. Payments are negotiated according to subject and author's qualifications. Photos and drawings are used to illustrate features.

Architecture Today
161 Rosebery Avenue
London EC1R 4QX
United Kingdom
Tel. 44-171-837-0143
Fax 44-171-837-0155
Editor: Mark Swenarton
 A free distribution magazine published ten times a year, *Architecture Today* covers mainly European design and art as it relates to architecture. Most articles are assigned to experts in the field. Query first. Length: 200-800 words. Color transparencies are used for illustrations. Payment is negotiated with editor.

Arena
Third Floor, Block A
Exmouth House
Pine Street
London EC1R 0JL
United Kingdom
Tel. 44-171-837-7270
Fax 44-171-837-3906
Editor: Peter Howarth

Articles up to 3,000 words bring £200 per 1,000, while images bring fees based on usage/size. And what about topics? Nearly anything: art, architecture, profiles, politics, sports, business, music, movies, fashion, news. You name it, *Arena* covers it. Query first.

Army Quarterly and Defence Journal

1 West Street
Tavistock
Devon PL19 8DS
United Kingdom
Tel. 44-1822-613577/612785
Fax 44-1822-612785
Editor: T. D. Bridge

These publications are dedicated to British, UN, and NATO military affairs, both historical and contemporary. Short items include defense contracts, sales, reports, and book and video reviews. Query first. Photos and line drawings are preferred with features of 1,000–4,800 words. Payments are negotiated with assignment given.

Art and Design

Academy Group Ltd.
42 Leinster Gardens
London W2 3AN
United Kingdom
Tel. 44-171-402-2141
Fax 44-171-723-9540
Editor: Nicola Kearton

Bimonthly magazine covering contemporary art, with an international flavor. Highly illustrated features on specific themes run 1,000–2,000 words. There are also exhibition and book reviews. All articles are commissioned and payments are negotiated with the editor. Query first.

Art Business Today

The Fine Art Trade Guild
16-18 Empress Place
London SW6 1TT
United Kingdom
Tel. 44-171-381-6616
Fax 44-171-381-2596
Editor: Annabelle Ruston

A quarterly distributed to the fine arts industry, *Art Business Today* covers new products, technology, aspects of doing business in the art trade, and market trends. Length: 800–1,600 words. Color slides are used to illustrate features. Payment is negotiated.

Art Monthly
Britannia Art Publications Ltd.
26 Charing Cross Road, Suite 17
London WC2H 0DG
United Kingdom
Tel. 44-171-240-0389
Editor: Patricia Bickers
 Art Monthly covers visual artists, art history, theory, and related issues and is published ten times each year.

The Art Newspaper
27-29 Vauxhall Grove
London SW8 1SY
United Kingdom
Tel. 44-171-735-3331
Fax 44-171-735-3332
Editor: Laura Suffield
 A news publication for the arts that is monthly except December. Subjects with an international flavor on art markets, breaking news, trends, and essays. Length can be as short as 200 words or as long as 1,000. Black-and-white photos are used to illustrate text. Payment: £120 per 1,000 words.

Art Review
Art Review Ltd.
Hereford House
23-24 Smithfield Street
London EC1A 9LB
United Kingdom
Tel. 44-171-236-4880
Fax 44-171-236-4881
Editor: David Lee
 Both color and black-and-white illustrations are used in this monthly. Articles of 500–1,500 words cover all aspects of contemporary art from around the world. Payment: £150 per 1,000 words.

Artists Newsletter
AN Publications
P.O. Box 23
Sunderland SR4 6DG
United Kingdom
Tel. 44-191-567-3589
Fax 44-191-564-1600
E-mail *anpubs@gn.apc.org*
Editor: Hannah Firth

A monthly publication for active artists featuring profiles, reviews, news, and topics of interest to its readership. Length: 500–1,500 words. Color and black-and-white photography used. Payment: £90 per 1,000 words; photo fees are negotiated.

The Asda Magazine
River Publishing
55 Greek Street
London W1H 5LR
United Kingdom
Tel. 44-171-306-0304
Fax 44-171-306-0314
Editor: Jacqueline Keelan

Monthly magazine with special focus on food, health, and nutrition. The editor is particularly interested in consumer articles. Articles run from 200 to 1,500 words. Payment: £100–£500.

Asia Travel Trade and Frequent Traveller
Eastern Publishing Ltd.
8 Lorong Bakar Batu #07-12
Singapore 348743
Tel. 65-743-6003
Fax 65-842-2301
E-mail *eastern@mbox2.singnet.com.sg*
Associate Editor: France Lee

Features articles on travel, lifestyle, and news topics that relate to the Far East travel industry. Article lengths run from 250 for news items to 1,500 for features. Color slides are used for illustrations. Payments are negotiated upon assignment. Query first.

The Asian Age
55 Park Lane, Suite No. 4
London W1Y 3DB
United Kingdom
Tel. 44-171-304-4028
Fax 44-171-304-4029
Editor: M. J. Akbar

Distributed to the Asian community of London, this daily covers news, features, business, politics, and anything else that interests its readership. Articles run from 200 to 1,500 words. Black-and-white photos are used. Payment: £50 per 1,000 words; £40 per photo.

Asian Diver Online
P.O. Box 335
Singapore 912412

E-mail *Infor@asiandiver.com*
Web site *www.asiandiver.com*
Editors: Julia Goh and Barry Lee Brisco

As the name indicates, this is an Internet magazine covering all aspects of sport diving, with emphasis on Asian locations. Length: 400–1,200 words. Payment is 15¢ per word; $35 per photo—$100 for the cover. Query by e-mail

Asian Hotelier
Canthers Publications
H1 Lo Kwai Path
Fo Tan, Sha Tin
Hong Kong
Editor: Kevin Sinclair

Published monthly and distributed to the hotel industry in Hong Kong, *Asian Hotelier* cover news items, profiles, lifestyle, and some travel. Payments are arranged with the editor. Photo-essays are also used. Send queries for articles and photos to the editor.

Astronomy Now
Pole Star Publications
P.O. Box 175
Tonbridge
Kent TN10 4ZY
United Kingdom
Tel. 44-1732-367542
Fax 44-1732-356230
Editor: Steven Young

Read by amateur astronomers, this monthly uses news items as well as features related to the heavens and topics associated with space. Length: 1,500–3,000 words. Color and black-and-white photography is used. Payment: 5p (pence) per word; photos bring £10 and up per image.

Attitude
Northern and Shell Place
Northern and Shell Tower
City Harbour
London E14 9GL
United Kingdom
Tel. 44-171-987-5090
Fax 44-171-538-3690
Editor: Paul Hunwick

A monthly men's magazine targeted at the gay communities of England. Fashion, style, news, arts, leisure, profiles, and reviews make up 90 percent of the editorial content. Color photos are used throughout. Features run 1,000–2,500 words. Payment: £150 per 1,000 words; £100 for a full-page illustration. Query first.

Australian Geographic

P.O. Box 321
Terrey Hills NSW 2084
Australia
Tel. 61-2-450-2344
Fax 61-2-450-2990
Editor: Howard Whelan

Covers Australian lifestyle, natural history, technology, research, and science. Most articles are commissioned, so a query is suggested. Length for short items is 300–800 words; features are 2,000–3,000 words. Photos are also commissioned or purchased as a package with text. Payment: $500 per 1,000 words; photo rates are negotiated.

Australian Photographer

Yaffa Publishing Group
17-21 Bellevue Street
Surry Hills NSW 2010
Australia
Tel. 61-2-281-2333
Fax 61-2-281-2750
Editor: Steve Packer

This monthly, dedicated to the techniques of photography, also covers new equipment, technical aspects of images, and various topics related to the field. All articles are highly illustrated. Features run 2,000 words. Payment is $A80 (Australian dollars) per page.

Australian Skiing

P.O. Box 746
Darlinghurst SW 2010
Australia
Tel. 61-2-331-5006
Fax 61-2-360-5367
Editor: Matt Johnson

Water-skiing features around the world. Covers travel, techniques, personalities, equipment, etc. Length: 1,500 words. Payment: $200 per 1,000 words; $190 for a two-page color-image spread, $120 for single-page image, and $300 for a cover image.

The Australian Way

Qantas Airways Magazine
GPO Box 55A
Melbourne, Victoria 3001
Australia
Tel. 61-3-9603-3346
Fax 61-3-9642-0852
Assistant Editor: Emily Ross

The in-flight magazine of Qantas Airways uses a lot of travel, business, profiles, entertainment, and general-interest articles. The monthly is in full-color and articles run 800–1,500 words. Payment is negotiated with writer/photographer based on story idea and illustrations.

Auto Express
Express Newspapers
Ludgate House
245 Blackfriars Road
London SE1 9UX
United Kingdom
Tel. 44-171-928-8000
Fax 44-171-928-2847
Editor: David Jones

Entering its twentieth year of publication, *Auto Express* covers news and general-interest articles about cars and drivers (that is, professional drivers on the race circuit). Color photos are used throughout. Payment: £250 for 1,000 words; rates for images are based on published size/topic.

Autocar
Haymarket Publishing Ltd.
38-42 Hampton Road
Teddington
Middlesex TW11 0JE
United Kingdom
Tel. 44-181-943-5851
Fax 44-181-943-5853
E-mail *100020.2017@compuserve.com*
Editor: Michael Harvey

All topics dealing with motoring, cars, and the auto industry, whether technical, practical, or competitive, would fit *Autocar's* format. This weekly publication uses color images. Features run 700–1,500 words. Payments are made two weeks after publication and vary with the size of article and printed photos.

Babycare and Your Pregnancy
D.C. Thomson and Company, Ltd.
80 Kingsway East
Dundee DD4 8SL
United Kingdom
Tel. 44-1382-223131
Fax 44-1382-452491
E-mail *baby@dcthomson.co.uk*
Editor: Moira Chisholm

All aspects of pregnancy, motherhood, and family relationships are covered in this

magazine. Features of interest to mothers-to-be are also considered. Length: 1,200–1,500 words. Color and black-and-white photos are used. Payment varies, based on research and length. Query by e-mail.

Back Brain Recluse
P.O. Box 625
Sheffield S1 3GY
United Kingdom
E-mail *bbr@fdgroup.co.uk*
Editor: Chris Reed
A publication for startling and daring science fiction, Reed suggests reading a couple of back issues before sending submissions. "We tread the thin line between experimental speculative fiction and avant-garde literary fiction," explains Reed. E-mail submissions are not considered. Payment is $15 for 1,000 words. Art brings $30 per page.

Balance Fitness
8 Upper Saint Martins Lane
London WC2H 9DL
United Kingdom
Tel. 44-171-240-8121
Fax 44-171-240-8098
E-mail *Howard.Jardine@hyperlink.com*
Web site *balance.net/index.html*
Executive Editor: Howard Jardine
Monthly e-zine that focuses on health, fitness, and nutrition. Both queries and complete manuscripts are accepted. Length: 1,500 words. Submit seasonal materials three months in advance. Payment is negotiated based on merit.

Bali Echo
Julan Hayam Wuruk No. 173
Denpasar, Bali
Indonesia
Tel./Fax 62-361-228888
E-mail *baliecho@denpasar.wasantara.net.id*
Editor: Dr. M. Sarlan
Art Director: I. Wayan Windra
This bimonthly magazine covers culture, tourism, adventure, travel, food, and restaurants in the Bali area. Articles are illustrated with color transparencies and prints. Stories run 800–1,000 words. Payments range (in rupiahs) from Rp 300.000 per 1,000 words to Rp 400.000 for 2,000 words. Images bring Rp 400.000–500.000.

The Bath Chronicle
Westminster Press Ltd.

Media in Wessex
33-34 Westgate Street
Bath BA1 1EW
United Kingdom
Tel. 44-1225-444044
Fax 44-1224-445969
Editor: David Gledhill

Published Monday through Saturday, the *Bath Chronicle* uses both local and national news as well as general-interest features: personalities, arts, lifestyle, and travel. Length: 200–500 words. Color photos are used. Payment: 8p–15p per printed line; £5 per photo.

BBC Music Magazine
BBC Worldwide Publishing
A1004, Woodlands
80 Wood Lane
London W12 0TT
United Kingdom
Tel. 44-181-576-3283
Fax 44-181-576-3292
Editor: Graeme Kay

Focusing on classical music, this monthly magazine takes features, news, and reviews. All articles are commissioned, so query first. Length: up to 2,000 words. Color and black-and-white photographs are used. Payment: £150 for 1,000 words; picture fees vary based on usage.

BBC Top Gear Magazine
BBC Worldwide Publishing
Woodlands
80 Wood Lane
London W12 0TT
United Kingdom
Tel. 44-181-576-2000
Fax 44-181-576-3754
Editor: Kevin Blink

Car and motoring are featured here: new cars, tests, technology, drivers, etc. Most articles are assigned based on queries and author's experience. Articles run 1,500–3,000 and bring £200 per 1,000 words. The editor requests color slides and will arrange payment according to quality and use.

BBC Wildlife Magazine
Broadcast House
Whiteladies Road
Bristol BS8 2LR

United Kingdom

Tel. 44-117-973-8402

Fax 44-117-946-7075

Editor: Rosamund Kidman Cox

This popular monthly publication covers national and international conservation and wildlife. Some of the topics are linked to BBC's TV and radio coverage. There are also short news sections covering biology, discoveries, and scientific issues in the environment arena. The best in color photography is used. Articles run 500–3,000 words. Payment: £200–£350 per article; £45–£150 for photos, according to published size.

Big!

EMAP Metro

Mappin House

4 Winsley Street

London W1N 7AR

United Kingdom

Tel. 44-171-436-1515

Fax 44-171-631-0781

Features Editor: Richard Galpin

Readers of *Big!* are eleven to seventeen years old. The twice-a-month magazine covers pop and movie celebrities and teenage entertainment, including music, videos, fashion, and trends. Interviews are particularly welcome, as is gossip. All articles are by assignment. Query by phone, fax, or letter. Articles run 800 words. Both color and black-and-white images are used. Payment: £80–£250 for both articles and photos.

The Big Issue

57-61 Clerkenwell Road

London EC1M 5NP

United Kingdom

Tel. 44-171-418-0427

Editor: Joanne Mallabar

A weekly publication running news, reviews, interviews, and features covering social issues, with emphasis on the homeless. Length: 1,200–2,000 words. Color and black-and-white photos are used. Payment: £150 per 1,000 words. Photos are negotiated based on size, subject, and quality.

Bike

EMAP Nationals

Bushfield House

Orton Centre

Peterborough PE2 5UW

United Kingdom

Tel. 44-1733-237111
Fax 44-1733-370283
Editor: Phil West

The most popular motorcycle magazine in Britain. Features of 1,000–3,000 words on all aspects of leisure and sport biking are used, as well as news and short stories. Color and black-and-white photos, line drawings, and cartoons are purchased as illustrations. Payment: £120 per 1,000 words; illustration fees vary with size.

Billboard
23 Ridgemount Street
London WC1E 7AH
United Kingdom
Tel. 44-171-323-6686
Fax 44-171-323-2314
International Editor: David Sinclair

Covering the music scene around the globe, *Billboard* is primarily read by young music lovers and those interested in the pop industry. Personality profiles, reviews, industry news, trends, and music charts are found in this large-format publication. Article length: 500–2,000 words. Color slides and black-and-white prints are used. Payment: negotiated.

Bird Keeper
IPC Magazines Ltd.
King's Reach Tower
Stamford Street
London SE1 9LS
United Kingdom
Tel. 44-171-261-6201
Fax 44-171-261-7851
Editor: Peter Moss

A monthly how-to magazine for amateur bird keepers, covering care, health, and breeding. The editor requires queries only. Articles can be up to 1,200 words. Color photos and picture essays are used. Payment: £65–£85 per 1,000 words; £20–£45 per photo.

Birdwatch
Solo Publishing Ltd.
310 Bow House
153-159 Bow Road
London E3 3SE
United Kingdom
Tel. 44-181-983-1855
Fax 44-181-983-0246
Editor: Dominic Mitchell

Articles of 700–1,500 words on all aspects of birds and bird-watching, including identification, observation sites, habitats, equipment, and travels around the world that involve bird-watching. Color slides are used almost exclusively. Payment begins at £40 per 1,000 words; £15-£40 per photo.

Black Beauty and Hair
Hawker Publications
13 Park House
140 Battersea Park Road
London SW11 4NB
United Kingdom
Tel. 44-171-720-2108
Fax 44-171-498-3023
Editor: Irene Shelley

This quarterly is dedicated to black women. Features include beauty, style, fashion, and celebrity profiles/interviews. Average length is 1,000 words. Both color and black-and-white photographs are used. Payment: £85 per 1,000 words; £50–£100 for photographs.

Blue Wings
Helsinki Media Company Oy
P.O. Box 16
Kornetintie 8
00040 Helsinki, Finland
Tel. 22-9-1205911
Fax 22-9-1205999
E-mail *Tim.Bird@online.tietokone.fi*
Editor: Tim Bird

The bimonthly publication of Finair uses travel, personality profiles, and general interest pieces. Articles run 700–1,500 words. Query the editor with ideas first. Rates were not provided, but we've received reports that they are relatively the same as other in-flight magazines ($200–$600).

Boards Magazine
196 Eastern Esplanade
Southend on Sea
Essex SS1 3AB
United Kingdom
E-mail *billdawes@compuserve.com*
Web site *www.boards.co.uk*
Editor: Bill Dawes

This magazine, published ten times a year, covers all aspects of sport windsurfing: equipment, tournaments, personalities, and travel. Articles run 500–1,500 words and are illustrated with high-quality, color transparencies. Payment is £30–50 per page. Query first, says the editor.

Boating World
Private Bag 93209
Parnell, New Zealand
Tel. 64-9-309-8292
Fax 64-9-309-6361
Editor: Geoff Green

A monthly, full-color publication covering leisure boating—both power- and sailboating. Articles should be of interest to New Zealanders and cover how-to, technology, travel, new equipment, or ways to enjoy boating. Payment is $180 per 1,000 words. Color photos paid separately.

The Boatman
Waterside Publications Ltd.
P.O. Box 1992
Falmouth
Cornwall TR11 3RU
United Kingdom
Tel. 44-1326-375757
Fax 44-1326-378551
Editor: Pete Greenfield

Each year ten issues of the *Boatman* hit the newsstands with features on traditional boats and the craft of boating. Both contemporary and historical themes are used, as well as news items, equipment, travel, and races. Length: 1,000–3,000 words. Photos: color prints or transparencies. Payment: £100 per 1,000 words; £100 for full-page photo, smaller sizes decrease proportionally.

Bowls International
Key Publishing Ltd.
P.O. Box 100
Stamford, Lincs PE9 1XQ
United Kingdom
Tel. 44-1780-55131
Fax 44-1780-57261
Editor: Melvyn Beck

Monthly publication covering sports and news. There are no set lengths, but one should try to stay below 1,200 words. Color and black-and-white photographs are used. Payment: 25p per line for short items, £50 per page for features; photos bring £25 for color and £10 for black and white.

Brownie
The Guide Association
17-19 Buckingham Palace Road
London SW1W 0PT
United Kingdom

Tel. 44-171-834-6242

Editor: Marion Thompson

The Guide Association's official publication, *Brownie* is for girls seven to ten years old. Crafts, art, how-to, and short stories with Brownie themes are all used. General length is 500–800 words for fiction, up to 1,200 for features. Color slides are used. Payment: £40 per 1,000 words; fees for photographs vary with use.

Building Design

30 Calderwood Street

Woolwich

London SE18 6QH

United Kingdom

Tel. 44-181-855-7777

Fax 44-181-854-8058

Editor: Lee Mallett

This weekly covers news and features of the building design industry—from raw materials to final accessories. All work is assigned based on initial queries. Features run up to 1,500 words. Articles are illustrated with color slides, black-and-white prints, and line drawings. Payment: £120 per 1,000 words; illustrations are negotiated.

The Bulletin with Newsweek

54 Park Street

Sydney, NSW 2000

Australia

Tel. 61-2-282-8200

Fax 61-2-267-4359

Editor: Lyndall Crisp

A weekly publication covering general-interest features and humor. Minimum length is 750 words, maximum 2,100. Color photography is used exclusively. Payment: $450 per 1,000 words; $100 per photo, according to published size.

Burlington Magazine

14-16 Duke's Road

London WC1H 9AD

United Kingdom

Tel. 44-171-388-1228

Fax 44-171-388-1230

Editor: Caroline Elam

Focused on the history and criticism of art, *Burlington* magazine buys articles of 500–3,000 words. Writers must have special insight into the topic of which they propose; no secondhand, or reference-book pieces. There are book and exhibition reviews rounding out the text. An illustrated monthly calendar is also included. Payment is up to £100. Color photo prices are negotiated for one-time rights.

Business Age
VNU Business Publications Ltd.
32-34 Broadwick Street
London W1A 2HG
United Kingdom
Tel. 44-171-316-9605
Fax 44-171-316-9612
Editor: Peter Kirwan

Most features in this monthly review management performance and contemporary business decisions and activities. New items that affect British or international commerce are also covered. Length: 500–2,000 words. Color photos are used. Payment: £100–£150 per 1,000 words. Illustrations are negotiated based on published size and topic.

Business Life
Premier Magazines Ltd.
Haymarket House
1 Oxendon Street
London SW1Y 4EE
United Kingdom
Tel. 44-171-925-2544
Fax 44-171-839-4508/4491
E-mail *busess_life@premiermags.com.uk*
Editorial Assistant: Catherine Flanagan

Distributed aboard British Airways flights, *Business Life* covers all aspects of business: personality profiles, products, technology, services, travel, and legislation. Article length runs 850–1,500 words. Payment is negotiated with the writer. Reported fees are £300 per 1,000 words and £100–400 for illustrations. Query first.

Business Matters
GMC Publications
Castle Place
166 High Street
Lewes, East Sussex BN7 1XU
United Kingdom
Tel. 44-1273-477374
Fax 44-1273-486300
Editor: Elly Donovan

Articles on how to run a small or medium-sized business are the mainstay of this bimonthly publication. The editor likes articles based on real businesses. New items that affect entrepreneurs are also desired. Color and black-and-white photography is used. Article lengths range from 400 words for news to 2,400 words for features. Payment: £1 per word; £50 for each photo.

Car
EMAP National Publications Ltd.
Abbots Court
34 Farringdon Lane
London EC1R 3AV
United Kingdom
Tel. 44-171-216-6200
Fax 44-171-216-6259
Editor: Peter Simpson

> A top, slick monthly covering automobiles, drivers, people in the industry, and news revolving around cars of the world. Length: 500–1,500 words. Top-quality color transparencies are used, including photo-essays. Payment is among the best in the United Kingdom: £260 minimum for 1,000 words. Photo rates are negotiated, but always good.

Caribbean Beat
6 Prospect Avenue
Maraval, Port of Spain
Trinidad and Tobago
E-mail *mep@wow.net*
Editors: Brenden de Caires and Skye Hernandez

> This bimonthly in-flight magazine for BWIA International Airways uses upbeat destination articles of 900–3,000 words. Features should deal with the Caribbean, the people, the issues, the events, and the concerns. Color slides are desired to illustrate articles as well as photo-essays. Payment: $300 minimum; photos negotiated. Query by e-mail.

Cat World
Ashdown Publications
Avalon Court, Star Road
Partridge Green
West Sussex RH13 8RY
United Kingdom
Tel. 44-1403-711511
Fax 44-1403-711521
Editor: Joan Moore

> This monthly has been providing lively, entertaining, and informative articles to cat lovers since 1981. Moore wants queries and no fiction. Articles cover cat breeds, health, veterinary services, and all other aspects of felines. Black-and-white and color photos are used. Payment is negotiated for articles; images bring £7.50 each.

Catholic Times
First Floor
St. Jame's Building

Oxford Street
Manchester M16FP
United Kingdom
Tel. 44-161-236-8856
Fax 44-161-237-5590
Editor: Norman Cresswell
This weekly uses 400-word news items relating to all aspects of the Catholic religion as well as 800-word features. Illustrations are in black-and-white. Payment: £30–£80 for articles; £50 for photographs.

Cellar Notes
Queen Anne House
15 Thames Street
Hampton
Middlesex TW12 2EW
United Kingdom
Editor: Hugh Slater
The company publication of Victoria Wines covers industry news as well as topics of interest to customers. The magazine is distributed free in stores selling Victoria Wines. Recent articles included "The Art of Parties," "Cheese and Wine Classics," and a guide to Italian wine regions. Query the editor with ideas and payment requests.

Changi
MPH Magazines (S) Pte Ltd.
12 Tagore Drive
Singapore 787621
Tel. 65-453-8200
Fax 65-453-8600
Editor: Claudette Peralta
Changi is a bimonthly English-language publication of the world's number one airport, Changi. Published for the Civil Aviation Authority of Singapore by MPH Magazines, it caters to the divergent interests of different travellers passing through the airport. The magazine features a wide range of topics such as travel, entertainment, and business. Avoid a guidebook approach; issues of a political, racial, or religious nature that might offend the sensitivities of readers; and topics dealing with death. Length: 1,000–3,000 words. Images should be high-quality original color. Payment: (in Singapore dollars) is S$250 per 1,000 words; S$100 per photo (S$200 for the cover).

Chapman
4 Broughton Place
Edinburgh EH1 3RX
United Kingdom

Tel. 44-131-557-2207
Fax 44-131-556-9565
Editor: Joy Hendry
Subtitled "Scotland's Quarterly Literary Magazine," *Chapman* publishes short stories, poetry, reviews of the arts, and articles associated with Scottish culture. There is no minimum or maximum length. All illustrations are line drawings. Payment: £8 per page; illustrations are negotiated.

The China Quarterly
School of Oriental and African Studies
Thornhaugh Street
Russell Square
London WC1H 0XG
United Kingdom
Tel. 44-171-323-6129
Fax 44-171-580-6836
Editor: Dr. David Shambaugh
In-depth articles on contemporary China, including social issues, culture, business, and international trade. Length: up to 8,000 words. Payments by this quarterly are negotiated with the assignment. Query first.

Church of England Newspaper
10 Little College Street
London SW1P 3SH
United Kingdom
Tel. 44-171-976-7760
Fax 44-171-976-0783
Submit inquiries to the managing editor.
News and features relating to the Christian follower. All articles should carry a theme for everyday life. All articles for this weekly newspaper are commissioned so send only queries. Length: 300–1,000 words. Illustrations include color and black-and-white photography, line drawings, and cartoons. Payment: £40 per 1,000 words; £22 per photo.

Church Times
33 Upper Street
London N1 0PN
United Kingdom
Tel. 44-171-359-4570
Fax 44-171-226-3073
Editor: Paul Handley
Articles of up to 1,000 words are used in this weekly dedicated to the Christian religion. Fiction and poetry are not considered. Ideas should be first sent in summary (query) form to Handley. Color and black-and-white photos are used. Payment: £100

per 1,000 words; image fees vary according to size, but follow the standards of U.K. photo associations.

Classic and Sportscar
Haymarket Magazines Ltd.
38-42 Hampton Road
Teddington
Middlesex TW11 0JE
United Kingdom
Tel. 44-181-943-5000
Fax 44-181-943-5844
Editor: Ian Bond

Classic and sports cars are featured in this monthly, full-color publication. Interviews with drivers and industry personnel, auto shows, news, and reviews are also used. There is no fixed length, but most articles fall within 500–1,700 words. Color transparencies are used. Payment: £150 per 1,000 words; photo fees vary with use.

Classic Boat
Boating Publications Ltd.
Link House
Dingwall Avenue
Croydon CR9 2TA
United Kingdom
Tel. 44-181-686-2599
Fax 44-181-781-6535
Editor: Nic Compton

Entering its twelfth year of publication, *Classic Boat* is a monthly dedicated to maritime history, news, practical and technical information, new equipment and boats, restoration, and general cruising. Articles run 500–3,000 words. Each issue is illustrated with black-and-white and color images. Payment: £75–£100 per published page.

Classic CD
Future Publishing
30 Monmouth Street
Beauford Court
Bath BA1 2BW
United Kingdom
Tel. 44-1225-442244
Fax 44-1225-312228
Editor: Neil Evans

Informative, educated, and entertaining articles covering classic music on CDs are sought by the magazine. Reviews of new CDs, news of the classic music and CD industry, and profiles of composers and performers are all used. Query first, as all

articles are commissioned. Both color and black-and-white images are used. Length: 1,000–2,000 words. Payment: £125 per 1,000 words; black-and-white images bring £280 per page, color £300 per page.

Classic Music
Rhinegold Publishing Ltd.
241 Shaftesbury Avenue
London WC2H 8EH
United Kingdom
Tel. 44-171-333-1742
Fax 44-171-333-1769
E-mail *100546.1127@compuserve.com*
Editor: Keith Clarke

All articles are commissioned based on queries to the magazine dedicated to the world of classical music. Profiles, industry news, and features dealing with concerts, CDs, composers, and performers are used. Color and black-and-white photos accepted for illustrations. Length: 500–2,000 words. Payment: £85 per 1,000 words; £40 per photo.

Clocks
Nexus Special Interests Ltd.
28 Gillespie Crescent
Edinburgh EH10 4HU
United Kingdom
Tel. 44-131-229-5550
Editor: John Hunter

Antique clocks are the theme of this monthly publication begun in 1978. Historical features on antique clocks, clock makers, as well as the repair and restoration of timepieces are used. Pieces on scientific instruments, such as sundials and barometers, are also used. Length: 1,500–3,000 words. Color and black-and-white photos are used. Payment: £30 per 1,000 words; £8 for color images, £5 for black and white.

Communicate
The Economist Group
15 Regent Street
London SW1Y 4LR
United Kingdom
Tel. 44-171-830-7000
Fax 44-171-839-1475
Editor: Eddie Hold

Telecommunications news, personalities, management, analysis, and world developments are used in this monthly. Short items run 200–700 words, while features run 800–1,800. Hold requires queries and assigns all stories. Color and black-and-white photography is used. Payment: £180 per 1,000 words; photo prices are negotiated.

Company Magazine
National Magazine Company Ltd.
72 Broadwick Street
London W1V 2BP
United Kingdom
Tel. 44-171-439-5000
Editor: Fiona McIntosh

This monthly publication for contemporary women covers a wide range of topics. A recent issue, for example, carried "51 Shameless Orgasm Confessions," "Love by Numbers," "Summer's Ten Most Wanted Swimsuits," "Drugs and You," makeovers, and a true story about doctors and babies. While specific rates were not provided, U.K. writers' organizations say that this is one good-paying magazine. General people and glamour photos are used as well as celebrity and news images with captions.

Compuserve
Compuserve Information Services Ltd.
Apex Plaza
Forbury Road
Reading RG1 1AX
United Kingdom
E-mail *iballantyne@csi.compuserve.com*
Editor: Innes Ballantyne

Compuserve Information Services uses freelance writers for much of its online features, including computing, computer games, sports, entertainment, business, science, and travel. Payment is negotiated with the writer prior to acceptance. Query by e-mail.

Computer Business Review
12 Sutton Row, Fourth Floor
London W1V 5FH
United Kingdom
Tel. 44-171-208-4200
Fax 44-171-439-1105
E-mail *100537.2236@compuserve.com* (Richard Carpenter)
Web site *www.computerwire.com*
Editor: Jana Sanchez-Klein

Monthly publication covering business computer trends in Europe and the United States. Desires high-tech features. Always keep in mind the readership: computer industry managers, investors, and analysts. Articles run 2,200–3,000 words and bring 50¢ a word. Photo rates are negotiated based on usage.

Computer Weekly
Reed Business Publishing Group

Quadrant House
The Quadrant, Sutton
Surrey SM2 5AS
United Kingdom
Tel. 44-181-652-3122
Fax 44-181-652-3038
News Editor: Karl Schneider
Features Editor: David Evans

News, new product reviews, and features on all aspects of the computer industry are used in this weekly. News items can run 150–700 words. Feature length is 1,200 words. Photos are black and white. Payment: £150 per article; photos negotiated.

Connected (The Daily Telegraph)
1 Canada Square
London E14 5DT
United Kingdom
Tel. 44-171-538-5000
Fax 44-171-538-6242
E-mail *connected@telegraph.co.uk*
Editor: Ben Rooney

A weekly insert of the *Daily Telegraph* covering the Internet, computing, and software. Everything from new technology and games hardware to Web sites and search engines are covered. News items run 75–300 words; features run 700–1,000 words. Payment is negotiated directly with the editor based on topic, length, and author's expertise.

Contemporary Art
197 Knightsbridge
Eigth Floor North
London SW7 1RB
United Kingdom
Tel. 44-171-823-8373
Fax 44-171-823-7969
Editor: Lynne Green

All forms of contemporary art—painting, theater, literature—are reviewed and featured in this quarterly magazine. Profiles of artists, authors, and galleries are also used. Length: 1,000–2,000 for features, 750–1,000 for reviews. Color and black-and-white photographs are used to illustrate articles. Payment: £120 per 1,000 words; illustrations are normally purchased as part of a text/photo package.

Cornucopia
Kayik Yayincilik ve Turizm Ticaret Ltd. Sti.
CC 480, Mecidiyekoy
80303 Istanbul

Turkey
Tel./Fax 90-212-248-3607
E-mail *cornucopia@atlas.net.tr*
Editor: John Scott

According to the editor, most articles in *Cornucopia* are produced by a small circle of writers. "This is . . . because there are so few writers/photographers who we feel really understand Turkey . . . That said, we always welcome suggestions." This full-color, slick publication covers food, travel, and culture articles dealing with this country. Payment (in British pounds) is £350–£400.

Corporate Traveller
Level Twelve, 157 Ann Street
Brisbane, Queensland 4000
Australia
Tel. 61-7-3229-7689
Fax 61-7-3229-9743
Editor: Mike Sullivan

A publication for business travellers, *Corporate Traveller* covers industry news, profiles, lifestyle, and travel around the world. Illustrated with color slides. Length: 500–1,700 words. Payment information not available.

Cosmetic World News
130 Wigmore Street
London W1H 0AT
United Kingdom
Tel. 44-171-486-6757
Fax 44-171-287-5436
Editor: Caroline Marcuse

This bimonthly, international news magazine focuses on new products, developments, trends, and business in the perfumery, cosmetics, and toiletries industry. Personality and company profiles are also welcome. Length: 500–1,000 words. Photos: color slides and black-and-white prints. Payment: 10p per word minimum; photo prices vary based on usage.

Cosmopolitan (U.K.)
National Magazine House
72 Broadwick Street
London W1V 2BP
United Kingdom
Tel. 44-171-439-5000
Fax 44-171-439-5016
Editor: Mandi Norwood

One of Britain's most popular magazines for women, this monthly features relationships, fashion, cosmetics, family life, health, beauty, and short stories. Both pho-

tography and articles are assigned based on queries. All payments are negotiated when assignments are given.

Cosmopolitan (South Africa)
P.O. Box 5355
Cape Town 8000
South Africa
Tel. 27-21-462-3070
Fax 27-21-461-2500
E-mail *cosmosa@iafrica.com*
Editor: Vanessa Raphaely

Monthly magazine covering health, relationships, beauty, fashion, and travel. Articles run 800–2,000 words and pay (in rands) R1 per word. Images—generic couples, single women, news shots—are paid R150–R380 depending on their importance and work involved.

Country Garden and Smallholding
Broad Leys Publishing Company
Buriton House, Station Road
Newport, Saffron, Walden
Essex CB11 3PL
United Kingdom
Tel. 44-1799-540922
Fax 44-1799-541367
Editor: Helen Sears

The readers of this monthly are small-scale farmers looking for how-to tips, practical advice, new products, and general home living information. More specifically, themes include planting, seasonal crops, organic gardening, poultry and livestock raising, crafts, and cooking. The editor prefers queries. Articles run up to 2,000 words and bring £25 per 1,000 words. Photos, which can be either color slides or black-and-white prints, bring £5–£10; more for cover photos.

Country Homes and Interiors
IPC Magazines Ltd.
King's Reach Tower
Stamford Street
London SE1 9LS
United Kingdom
Tel. 44-171-261-6451
Fax 44-171-261-6895
Editor: Julia Watson

A slick, color monthly magazine dedicated to elegant country property and interior designs. Query with ideas and indicate availability of photography. This may be a good market for photo-essays of country homes. Length: 700–2,000 words.

Color photography throughout. Payment: £250 per 1,000 words; images by arrangement.

Country Walking
EMAP Pursuit Publishing
Bretton Court
Bretton, Peterborough
Cambridgeshire PE3 8DZ
United Kingdom
Editor: Lynne Maxwell
Monthly magazine dedicated to leisure walking. Focus is British for the most part, with periodical walks in other European countries. Articles run 800 words and bring £30.

The Countryman
Sheep Street
Burford
Oxon OX18 4LH
United Kingdom
Tel. 44-1993-822258
Editor: Christopher Hall
For more than seventy years the *Countryman* has covered rural life in Britain, from history and sentimental essays to nature and people. Writing style should be light, entertaining, and accurate. Articles run 700–1,500 words. Excellent photography and sketches of country lifestyles and personalities are also desired. Most photos are black and white. Payment: minimum £40 per 1,000 words; photos and art are negotiated.

Country-Side
P.O. Box 87
Cambridge CB1 3UP
United Kingdom
Tel./Fax 44-1933-314-672
Editor: Dr. David Applin
This quarterly is the official publication of the British Naturalist's Association. Editorial content focuses on wildlife and its protection, as well as natural history. The editor prefers queries. Photos are desired as part of the editorial package. Features run 1,200 words and bring £50; illustrations are negotiated based on quality.

The Cricketer International
Third Street
Langton Green
Tunbridge Wells
Kent TN3 0EN

United Kingdom
Tel. 44-1892-862551
Fax 44-1892-863755
Editor: Peter Perchard

If you're a cricket fan, this monthly magazine, produced since 1921, may be a good market. Articles cover all levels of play, from grade school to the Olympics. Personalities, teams, national profiles of the sport, rules, equipment—almost anything and everything that is encompassed by cricket—will fit the editorial guidelines. Length: 500–2,000 words. Photos: color and black and white. Payment: £50 per 1,000; photos bring £17.50 minimum.

Cuisine
Cuisine Publications
P.O. Box 37-349
Parnell, Auckland
New Zealand
Editor: Julie Dalzell

Monthly magazine for well-educated buyers and users of fine food and wine in New Zealand. Travel, wine tasting, recipes, and general-interest topics dealing with cuisine are used. Lengths vary from 300 to 2,000 words. Query with ideas as well as photo-essays. All payments are negotiated with the editor.

Cycling and Mountain Biking Today
196 Eastern Esplanade
Southend on Sea
Essex SS1 3AB
United Kingdom
Tel. 44-1702-582245
Fax 44-1702-588434
E-mail *106003.3405@compuserve.com*
Editorial Assistant: Justin Pearse

This monthly uses commission-only features. A query letter is therefore a must. Everything from leisure bicycling to professional racing is covered by this publication. World travel—in travelog style—cycle news, fitness, equipment, profiles, and manufacturers are all topics of consideration by the editor. It is helpful if a writer has a knowledge of cycling. Top-quality, color images are also sought. Features run 1,500–2,000 words, while news items run 150–200 words. Payment: £75 per published page, with photos. Shorter items bring £20, as do single pictures.

Daily Mirror
1 Canada Square
Canary Wharf
London E14 5AP
United Kingdom

Tel. 44-171-293-3000
Fax 44-171-293-3758
Editor: Piers Morgan
 One of the United Kingdom's most popular daily newspapers, the *Daily Mirror* pays top dollar for exclusive news stories and pictures. Length varies from 500 to 2,200 words. The editor wants queries only. All article and photo payments are negotiated.

Daily Sport
19 Great Ancoats Street
Manchester M60 4BT
United Kingdom
Tel. 44-161-236-4466
Fax 44-161-236-4535
Editor: Jeff McGowan
 Published daily, Monday through Friday, with articles up to 1,000 words on all facets of sports: personalities, events, matches, equipment, etc. Photos: color and black and white. Payment: £30–£500.

Daily Star
Ludgate House
245 Blackfriars Road
London SE1 9UX
United Kingdom
Tel. 44-171-928-8000
Fax 44-171-620-1641
Editor: Dawn Neeson
 Dedicated to hard news, exclusives, political, social, and personality affairs, the *Daily Star* offers top rates: £75–£100 for short items; £250–£300 for full-page pieces; £400–£600 for double pages. All other fees, including photos, are negotiated. The key here is *people*—make them the topic of your story. Photo-essays are particularly desired.

The Daily Telegraph
1 Canada Square
Canary Wharf
London E14 5DT
United Kingdom
Tel. 44-171-538-5000
Fax 44-171-538-6242
Web site *www.telegraph.co.uk/*
Editor: Charles Moore
Telegraph Magazine Editor: Emma Soames
 A vast array of articles, from personality profiles to breaking news, are used. Length is 700–1,000 words and all payments are negotiated, based on subject. The *Telegraph*

Magazine, distributed free with the newspaper each Saturday, uses profiles of 1,600 words and features of current interest to the general public. Color and black-and-white photos are used. Payments are also negotiated.

Dance Australia
Yaffa Publishing Group
GPO Box 606
Sydney NSW 2001
Australia
Tel. 61-2-281-2333
Fax 61-2-281-2750
Editor: Karen van Ulzen

Most articles and photos in this bimonthly magazine are commissioned, so query first. Any aspect of dance in Australia or dance personalities from this country is a potential article. Illustrations: black-and-white photos. Payment: $150 per 1,000 words; photo rates are according to subject and size used.

Darts World
World Magazines Ltd.
9 Kelsey Park Road
Beckenham, Kent BR3 9LH
United Kingdom
Tel. 44-181-650-6580
Fax 44-181-650-2534
Editor: Tony Wood

A monthly magazine dedicated to all aspects of darts and topics that have dart themes. Articles run 700–1,500 words. Photos are primarily black and white. Payment: £40–£50 per 1,000 words; negotiated for images. Query or send complete manuscript.

Day by Day
Woolacombe House
141 Woolacombe Road
Blackheath
London SE3 8QP
United Kingdom
Tel. 44-181-856-6249
Editor: Patrick Richards

This monthly focuses on general-interest, nonviolent topics. News and features are used. Some of the more common subjects covered include book, film, and art reviews; theater—from fast-paced musicals to opera; sports; and even an occasional poem or short story. Since this is a literary publication, there are no images. Payment: £20 per 1,000 words.

Dental Update
Goerge Warman Publications Ltd.
20 Leas Road
Guildford, Surrey GU1 4QT
United Kingdom
Tel. 44-1483-304-944
Fax 44-1483-303-191
Editor: Susan Joyce

This ten-issue-per-year publication uses features on clinical innovations, techniques, equipment, new developments, and news items that relate to dentistry. Length: 250–2,500 words. Photos should be color. Payment: £50–£100 per 1,000 words; £50 for cover photo.

Dirt Bike Rider
Key Publishing Ltd.
P.O. Box 100
Stamford, Lincs PE9 1XQ
United Kingdom
Tel. 44-1780-55131
Fax 44-1780-57261
Editor: Roddy Brooks

Dirt bike topics from the United Kingdom and around the world are covered in this monthly, including personality features, track tests, new equipment, motorcycles, and trends. Length: 200–1,000 words. Images can be color or black and white. Payment: £80 per 1,000 words; photo rates are negotiated.

Disability News
12 Park Crescent
London W1N 4EQ
United Kingdom
Tel. 44-171-636-5020
Fax 44-171-436-4582
Editor: Mary Wilkinson

Since 1957, this monthly magazine has published authoritative stories of interest to disabled individuals. Most features are general interest, such as arts, book reviews, personality profiles, and travel, but there are also news topics. The editor desires a query first. Most articles run no more than 1,000 words and bring £85. Illustrations, which are both color and black and white, are paid for according to size used.

Diver
55 High Street
Teddington
Middlesex TW11 8HA
United Kingdom

Tel. 44-181-943-4288
Fax 44-181-943-4312
Editor: Nigel Eaton

One of England's oldest monthly magazines dedicated to the sport of subaqua diving, *Diver* uses travel, underwater developments, equipment, and personality profiles. Length: 1,500–2,500 words. Color and black-and-white photographs are used. Payment: negotiated based on the topic and length.

Doctor

Reed Healthcare
Quadrant House
The Quadrant
Sutton, Surrey SM2 5AS
United Kingdom
Tel. 44-181-652-8740
Fax 44-181-652-8701
Editor: Helena Sturridge

All articles published in this weekly are commissioned, so send queries. Authoritative features of interest to general practitioners on research, medical development, treatments, pharmaceuticals, and medical news are used. Length: 250–3,000 words. Illustrations are in color and black and white. Payment: negotiated for both articles and photos, but in line with National Union of Journalists rates.

Early Music

Oxford University Press
3 Park Road
London NW1 6XN
United Kingdom
Tel. 44-171-724-1707
Fax 44-171-723-5033
E-mail *jnl.early-music@oup.co.uk*
Editor: Tess Knighton

For more than twenty-five years, this quarterly has explored the developments of music throughout history. Most articles are scholarly in nature, as well as informative. The editor likes writers who can stay within these guidelines, while making their articles entertaining and lively. Length: varies with topic. Photos: color and black and white. Payments: £20 per 1,000 words; photos are paid for based on usage.

Eastern Eye

Eastern Eye Publications Ltd.
138–148 Cambridge Heath Road
London E1 5QJ
United Kingdom
Tel. 44-171-702-8012

Fax 44-171-702-7937
Editor: Sarwar Ahmed

A weekly publication targeting the young—sixteen through thirty-six—Asian market. Anything of interest to this market will be considered. Both features and news items are used. Maximum length: 1,800 words. Both color and black-and-white photos are used. Payment: £80 per 1,000 words; photos are £10 each.

Electrical Times
Reed Business Publishing
Quadrant House
The Quadrant
Sutton, Surrey SM2 5AS
United Kingdom
Tel. 44-181-652-3115
Fax 44-181-652-8972
Editor: Steve Hobson

This monthly magazine has been published for more than one hundred years. Targeted at professionals in the electronics industry, such as contractors and builders, features cover both business and technical aspects. Average length is 750 words. Color and black-and-white images are used. Payment: £150 per articles; photo rates negotiated based on usage.

Emirates Woman
Motivate Publishing
P.O. Box 2331
Dubai, United Arab Emirates
Tel. 97-1-824-060
Fax 97-1-824-436
Editor: Else Powell

Published for influential women, this monthly covers travel, housekeeping, gardening, motherhood, health, fashions, etc. Payment is based on the length and topic of the articles. Photos bring additional fees.

Empire
Mappin House
4 Winsley Street
London W1N 7AR
United Kingdom
Tel. 44-171-436-1515
Fax 44-171-312-8249
Editor: Mark Salisbury

Dedicated to the film and video market, *Empire* is published monthly. Film personalities, features, news, and reviews are used. Length: 400–2,000 words. Photos: color and black and white. Payment: £125 per 1,000 words; photo fees are based on published size.

The Engineer
30 Calderwood Street
London SE18 6QH
United Kingdom
Tel. 44-181-855-7777
Fax 44-181-316-3040
Editor: Adèle Kimber

> If you can produce articles or news items related to business and technical aspects of the engineering industry, this may be a market for you. Profiles of engineers, reviews of projects, techniques, and new developments are covered. Length: 200 words for short news; 1,000 for features. Photos: color slides or prints. Payment: £150 per page; £50 per photo.

English Garden
4 The Courtyard
Denmark Street
Workingham, Berkshire RG40 2AZ
United Kingdom
Tel. 44-1734-771677
Editor: Vanessa Berridge

> This is a good market for photographers that can offer short text/photo-essays. Published monthly and distributed in both the United Kingdom and the United States, *English Garden* focuses on just that—how to create, cultivate, and maintain beautiful gardens with a British flair. One writer reported rates of £25 per 1,000 words.

Euromoney
Nestor House
Playhouse Yard
London EC4V 5EX
United Kingdom
Tel. 44-171-779-8888
Fax 44-171-779-8641
Editor: Garry Evans

> A monthly publication, printed in full color, that covers general-interest features on finance, capital investments, and banking matters in Europe. Profiles are also used. Length: 1,000–6,000 words. Photos: color slides. Payment: £250 per 1,000 words; £50 per photo.

The European
200 Gray's Inn Road
London WC1X 8NE
United Kingdom
Tel. 44-171-418-7777
Fax 44-171-713-1840

E-mail *editor@the-european.com*
Editor: Charles Garside
Magazine Executive Editor: Susan Douglas
A weekly that covers news, politics, sports, and current affairs of Europe. Arts, leisure, literature, and entertainment—including travel—are also used. Printed in full color. Features run 1,000 words. Payment is coordinated with the editor. The *European MagAzine: "The A–Z of Europe"* is distributed in the newspaper and edited by Andrew Harvey. Art, fashion, leisure, health, technology, and travel are covered. Listings of European events also appear in a regular column. Articles run 600–1,000 words.

European Bookseller
15 Micawber Street
London N1 7TB
United Kingdom
Tel. 44-171-336-6650
Fax 44-171-336-6640
Editor: Marc Beishon
A bimonthly magazine, published since 1990, for the European book industry. Features and news items are used, including book and publisher reviews. Length: 200–2,000 words. Photos: black and white. Payment: £100 per 1,000 words; photos paid according to published use.

European Chemical News
Reed Business Publishing
Quadrant House
The Quadrant
Sutton, Surrey SM2 5AS
United Kingdom
Tel. 44-181-652-3187
Fax 44-181-652-3375
Editor: John Baker
This is a business weekly for those seeking to invest in the chemical markets. Most articles focus on companies, markets, investments, and news of the industry. Length: 400 words for news items; 1,000–2,000 for features. Photos: black and white. Payment: £120–£150 per 1,000 words; photos by arrangement.

European Drink Buyer
Crier Publications
Arctic House
Rye Lane
Dunton Green
Sevenoaks, Kent TN14 5HB
United Kingdom

Tel. 44-1732-451515

Fax 44-1732-451383

Editor: Heather Buckle

Bimonthly, giveaway publication covering all aspects of the beverage industry, including business, marketing, retail, trends, labeling, and duty-free sales. The editor requires queries, but says she is interested in overseas (i.e., outside the United Kingdom) writers. Profiles, interviews, and essays are also wanted. Length: news items run 150–500 words, while features run 1,000–2,000 words. Photos: color and black and white. Payment: £80 per 1,000 words; photo payments negotiated.

European Frozen Food Buyer

Crier Publications

Arctic House

Rye Lane

Dunton Green

Sevenoaks, Kent TN14 5HB

United Kingdom

Tel. 44-1732-451515

Fax 44-1732-451383

Editor: Alwyn Brice

Free bimonthly magazine using news items and features of interest to Europeans working in the frozen food industry. All aspects—from packaging and marketing to hygiene and consumption. Length: 100–500 words for news items, 1,000–2,000 for features. Photos: color and black and white. Payment: £80 per 1,000 words; photos negotiated. Query first.

European Information Network

Pizenska 181

150 000 Prague 5

Czech Republic

E-mail *deirdre@ein.cz*

Editor: Deirdre Brennan

This English-language daily newspaper needs travel features of Eastern Europe: Czech Republic, Poland, Hungary, Slovakia, and Slovenia. Length: 700–1,500 words. Payment (in U.S. dollars): $50 for articles and $20 for photos. Fees vary for other categories of writing.

Evening Courier

P.O. Box 19

King Cross Street

Halifax HX1 2SF

United Kingdom

Tel. 44-1422-365711

Fax 44-1422-330021

Editor: Edward Riley

Published Monday through Saturday, the *Evening Courier* covers local, natural, and world news. Outside articles normally offer background to current news or local interest. Length: 100–500 words. Illustrations: black-and-white prints. Payment: £25–£40 per article; photo fees are based on size used.

Evening Gazette (Teesside)
North Eastern Evening Gazette Ltd.
Borough Road
Middlesbrough TS1 2AZ
United Kingdom
Tel. 44-1642-245401
Fax 44-1642-232014
Editor: Ranald Allan

A weekly newspaper (with the exception of Sunday), the *Evening Gazette* runs news as well as current-interest personality profiles, features, and lifestyle. Length: 600–800 words. Photos: color and black-and-white. Payment: £50 per 1,000 words; photo fees based on size used.

Eventing
IPC Magazines Ltd.
Room 2105
King's Reach Tower
Stamford Street
London SE1 9LS
United Kingdom
Tel. 44-171-261-5388
Fax 44-171-261-5429
Editor: Kate Green

This monthly uses news, features, reviews, and essays dealing with the sport of trial horses. Query first. Length: up to 1,500 words. Photos: color and black and white. Payment is negotiated for articles while images bring £30–£45.

Everyday Practical Electronics
Wimborne Publishing Ltd.
Allen House
East Borough
Wimborne, Dorset BH21 1PF
United Kingdom
Tel. 44-1202-881749
Fax 44-1202-841692
Editor: Mike Kenward

Read by student and amateur electronic enthusiasts, this monthly offers practical and theoretical articles of 1,000–5,000 words. Most illustrations are line drawings. Payment: £55–£90 per 1,000 words.

Everywoman
9 St. Albans Place
London N1 0NX
United Kingdom
Tel. 44-171-359-5496
Editor: Lorna Russell
Monthly publication for women and the feminist movements around the world. News, features, profiles, and campaigns organized by feminists are covered. The editor says "no short stories." Women in business are also highlighted. Length: 1,000–2,500 words. Photos: black and white. Payment: £50 per 1,000 words; photos according to use.

Executive PA
Hobsons Publishing
Bateman Street
Cambridge CB2 1LZ
United Kingdom
Tel. 44-1223-354551
Fax 44-1223-322850
Editor: Jean Postle
A free quarterly magazine for secretaries. Covers personalities, business methods, equipment, and current issues. Length: 700–1400 words. Photos: color. Payment: £110 per 1,000 words; photo rates are negotiated.

Executive Woman
Saleworld Ltd.
2 Chantry Place
Horrow, Middlesex HA3 6NY
United Kingdom
Tel. 44-181-420-1210
Fax 44-181-420-1691
Editor: Angela Giveon
Published bimonthly, *Executive Woman* uses news and features on successful working women around the world. Profiles—both personality and business—and in-depth business management articles are especially welcome. Length: 500–100 words. Photos: color and black and white. Payment: £150 for 1,000 words; £50–£100 for photos.

The Face
Exmouth House
Pine Street
London EC1R 0JL
United Kingdom
Tel. 44-171-837-7270
Fax 44-171-837-3906

Editor: Adam Higginblade

Music, fashion, movies, celebrities, and popular culture for youth are the themes most often selected for this monthly. The editor advises that this is not just another teen magazine and you should study the magazine's style before sending a query. Length: 700–2,000 words. Photos: color. Payment: £150 per 1,000 words; photos bring £120 per page.

Fair Lady
National Magazines
P.O. Box 1802
Cape Town 8,000
South Africa
Tel 27-21-406-2204
Editor: Roz Wrottesley

South Africa's top publication for women, using features on beauty, fashion, health, travel, humor, celebrities, and interviews of prominent women. Length: up to 2,000 words. Short stories, up to 3,000 words, are also used. Photos are purchased as part of the text package. All payments are negotiated.

Family Law
21 St. Thomas Street
Bristol BS1 6JS
United Kingdom
Tel. 44-117-923-0600
Fax 44-117-925-0486
Editor: Elizabeth Walsh

Articles deal with all aspects of family law, written with a legal point of view, but also taking into consideration social and cultural aspects. Length: 1,000 words and up. Payment: £15 per 1,000 words. No photos. Query first.

Family Tree
61 Great Whyte
Ramsey, Huntington
Cambridgeshire PE17 1HL
United Kingdom
Tel. 44-1487-814050
Editor: Michael Armstrong

Published monthly, *Family Tree* uses articles on genealogically related subjects, including research, tips, and studies. Length: 700–2,000 words. Photos: color and black and white. Payment: £20 per 1,000 words; photos paid according to size used.

Far East Traveler
Phoenix Building, 5F
1-4-3 Azabudai, Minato-ku

Tokyo 106, Japan
Tel. 81-3-557-09703
Fax 81-3-557-09704
Editor: Mike Pokrovshy
Far East Traveler is distributed to hotels in the Asia-Pacific region. A slick, full-color monthly covering travel in the Far East, as well as lifestyle and general interest. Photos are very important. Payment is 25¢ per word, upon publication.

Femina
Associated Magazines
Box 3647
Cape Town 8000
South Africa
Tel. 27-21-462-3070
E-mail *femina@iafrica.com*
Editor: Melinda Shaw
Published for young, married women, *Femina* uses some fiction, humor, personalities, true-life drama, innovations in medicine, and science. As with many foreign publications, rates are negotiated with the writer/photographer. Color slides are used with articles.

Financial Director
VNU Business Publications
VNU House
32-34 Broadwick Street
London W1A 2HG
United Kingdom
Tel. 44-171-316-9000
Fax 44-171-316-9250
Editor: Richard Shackleton
Articles on financial management, development, and strategies are published in the monthly magazine, distributed free to financial directors. International topics that influence the decisions of these individuals are also desired. Length: 1,500–2,000 words. Photos: color and black and white. Payment: £150 per 1,000 words; £250–£300 for photos.

FlyPast
Key Publishing Ltd.
P.O. Box 100
Stamford, Lincs PE9 1XQ
United Kingdom
Tel. 44-1780-55131
Fax 44-1780-57261
Editor: Ken Delve

The history of aviation, personal accounts on flying, museums, and airplane collections around the globe are used in this monthly magazine. Length: up to 3,000 words. Photos: color and black and white. Payment: £50 per 1,000 words; £25 for color photos, £10 for black and white.

Focus
Gruner + Jahr U.K.
197 March Wall
London E14 9SG
United Kingdom
Tel. 44-171-519-5500
Deputy Editor: John Westlake

Subtitled "Technology, Life, and Outrageous Science," this monthly carries lots and lots of articles—of all lengths—and photos. A recent issue contained: "Men and Hormones," "Twenty-Four Hours with Top Gun Pilots," "Fast Driving Cars," "UFOs in the U.K.," "The Secrets of Psychogeography," "NASA's Vision of the Future,"an interview with Terry Pratchett, and about one hundred short news items on medicine, computers, animals, space, sports, etc. When proposing articles for this publication, think of a more tabloid version of *Newsweek* and *Life* combined. Photo features are used and articles are highly illustrated. The editor prefers to negotiate rates with writers and photographers rather than to reveal any fixed fees.

For Women
Portland Publishing Ltd.
4 Selsdon Way
London E14 9GL
United Kingdom
Tel. 44-171-538-8969
Fax 44-171-538-3690
Editor: Ruth Corbett

A general-interest, monthly publication covering issues of interest to women. Most features have erotic content and focus on sex, beauty, fitness, health, relationships, and personality profiles/interviews. Some fiction—erotic—is also used. Queries are desired. Length: 1,500–2,000 words. Photos: color. Payment: £150 per 1,000 words; £150 per photo.

Fore!
EMAP Pursuit Publishing Ltd.
Bretton Court, Bretton
Peterborough PE3 8DZ
United Kingdom
Tel. 44-1733-264666
Fax 44-1733-267198
Editor: Paul Hamblin

While being a golf magazine, this monthly does not use traditional features. Most articles are offbeat and sometimes even irate and thought provoking. Length: 1,000 words max. Photos: color. Payment: £100 for 1,000 words; photos paid according to printed size.

Foreign Service
CRU Publications Ltd.
58 Theobalds Road
London WC1X 8SF
United Kingdom
Tel. 44-171-405-4874/4903
Fax 44-171-831-0667
E-mail *mcockle@cruint.tcom.co.uk*
Editor in Chief: Mark Cockle
This quarterly, recently taken over by CRU Publications, deals with and is distributed to the Foreign Service market. A recent issue included: the Vatican City's diplomatic policy, hazards of being in the diplomatic corps, the United Nation's efforts to increase trade, NATO expansion, and two profiles of diplomats. According to Cockle, "The features are around 1,200 words and we pay £200 per thousand words."

Forte Magazine
Highbury House Communications
The Publishing House
1-3 Highbury Station Road
London N1 1SE
United Kingdom
Editor: Penny Hosie
Published for the Forte hotel chain (U.K.), this full-color quarterly is heavy on travel, business, celebrities, luxury, art and entertainment, cuisine, sports, fashion, and beauty. A recent issue featured actor Antonio Banderas, New Orleans and Mauritius. Features run up to 2,000 words, shorter items of 800–1,000 words are used in many column departments. Photos are required with articles. Query first. Payment is negotiated with writer/photographer prior to giving assignment.

Fourth World Review
Fourth World Educational Research Association Trust
24 Abercorn Place
London NW8 9XP
United Kingdom
Tel. 44-171-286-4366
Fax 44-171-286-2186
Editor: John Papworth
Focusing on small world societies, this bimonthly's focus is on politics—but not parties—and economics. The key factor here is "small," whether it be a nation or

community. Length: 3,000–5,000 words. Photos: black and white. Payment: £10 per page; £25 for images.

FRANCE Magazine
FRANCE Magazine Ltd.
France House, The Square
Stow-on-the-Wold
Glos. GL54 1BN
United Kingdom
Tel. 44-1451-831398
Fax 44-1451-830869
E-mail *francemag@btinternet.com*
Editor: Jon Stackpool

This quarterly looks at all aspects of France and French living. All features must be well researched, informative, and entertaining. Travel, cooking, history, architecture, and travelogs have all been common themes. Length: 800–2,500 words. Photos: color. Payment: £100 per 1,000 words; £50 per page for photos.

Freelance Market News
Sevendale House
7 Dale Street
Manchester M29 7WL
United Kingdom
Tel. 44-161-228-2362
Fax 44-161-228-3533
Editor: Angela Cox

Tips and advice for writers looking to sell their articles. Short pieces on special markets and news items are also used. Length: 200–700 words. Payment is 2.5 pence per word.

Freelance Writing and Photography
Clarendon Court
Over Wallop, Stockbridge
Hants SO20 8HU
United Kingdom
Tel./Fax 44-1264-782298
Editor: Paul King

Covers all aspects for freelancing: advice, how-to, and marketing. Length: 500–1,200 words. All payments negotiated upon assignment. Query first.

The Garden
Apex House
Oundle Road
Peterborough PE2 9NP

United Kingdom
Tel. 44-1733-898100
Fax 44-1733-890657
Editor: Ian Hodgson
This is the monthly publication of the Royal Horticultural Society. Research, news, and well-researched features on horticulture and botanical subjects are used. Length: 1,200–2,500 words. Photos: color slides. Payment: £120 per 1,000 words; photo fees are determined according to printed use.

Garuda
Aerospace Communications Pte Ltd.
15 Beach Road, #03-06
Singapore 189677
Tel. 65-334-3687
Fax 65-334-8154
Editor/Publisher: Gerald Dick
Art Director: James Poh
This in-flight magazine of Garuda Indonesia Airlines is published in slick, full color and uses highly illustrated features. Business, entertainment, travel, general interest, personalities, and the arts are all covered. Article lengths run 500–2,000 words. Photos: color transparencies. Payment is arranged according to subject and illustrations. Query first.

Geo Australia
Geo Productions Pty Ltd.
P.O. Box 1390
Chatswood NSW 2057
Australia
Tel. 61-2-411-1766
Fax 61-2-413-2689
Editor: Michael Hohensee
Animals, adventure, cultures, unique lifestyles, environmental issues, and natural history make up the core of editorial in this slick, bimonthly publication. The geographical region covered includes Australia, New Zealand, the Pacific, and Southeast Asia. Articles run 1,500–3,000 words. Photos are color transparencies. Payment: $600–$1,500 for text/photo packages; individual submissions of text and/or images will be negotiated with freelancer prior to acceptance.

Geographical Magazine
Campion Interactive Publishing Ltd.
Carriage Row
203 Eversholt Street
London NW1 1BW
United Kingdom

Tel. 44-171-391-8833
Fax 44-171-391-8835
Editor: Lisa Sykes

Published monthly for the Royal Geographic Society, this colorful magazine considers anything that fits into or is related to the "geographic" theme: earth sciences, research, exploration, and cultures. Query first. Length: 1,500 words. Photos: color. Payment: £150 per 1,000 words; photo rates are negotiated.

Germany Inc.
Healy Communications Services GmbH
Postfach 14 14
65404 Russelsheim
Germany
Tel. 49-61-428-1850
Fax 49-61-428-18531
E-mail *Healy@t-online.de*
Web site *www.agbc.com*
Editor: Charles D. Cole, Jr.

This monthly publication of the American-German Business Club covers issues in the following categories: business, government, technology, sports, and lifestyle. Articles average 1,000–2,000 words and carry color illustrations. There are also short "Local Focus" pieces of 200–400 words, covering major cities in Germany. All articles should have an American-German business angle. Freelance rates were not provided.

Gibbons Stamp Monthly
Stanley Gibbons Ltd.
5 Parkside
Ringwood
Hants BH24 3SH
United Kingdom
Tel. 44-1425-472363
Fax 44-1425-470247
Editor: Hugh Jefferies

Published each month for British philatelists, all articles should cover some aspect of this field, whether it be local or global. Query desired. Length: 500–2,500. Photos: color. Payment: rates begin at £25 per page; photo fees are based on usage.

Go Magazine
Times Periodicals Pte Ltd.
422 Thomson Road
Singapore 1129
Tel. 65-2-55-0011
Fax 65-2-56-8016

Editor: Sandra Campbell

For nearly twenty years this monthly magazine has been produced for women eighteen to twenty-eight years old. Topics cover fashion, beauty, and lifestyle. Articles run 500–1,600 words. Color photography is used. Payment is negotiated upon assignment. Query first.

Going Places Doing Things
Via Sicilia 24
00183 Rome, Italy
Tel. 39-06-482-1798
Fax 39-06-481-7424
Publisher/Editor: Madeline Grimoldi

A good reprint market for articles dealing with Italy. Grimoldi says that she seeks articles of 500–1,500 words related to Italian travel, culture, cuisine, and personalities. Payment: $35. Send complete manuscripts or clips.

Golden Falcon and FALCONLink
Promoseven Holdings E.C.
609 City Centre, Government Avenue
P.O. Box 5989
Manama, Bahrain
Tel. 97-3-250148
Fax 97-3-271451 or 97-3-211457
E-mail *fp7pub@batelco.com.bh.*
Editor: Maeve Kelynack Skinner

These monthly in-flight magazines for Gulf Air are all-color, 104 pages, and split between Arabic and English. Editorial content covers art, business, gardening, fashion, science, sports, technology, and travel. "While we look at European, American, and Far Eastern subjects," says (former editor) Roberta Collier-Wright, "we are particularly keen to receive material concerning the Gulf region (Abu Dhabi, Al Ain, Bahrain, Dhahran, Doha, Dubai, Fujairah, Jeddah, Kuwait, Muscat, Ras al Khaimah, Riyadh, Salalah, and Sharjah). All major Middle Eastern and African cities are serviced by Gulf Air, as are Asian, Far Eastern, and European capitals. In North America: Houston and New York. In Australia: Melbourne and Sydney. Query first. Article length: 800–1,200 words. It also runs one-page stories of 400–600 words. Payment (in U.S. dollars) is $250–$500 for a text/photo package, $150 for short items.

Goldlife for 50-Forward
First Floor, 5 Charterhouse Buildings
Coswell Road
London EC1M 7AN
United Kingdom
Tel. 44-171-251-5489
Fax 44-171-251-5490

Editor: N. Parmer

Readers of this bimonthly are over fifty years old, with interest in travel, social issues, general-interest features, and celebrity profiles. Length: 700–1,000 words. Photos: color slides. Payment: £150 for 1,000 words; £20 for photos.

Golf Monthly

IPC Magazines Ltd.

King's Reach Tower

Stamford Street

London SE1 9LS

United Kingdom

Tel. 44-171-261-7237

Fax 44-171-261-7240

Editor: Colin Callander

The editor looks for both domestic (U.K.) and international features on the game of golf and topics of interest to golfers, including travel. Articles run 1,500 words and bring about £350. Color photos are requested and are paid for according to use.

The Good Society Review

Holman's Press

Elm Lodge

Anstruther

Fife KY10 3HQ

United Kingdom

Tel. 44-1333-310313

Editor: Masry MacGregor

Covering the arts, environment, and social issues, the editor desires ideas that take a look at not only what's happening today, but what is to come in the next decade. Style is primarily documentary, with a touch of creativity. Length: 500–1,000 words. Photos are rarely used. Payment: £17 for 1,000 words.

Guiding

17–19 Buckingham Palace Road

London SW1W 0PT

United Kingdom

Tel. 44-171-834-6242

Fax 44-171-828-8317

Editor: Nora Warner

If you are not familiar with the Guide Association and its work, do some research before sending ideas to the editor of this monthly. It covers Guide Association activities, particularly youth work. The editor says that activities for children—crafts, games, outdoor recreation—are desired. Length: 200–1,200 words. Photos: color and black and white. Payment: £70 for 1,000 words; £100 for full-page, color image, £60 for black and white.

Guns Australia
Yaffa Publishing Group Pty Ltd.
17–21 Bellevue Street
Surry Hills NSW 2010
Australia
Tel. 61-2-281-2333
Fax 61-2-281-2750
Editor: Ray Galea
 A bimonthly magazine using both color and black-and-white photography. *Guns Australia*'s editor wants features and short items on technical aspects of guns, personalities, new equipment, competitions, and legislation. Maximum length: 2,000 words. Payment: $50 per page.

Hairflair
Hair and Beauty Ltd.
Fourth Floor, 27 Maddox Street
London W1R 9LE
United Kingdom
Tel. 44-171-493-1081
Fax 44-171-499-6686
Editor: Hellena Barnes
 With a readership ranging from sixteen to forty years of age, *Hairflair* covers beauty, fashion, makeup, and, of course, hair and all related topics. Length: 700–1,000 words. Photos: color and black and white. Payment: £100–£120 per 1,000 words; photo prices are negotiated. Query first.

Healthy Eating
Spendlove Centre
Charbury
Oxfordshire OX7 3PQ
United Kingdom
Tel. 44-1608-811266
Fax 44-1608-811380
Editor: Jane Last
 Bimonthly publication focusing on health, nutrition, food, exercise, and stores that cater to the health-conscious individual. Length: 1,000–1,200 words. Photos: color. Payment: £150–£250 per article; £25–£80 for photos.

Her World
Berita Publishing Sdn Bhd.
22 Jalan Liku
59100 Kuala Lumpur
Selangor, Malaysia
Address all queries to the managing editor.

A monthly English-language publication for Malaysian women covering fashion, health, beauty, home, and family. Articles run 700–1,500 words. Payment information and other details are available upon request.

Heritage
Bulldog Magazines Ltd.
4 The Courtyard
Denmark Street
Wokingham, Berks RG40 2AZ
United Kingdom
Tel. 44-1734-771677
Fax 44-1734-772903
Editor: Siân Ellis

Historical Britain is the theme and geographical area of this bimonthly. The editor wants features on cities, towns, villages, people, crafts, cultures, and related topics. Length: 1,200 words. Photos: color slides. Payment: £1 per word; photo fees are based on usage.

High Life
Premier Magazines Ltd.
Haymarket House
1 Oxendon Street
London SW1Y 4EE
United Kingdom
Tel. 44-171-925-2544
Fax 44-171-839-4491
E-mail *high_life@premiermags.co.uk*
Deputy Editor: Caroline Cook

The official in-flight magazine of British Airways (BA) uses features (1,500–2,500 words) on travel, sports, interviews, fashion, business, entertainment, and science. Color transparencies are used with all features. Payment is negotiated with the writer, but reportedly very good ($500–$1,000 range). Query first. Keep in mind that all articles and photos should deal with topics and areas along BA's flight routes. Recent articles covered Calcutta, Bali, Beirut, Warsaw, scuba diving, Monaco's Grimaldi dynasty, contemporary music, art exhibits in Europe, and Alaska.

Holiday
RCI Europe, Publications Department
Kettering Parkway, Kettering
Northants NN15 6EY
United Kingdom
Tel. 44-1536-314270
Fax 44-1536-414682
Editor: Judi Everitt

The official publication of time-share owners and Resort Condominium International (RCI) members in England, *Holiday* uses a lot of travel pieces from around the world. A first-person approach is preferred for articles, which run 800–1,500 words in length. There is also a short freelance column called "In My Own Time," which runs 600 words and covers one's experience with owning a time-share. Photos are also desired with features. Payments run £50 for short items and proportionally upward for longer articles. Photographs are paid for separately—color slides only.

Home and Family
The Mothers' Union
The Mary Sumner House
24 Tufton Street
London SW1P 3RB
United Kingdom
Tel. 44-171-222-5533
Fax 44-171-222-1591
Editor: Margaret Duggan

Most articles used in this quarterly are Christian related, with family themes. Length: 1,000 words. Photos: color and black and white. Payment: £50–£80 for 1,000 words; photo prices are determined according to use.

Home and Life
Crusader House
145-147 St. John Street
London EC1V 4QJ
United Kingdom
Tel. 44-171-490-7997
Fax 44-171-490-7272
Editor: Maggie Goodman

This relatively new monthly published by XL Communications Ltd. is unique not only for its editorial content, but for its distribution. It is only available from milkmen that bring door-to-door products to British homes each morning. Standard features include cooking, home and gardens, fashion, beauty, fitness, health, interviews with noted personalities, and travel. Short stories (1,000–1,500 words) are also used. Rates were not revealed.

HomeFlair Magazine
Hamerville Magazines Ltd.
Regal House
Regal Way, Watford
Herts WD2 4YJ
United Kingdom
Tel. 44-1923-237799
Fax 44-1923-246901

Editor: Dawn Leahey

Home improvements, designs, new products, and tips on enhancing the home are all covered in this monthly. The editor advises that you query first, with clips. Length: 700–1,500 words. Photos: color slides. Payment: £120 per 1,000 words; photo fees based on usage.

House and Leisure
P.O. Box 12155
Mill Street
Cape Town 8010
South Africa
Tel. 27-21-462-3070
Fax 27-21-461-2521
E-mail *hleisure@iafrica.com*
Editor: Sumien Brink
Administration Assistant: Gillian Priem

This slick monthly publication focuses on decor, gardening, food, and travel. Articles average 800 words. Payment is in South African rands, at R1 per word. Photos are paid for separately, depending on the subject and package. Queries go to the editor either by e-mail, fax, or post.

House Beautiful
National Magazine House
72 Broadwick Street
London W1V 2BP
United Kingdom
Tel. 44-171-439-5500
Fax 44-171-439-5595
Editor: Caroline Atkings

Features on home improvement for contemporary owners in addition to well-illustrated how-to articles. Articles run 500–1,500 words. Reported payments: £125 per 1,000 words.

Illustrated London News
20 Upper Ground
London SE1 9PF
United Kingdom
Tel. 44-171-805-5555
Fax 44-171-805-5911
Managing Editor: Rosemary Duffy

Begun in 1842, this all-color publication deals primarily with London and U.K. travel, personalities, art, entertainment, and leisure activities. There is also a special Christmas edition. A recent issue included features and photos on summer travel, Erica Jong, sailing, horses, the Tate Gallery, and parks of the future. Rates are approximately £150 per article-photo package (1,000–1,500 words).

Index on Censorship
Lancaster House
33 Islington High Street
London N1 9LH
United Kingdom
Tel. 44-171-278-2313
Fax 44-171-278-1878
Editor: Ursula Owens
Anything dealing with censorship and freedom of speech is a potential article for this bimonthly publication. Length: 500–2,500 words. Photos: black and white. Payment: £60 per 1,000 words; £20 for photos.

The Indian Express
Indian Express Newspapers (Bombay)
Express Towers, Nariman Point
Maharashtra, Bombay 400 021
India
Tel. 91-21-202-6627
Fax 91-22-202-2139 or 285-2108
Managing Editor: Vivek Goenka
This daily newspaper, published in Bombay, has a circulation of over 3 million. Breaking news, sports, general interest, and celebrities are all used. International stories with a focus on India are particularly sought. Color and black-and-white photography is used. Payments are negotiated with writers and photographers.

Informer
Buroservice snc
Via dei Tigli, 2
20020 Arese (Milano)
Italy
Tel. 39-02-287-1578
Fax 39-02-935-80280
E-mail *phylmac@compuserve.com*
Associate Editor: Phyllis Macchioni
Published ten times a year, *Informer* provides useful information for travellers as well as expats living in Italy. If it's Italian, it will work here—travel, profiles, laws, food and cuisine, humor, and photo-essays with a theme. Payment is after publication and roughly $117 per 1,000 words. Query Macchioni by e-mail.

International Herald Tribune
181 Avenue Charles-de-Gaulle
92521 Neilly-sur-Seine
France
Tel. 33-1-41-439-338
Fax 33-1-41-439-210

E-mail *iht@iht.com*
Managing Editor: Walter Wells
Deputy Managing Editors: Katherine Knorr and Charles Mitchelmore
Deputy Editors: Samuel Abt and Carl Gewirtz
Business/Finance Editor: Jonathan Gage

One of Europe's oldest English-language daily newspapers, published in Paris since 1887, the *International Herald Tribune* covers world news, politics, and sports. European arts, entertainment, literature, exhibits, and travel round out the pages. News and political coverage should go to one of the deputy managing editors, whereas topics such as travel and entertainment should be sent to one of the deputy editors. Payment varies, depending on the length and subject, but averages $150–$200.

Irish Printer
Jemma Publications Ltd.
52 Glasthule Road
Sandycove, Co.
Dublin, Ireland
Tel. 353-1-280-0000
Fax 353-1-280-1818
Editor: Frank Corr

Utilizes articles focused on the printing industry: news, technology, equipment, personalities, fairs, and paper. Length: 800–1,000 words. Color and black-and-white photography is used. Payment: £80 for 1,000 words; £30 for each photo.

Jewish Affairs
P.O. Box 87557
Houghton 2041
Johannesburg
South Africa
Tel. 27-11-486-1434
Fax 27-11-646-4940
E-mail *071JOS@muse.arts.wits.ac.za*
Editor: Prof. Joseph Sherman

A quarterly journal of scholarly essays covering all aspects of Jewish history, culture, literature, philosophy, and religion; supported by research materials and documentation. Submit complete manuscript with cover letter and short biography. Payments are negotiated with the writer for first world rights. The magazine does not accept reprints nor simultaneous submissions. Feature style is used, rather than newspaper reporting.

Kem Chick's World
Jl. Kemang Raya 3-5
Kemang
Jakarta 12730

Indonesia
Tel. 62-21-719-4531
Fax 62-21-723-0323
E-mail *76255.3012@compuserve.com*
Editor: Debe Campbell

A monthly magazine running humor, culture, and profiles that focus on Indonesia. The magazine targets expatriate residents and upper-income Indonesians. The objective is to bridge the cultural gap for foreign residents and to increase Indonesians' understanding of their foreign guests. Articles must be accurate, informative, interesting, and with the target audience in mind. Full writer's guidelines and details available on request. Length: 700–2,100 words. Color slides preferred for illustrations. Payment (in U.S. dollars) is $125 per published page. Photos: $20 per photo, $100 for cover.

Limited Edition
Oxford and County Newspapers
Osney Mead
Oxford OX2 0EJ
United Kingdom
Editor: Andrew Chatfield

A monthly insert of the *Oxford Times*, this publication uses high-quality, illustrated, general-interest features. Readership lives in the Oxfordshire region. Travel, sports, interviews, and current events are all used. Articles can run 500–1,500 words. Stories with good-quality images have a better chance of being accepted. Query first.

Mabuhay
Eastgate Publishing Corporation
Rooms 603-604, Emerald Building
Emerald Avenue, Pasig
Manila, Philippines
Tel. 63-2-631-2921/2995
Fax 63-2-631-2992
E-mail *eastgate@skyinet.net*
Editor: Marita Nuque
Editorial Assistant: Fil Elefante

The monthly in-flight magazine of Philippine Airlines (PAL) is slick, colorful, and published entirely in English. *Mabuhay* covers travel, sports, personalities, environment, and general interest. Articles should focus on PAL destinations, which include every major city in Asia, Paris, Frankfurt, London, San Francisco, Los Angeles, Honolulu, New Jersey, New York, Vancouver, Brisbane, Sydney, and Melbourne. Articles run 500–2,000 words. Photos are very important for a sale. Editorial material is handled extremely well, and payments are made immediately upon publication (same month) in the form of a Citibank check in U.S. dollars. Payment is 15¢ per word, with images bringing $35 each. Query with clips.

MAG
14a North End Road
London NW11 7PH
United Kingdom
Editor: Peter Freedman

Mag uses "intelligent but accessible articles on relevant topics," says Freedman. And what are these topics? News, listings, and features about museums, galleries, and exhibitions across the United Kingdom. Writers as well as photographers should query by letter. While there are no fixed fees or freelance guidelines, one report indicated that features run 1,000 words and bring £100.

The Mag!
Specialist Publications (U.K.) Ltd.
Clifton Heights
Triangle West, Clifton
Bristol BS8 1EJ
United Kingdom
Tel. 44-117-925-1696
Fax 44-117-925-1808
Editor: Karen Ellison

This bimonthly uses 800-word features on health, beauty, gardening, home design, and personality profiles. The *Mag!* pays £200 per article and another £200 for photos. Images are color slides. Short fiction is also purchased.

Magazines Incorporated
15-B, Temple Street
Singapore 058562
Tel. 65-323-1119
Fax 65-323-7776
E-mail *mag_inc@pacific.net.sg*
Editor: Kim Lee

This company produces four quarterly magazines covering travel, business, lifestyle, culture, art, health, and other Asian-relevant topics. Titles include *Aspiration, Elite, Gold,* and *Priority.* Features run 1,200–1,600 words and are illustrated with quality color slides. Payment for articles range from S$.25 to S$.50 per word. Images bring S$50 each. Lee says she is "looking for lively, engaging material for this series of lifestyle magazines. Most material is targeted at male-dominated readerships of professional status, with family and business concerns." First-person accounts are accepted for travel and experience articles only. "Please use subheads to break text," requests Lee. "Sidebars and boxes are desirable. Contact numbers and addresses are also desirable where applicable, e.g., information agencies for travel stories."

Mail on Sunday
Northcliffe House
2 Derry Street

London W8 5TS
United Kingdom
Tel. 44-171-938-6000
Fax 44-171-937-6721
Editor: Jonathan Holborow
 This popular weekly newspaper uses not only "news" features, but also in-depth
 articles of 700–1,500 words. Included in the Sunday edition are a variety of supple-
 ments such as *Night and Day* (general interest), *You* (women), and *Programme* (en-
 tertainment and TV). Black-and-white photos are used in the newspaper, with color
 throughout the supplements. Rates range from £25–100 per article.

Making Music
Nexus Media Ltd.
Nexus House
Azalea Drive
Swanley, Kent BR8 8HU
United Kingdom
Tel. 44-1322-660070
Fax 44-1322-667633/615636
Editor: Paul Quinn
 A monthly magazine dedicated to the technical and musical aspects of popular
 music of all kinds, from jazz and pop to rock and classic (very little of the latter).
 Length: 500–2,500 words. Photos: color slides. Payment: £90 per 1,000 words; photo
 prices are negotiated.

Management
Profile Publishing
P.O. Box 5544
Auckland
New Zealand
Tel. 64-9-358-5455
Fax 64-9-358-5462
Editor: Carrol du Chateau
 Company and manager profiles and skills and techniques that managers can incor-
 porate into their jobs are the main themes of this monthly magazine. Australian
 and New Zealand business trends are also covered. Length: 2,000 words. Color pho-
 tographs are used. Payment: 23¢ per word; photos paid according to printed size.

Management Today
176 Hammersmith Road
London W6 7JB
United Kingdom
Tel. 44-171-413-4566
Fax 44-171-413-4138
Editor: Charles Skinner

In-depth, analytic reports on companies, their managers, business techniques, and news items are used by this monthly. Lengths run 1,000 words for short, column pieces and 3,000 for features. Color photos are used. Payment: £250 per 1,000 words; photos are purchased with articles or commissioned.

Marketing Week
St. Giles House
50 Portland Street
London W1V 4AX
United Kingdom
Tel. 44-171-439-4222
Fax 44-171-439-9669
Editor: Stuart Smith

As the name suggests, this is a weekly publication geared toward those in marketing management. Profiles, analysis features, and news of marketing strategies are covered. Length: 1,000–2,000 words. Photos: color slides. Payment: £150 per 1,000 words; photo prices are negotiated.

Medal News
Token Publishing Ltd.
P.O. Box 14
Honiton, Devon EX14 9YP
United Kingdom
Tel. 44-1404-831878
Fax 44-1404-831895
Editor: Diana Birch

A unique ten-issue-a-year publication covering military medals, their history, those who receive them, and significance. Length: up to 2,000 words. Photos: black and white. Payment: £20 per 1,000 words; photos purchased with articles.

Media Partners International
Stroombaan 4
1180 Amstelveen
The Netherlands
Tel. 31-20-547-3550
Fax 31-20-643-8581
E-mail *Ken_wilkie@rotonet.rsdb.nl*
Editor in Chief: Ken Wilkie
Director: Rob Verwijk

Media Partners International is contracted by businesses to produce newsletters, magazines, videos, books, CD-ROMs, and other media. Some of its clients include KLM Royal Dutch Airlines, Amsterdam Promotion, Air UK, and the Netherlands Board of Tourism. It currently publishes forty-five magazines, of which only two are in the English language: *Holland Herald* (KLM) and the magazine for Air UK.

Length: 3,000–4,000 words; shorter front-of-the-book items run 200–300 words. Topics cover travel, personalities, business, news, and the arts. Focus is on a European readership. Payment: 40¢ per word; photo rates are negotiated.

Metropolitan Style
P.O. Box 18
Prarhan, Victoria 3181
Australia
Send queries to the managing editor.

A slick monthly magazine for men that uses a wide range of well-illustrated lifestyle features as well as world affairs and culture. Travel, sports, adventure, relationships, and fashion are a few of the popular themes. Payments begin at $A300.

Middle East International
21 Collingham Road
London SW5 0NU
United Kingdom
Tel. 44-171-373-5228
Fax 44-171-370-5956
Editor: Steve Sherman

Featuring news and articles relating to the Middle East and Arab world, this biweekly publication pays £80 per 1,000 words. Articles average 1,200–1,600 words. Photos: color and black and white. Payment for images are negotiated based on subject, quality, and use.

Mini-World
Toho Edogawabashi Bl. 7F
Sekiguchi, Bunkyo-ku
Tokyo, 112 Japan
Tel. 81-3-235-2319
Fax 81-3-235-5545
E-mail *mworld@kozo.co.jp*
Editor in Chief: Brian Maitland

Mini-World is published bimonthly and sold throughout Japan with a circulation of about 15,000. The "mission" of the magazine is to deliver topical world news, entertainment, and general interest stories in English that Japanese people can understand (based on six years of second-language English study in high school). For one-page articles, the desired length is 450 words; for two-page articles, 750 words. "We prefer you to e-mail articles," says Maitland. "If not, by fax, or as a last resort, by air mail. Along with the articles, we need color photos—prints or slides. The more photos, the better, so we have a choice." Payment (in yen) for one page is ¥15,000; two-pages, ¥20,000. Photos bring ¥2,000.

Mobile and Cellular Magazine
Nexus Media
Nexus House
Azalea Drive
Swanley, Kent BR8 8HU
United Kingdom
Tel. 44-1322-660070
Fax 44-1322-667633/615636
Editor: Paul O'Rourke
 Readers of this monthly are radio communication experts. The editor seeks techni-
cal features, as well as in-depth news, world developments in the mobile and cellu-
lar arena, legislation, company profiles, and new equipment. Length: 800–1,500
words. Photos: color and black and white. Payment: £150 for 1,000 words; photos
are purchased with articles.

Mode Australia
ACP Publishing Pty Ltd.
54 Park Street
Sydney NSW 2001
Australia
Tel. 61-2-282-8703
Fax 61-2-267-4456
Editor: Karin Upton Baker
 The primary subjects of this bimonthly are fashion, health, beauty, and personal-
ity profiles. Features run up to 3,000 words. Color and black-and-white photos are
used. Payment: $500 per 1,000 words; $150 for images.

Model Boats
Nexus Special Interests
Nexus House
Azalea Drive
Swanley, Kent BR8 8HU
United Kingdom
Tel. 44-1322-660070
Fax 44-1322-667633/615636
Editor: John L. Cundell
 This monthly focuses on plans, drawings, and features geared toward the model-
boat enthusiast. New model designs, features on collectors, shows, and industry
news are among the topics used. Length: 500–1,200 words. Photos: black and white.
Payment: £25 per page; £100 for model plans; photo rates are negotiated.

Model Engineer
Nexus Special Interests
Nexus House

Azalea Drive
Swanley, Kent BR8 8HU
United Kingdom
Tel. 44-1322-660070
Fax 44-1322-667633/615636
Editor: Ted Jolliffe

All forms of features relating to model construction are used in this magazine. From model construction and equipment to workshop methods and experimental techniques. If it deals with models in some form, it has potential sales possibilities. Length: 500–1,500 words. Photos: color and black-and-white. Payment: £35 per page for articles and photos.

Modern Boating
180 Bourke Road
Alexandria NSW 2015
Australia
Tel. 61-2-693-6666
Fax 61-2-317-4615
Editor: Mark Rothfield

The editor requires articles on all aspects of boats and boating. Waterways and personalities are also covered. Color images are used. Length: 1,000 words. Payment: $130–200 per 1,000 words; photo prices are negotiated.

Modern Painters
Fine Arts Journals Ltd.
Universal House
251-255 Tottenham Court Road
London W1P 9AD
United Kingdom
Tel. 44-171-636-6305
Fax 44-171-580-5615
Editor: Karen Wright

According to the editor of this quarterly, *Modern Painters* is dedicated to the fine arts and architecture—so don't be misled by the name. Profiles, exhibits, new art forms, and styles are all commissioned. It is therefore important for you to query first. Length: 100–2,500 words. Photos: color. Payment: £120 per 1,000 words; photos are commissioned or purchased with article.

Mojo
EMAP Metro, Mappin House
4 Winsley Street
London W1N 7AR
United Kingdom
Tel. 44-171-436-1515
Fax 44-171-637-4925

Editor: Jerry Thackray

It calls itself "the serious rock magazine" and covers news and reviews of records and books, celebrities, and live concerts. Interviews are a big part of its editorial lineup each month. Length: up to 10,000 words. Photos: color and black and white. Payment: £150 per 1,000 words; £250 per photo.

Motorcycle International
P.O. Box 10
Whitchurch, Shropshire SY13 1ZZ
United Kingdom
Tel. 44-161-948-3480
Fax 44-171-941-6897
Editor: Frank Westworth

Motorcycle trends, products, news, and travel with cycling-related themes are used by this monthly magazine. Length: 1,000–2,500 words. Photos: color slides. Payment: £1 per word; photos are purchased with article or paid according to a prenegotiated fee.

Muhibah
Public Relations Department
Royal Brunei Airlines
RBA Plaza, First Floor
Jalan Sultan, Bandar Seri Begawan
Brunei Darussalam
Tel. 67-3-2-237779
Fax 67-3-2-237778
Editor: Fong Peng Khuan

"Our focus is on the available attractions found in the cities served by Royal Brunei Airlines," explains editor Khuan. Existing destinations include Beijing, Taipei, Manila, Hong Kong, Singapore, Bangkok, Kuala Lumpur, Jakarta, Bali, Abu Dhabi, Bahrain, Dubai, Darwin, Brisbane, Perth, and Osaka. Within Borneo, the airline flies from Bandar Seri Begawan to Kuching, Miri, Labuan, Kota Kinabalu, and Balikpapan. European stories on Zurich, Frankfurt, and London are also welcomed." Articles, averaging 800–1,000 words, cover arts, lifestyle, motoring, innovations, entertainment, book reviews, cuisine, and travel. One should be aware that since Brunei is an Islamic country, mention should not be made of alcohol, religion (other than Islam), dogs, pigs, political commentary, human body parts, or women in revealing clothing. Payment is B$.50 per published word; B$90 per photos, B$200 for covers (the Brunei dollar is the same as the Singapore dollar).

Nature
Porters South
4 Crinan Street
London N1 9XW

United Kingdom
Tel. 44-171-833-4000
Fax 44-171-843-4596/4597
E-mail *nature@nature.com*
Editorial Manager: Peter Wrobel

This weekly is one of the most prestigious science magazines in Europe and the world. Contributors must have a special knowledge on the subjects they write about. Articles run 1,000–6,000 words. Payments are by arrangement with the editor and author, but have been reported to be among the best in the United Kingdom. Research and scientific discoveries are the mainstay of editorial content. For example, a recent issue covered how insects fly, simulated geomagnetic reversal, aerodynamics, blood clotting, birds, and gamma-ray astronomy.

Needlecraft
Future Publishing Ltd.
30 Monmouth Street
Bath, Avon BA1 2BW
United Kingdom
Tel. 44-1225-442244
Fax 44-1225-484896
E-mail *needlecraft@futurenet.co.uk*
Editor: Rebecca Bradshaw

Most features have a focus on stitching: techniques, designs, step-by-step patterns, and projects. An occasional personality profile is also used. Length: 1,000 words. Photos: color slides. Payment: £110 per 1,000 words; photos purchased with article or separately, and fees are negotiated with the editor.

Nelson Evening Mail
P.O. Box 244
15 Bridge Street
Nelson, New Zealand
Tel. 64-3-548-7079
Fax 64-3-546-2802
Editor: David Mitchell

All articles for this daily newspaper should have a New Zealand tie-in, whether it be personality, travel, technology, or topical news. Length can vary from 500 to 1,000 words. Payment is $1 per word. Both black-and-white and color photography purchased separately.

.net The Internet Magazine
Future Publishing Ltd.
30 Monmouth Street
Bath, Avon BA1 2BW
United Kingdom

Tel. 44-1225-442244
Fax 44-1225-423212
E-mail *netmag@futurenet.co.uk*
Editor: Richard Longhurst
The topics covered in this publication are as varied as the Internet itself. All articles, features, and news are in some way related to the Net: new Web sites, sales, design, newsgroups, software, and personalities involved in new and unique ways to use the Internet. Length: 1,000–3,000 words. Photos: color slides. Payment: £110 per 1,000 words; photos purchased with article or separately, based on prenegotiated fees.

New Beacon
224 Great Portland Street
London W1N 6AA
United Kingdom
Tel. 44-171-388-1266
Editor: Ann Lee
This monthly includes news, features, and in-depth coverage on visual impairment. Length: 500–2,000 words. Photos: black and white. Payment: £30 for 1,000 words; photo rates are negotiated.

New Christian Herald
Herald House Ltd.
96 Dominion Road
Worthing, West Sussex BN14 8JP
United Kingdom
Tel. 44-1903-821082
Fax 44-1903-821081
Send submissions to the deputy editor.
This weekly paper has a strong Christian focus. Coverage of news and current events that influence the lives of Christians, as well as profiles, contemporary culture, and changes in church philosophy are used. Length: 300–1,000 words. Photos: color and black and white. Payment: £20–£50 per story; photos are purchased with articles.

New Impact
Answer House
P.O. Box 1448
Marlow, Bucks SL7 3HD
United Kingdom
Tel./Fax 44-1628-481581
Editor: Elaine Sihera
Focused on business training, this bimonthly runs features and news on nearly every aspect of business, as long as there is a link to education in the workplace. Teaching and learning techniques, profiles, and equipment that makes the job easier and

more efficient are just some of the editorial needs. Special features on women are also used. Length: 900–1,000 words. Photos: black and white. Payment: £40 per article; photos are purchased with articles.

New Internationalist
55 Rectory Road
Oxford OX4 1BW
United Kingdom
Tel. 44-1865-728181
Fax 44-1865-793152
E-mail *newint@gn.apc.org*
Editors: Vanessa Baird and David Ransom

Each month this publication focuses on a single issue of global importance—for example, food, feminism, peace, and the environment. Length: 1,000–2,000 words. Photos: color and black and white. Payment: £110 per 1,000 words; photo rates are negotiated.

New Scientist
IPC Magazines Ltd.
King's Reach Tower
Stamford Street
London SE1 9LS
United Kingdom
Tel. 44-171-261-7301
Fax 44-171-261-6464
E-mail *edit@mail.newsci.ipc.co.uk*
Editor: Alun Anderson

In-depth, authoritative features on all aspects of modern technology and science are used in this weekly publication. The editor suggests that writers first study the magazine, then submit an initial query. Length: 1,000–3,000 words. Photos: color and black and white. Payment: £200 for 1,000 words; photo prices are negotiated, but reportedly very good.

New Truth and TV Extra
News Media Auckland Ltd.
P.O. Box 1074
Auckland
New Zealand
Tel. 64-9-302-1300
Fax 64-9-309-2279
Editor: Hedley Mortlock

In-depth reporting, exposés, and investigative stories are the mainstay of this weekly. The editor prefers images with articles. Length: 500–1,000 words. Payment: $150 per 500 words; more for images.

New Welsh Review
Chapter Arts Centre
Market Road
Cardiff CF5 1QE
United Kingdom
Tel. 44-1222-665529
Fax 44-1222-515014
Editor: Robin Reeves

A quarterly publication dealing with Welsh writing and related topics. Interviews, profiles, book reviews, poems, short stories, and features on the relationship and influence of Welsh literature on the English language are used. Length: 1,000–4,000 words. Photos: color and black and white. Payment: £7–£20 per page, based on topic; £10–£20 per photo.

New Woman (Australia)
213 Miller Street
North Sydney, NSW 2059
Australia
Tel. 61-2-9956-1000
Fax 61-2-9956-1088
Editor: Josephine Brouard

One of Australia's more popular magazines for women, this monthly runs features for the self-made, over-thirty reader. Topics cover the arts, book reviews, personalities, beauty, fashion, health, and anything upscale. Most articles and photos are commissioned. Payment: 50¢ per word; photo prices are negotiated.

New Woman (U.K.)
EMPS Élan
20 Orange Street
London WC2H 7ED
United Kingdom
Tel. 44-171-957-8383
Fax 44-171-930-7246
Editor: Eleni Kyriacou

General-interest features, interviews, fashions, and other topics appealing to contemporary women are highlighted in this monthly publication. Writers should query first with ideas and clips. Length: up to 2,000 words. Photos: color and black and white. Payment: National Writers Union rates for articles and photos.

New Zealand Farmer
NZ Rural Press Ltd.
P.O. Box 4233
300 Great South Road
Greenlane

Auckland 5
New Zealand
Tel. 64-9-520-9451
Fax 64-9-520-9459
Editor: Hugh Stringleman
All aspects of farming—livestock, cropping, machinery, marketing—are used in this quarterly magazine. The editor prefers writers with in-depth backgrounds in the farming industry, and that of New Zealand in particular. Length: 500–1,000 words. Payment: $200 for 1,000 words.

New Zealand Herald (Auckland)
P.O. Box 32
Auckland
New Zealand
Tel. 64-9-379-5050
Fax 64-9-366-1568
Editor: P. J. Scherer
Articles on current events, personalities, and issues in the news are desired for this daily newspaper. Length: 800–1,100 words. Color prints are preferred. Payment: $50–$150.

New Zealand Woman's Day
Private Bag 92512
Wellesley Street
Auckland
New Zealand
Tel. 64-9-373-5408
Fax 64-9-357-0978
Editor: Louise Wright
Tabloid-style reporting, celebrity gossip, interviews, news features, and short stories are used in this popular weekly magazine. Color transparencies are used for illustrations. Articles run approximately 1,000 words. Payment: £400 for editorial package.

19
IPC Magazines Ltd.
King's Reach Tower
Stamford Street
London SE1 9LS
United Kingdom
Tel. 44-171-261-6410
Fax 44-171-261-7634
E-mail *19@ipc.co.uk*
Editor: April Joyce

Monthly publication for young women seventeen to twenty-two years old. Articles cover fashion, beauty, music, and social and contemporary issues. Writers as well as photographers should query the editor since all articles and photos are assigned. Length and fees are negotiated.

90 Minutes
IPC Magazines Ltd.
King's Reach Tower
Stamford Street
London SE1 9LS
United Kingdom
Tel. 44-171-261-7617
Fax 44-171-261-7474
Editor: Eleanor Levy
Anyone that thought of soccer when reading the title is well on his or her way to becoming a contributor. This weekly covers matches, players, soccer news, international competitions, and interviews. Length: 50–1,500 words. Photos: color, all commissioned. Payment: £30–£100, based on length; photo fees are based on the negotiated price between photographer and editor.

North-West Evening Mail
Newspaper House
Abbey Road
Barrow-in-Furness
Cumbra LA14 5QS
United Kingdom
Tel. 44-1229-821835
Fax 44-1229-840164/832141
Editor: Donald Martin
Published daily except Sunday, the *North-West Evening Mail* is subtitled "The Voice of Furness and West Cumbra." The best opportunities for writers and photographers outside this region are general-interest features, personality profiles, and news that affects the citizens of Britain. Length: 500 words. Photos: black and white. Payment: £30 for articles; £10 for photos.

Nursing Times and Nursing Mirror
Macmillan Magazines Ltd.
Porters South
406 Crinan Street
London N1 9XW
United Kingdom
Tel. 44-171-833-4600
Fax 44-171-843-4633
Editor: Jane Salvage

Well-researched articles on the nursing profession, healthcare, education and training, policy making, and clinical interest are used in these weekly publications. Most contributors are professional or somehow linked to the international health field. Length: 500–2,000 words. Photos: color and black and white. Payment: National Union of Journalists rates for text and images. Query first.

The Observer Life Magazine
119 Farringdon Road
London EC1R 3ER
United Kingdom
Tel. 44-171-713-4175
Fax 44-171-713-4217
Editor: Michael Pilgrim
Distributed free with the *Sunday Observer* newspaper, this magazine uses features related to current news topics, interviews, and general-interest articles. Length: 2,000–3,000 words. Photos: color and black and white. Payment: National Union of Journalists rates for articles; £150 per image.

Off Duty (Europe/Pacific)
3303 Harbor Boulevard, Suite C-2
Costa Mesa, CA 92626
Tel. 714-549-7172
Fax 714-549-4222
E-mail *OffDuty@aol.com*
Editor: Gary Burch
A longtime steady market for English-language writers, *Off Duty*'s overseas offices are operating on a shoestring following the military drawdowns and base closures in recent years. While the publisher continues to produce European and Pacific editions, they get smaller each month, while all editorial coordination is now done from the Costa Mesa office. Topics cover travel, entertainment, shopping, interviews, and general interest. Jim Shaw, the editor for many, many years (I sold my very first article to him in 1977) retired in December 1996. Payment is 12¢ per word; $25 for black-and-white photos; and $50 for color photos. Query first.

OK! Weekly
Northern and Shell plc
Northern and Shell Tower
City Harbour
London E14 9GL
United Kingdom
Tel. 44-171-987-6262
Fax 44-171-515-6650
Editor: Richard Barber

A weekly tabloid with celebrity interviews, news, and exclusive photos. Query before submitting completed manuscripts. Length: 2,000 words. Photos: color slides. Payment: £250–£500 per feature; high rates negotiated for exclusive images.

Oldham Evening Chronicle
P.O. Box 47
Union Street
Oldham
Lancs OL1 1EQ
United Kingdom
Tel. 44-161-633-2121
Fax 44-161-627-0905
Editor: Philip Hirst
Published Monday through Friday, this newspaper runs both news and features on current topics in the media. Also local and general interest. Length: 1,000 words. Photos: color and black and white. Payment: £20–£25 for 1,000 words; £16–£22 per image.

The Oldie
45-46 Poland Street
London W1V 4AU
United Kingdom
Tel. 44-171-734-2225
Fax 44-171-734-2226
Editor: Richard Ingrams
Aimed at senior citizens, this magazine focuses on general-interest articles of 500–900 words. Anything from cooking and camping to profiles and travel are considered. Query first. Photos: color and black and white. Payment: £80–£100 for 1,000 words; £30 minimum for photos.

Opera Now
241 Shaftesbury Avenue
London WC2H 8EH
United Kingdom
Tel. 44-171-333-1740
Fax 44-171-333-1769
Editor: Graeme Key
A bimonthly magazine aimed at various aspects of opera including performers, news, reviews, and composers. Because all articles are commissioned, you should query first. Length: 200–1,500 words. Photos: color and black and white. Payment: £120 per 1,000 words; photos purchased with articles or by prearranged commission.

Our Dogs
Oxford Road Station Approach
Manchester M60 1SX
United Kingdom
Tel. 44-161-236-2660
Fax 44-161-236-5534
Editor: William Moores
> A weekly publication for owners and breeders of show dogs. Articles include aspects of shows, pedigrees, breeding, and related subjects. News items are 150–300 words; features up to 1,000 words. Photos: black and white. Payment: National Union of Journalists rates; photos bring £7.50 each.

Outdoor Adventure Asia Pacific
Posigen SDN BHD, Lot 2
Arcade Level, Kelag Le Chateau
32 Lorong Syed Putra Kiri
50460 Kuala Lumpur, Malaysia
Tel. 60-3-274-0000
Fax 60-3-274-9228
E-mail *azizmd@pc.jaring.my*
Managing Editor/Director: Anthony Sullivan
> A new bimonthly publication covering outdoor activities such as camping, canoeing, climbing, hiking, diving, spelunking, and anything else that falls into the "adventure" category. There is a "green" concept to the magazine so all features should be nature friendly in style. Readers are twenty to forty years old. Query, requesting writer guidelines. Rates were not provided, but the publisher does pay for articles and photos, according to Sullivan.

Outdoor Illustrated
Discovery Publications Ltd.
Studio 2, 114-116 Walcot Street
Bath BA1 5BG
United Kingdom
Tel. 44-1225-443194
Fax 44-1225-443195
Editor: Fabian Russell-Cobb
> Outdoor recreation, sports, life, travel, and activities are the theme of this bimonthly. The editor suggests that you query with your ideas first. Length: 1,000–2,000 words. Photos: color slides. Payment: £90 for 1,000 words; photos fees based on published size.

Outbound Travel
60 Martin Road
#07-33/34 Trademart Singapore
Singapore 239065

Tel. 65-344-5250
Fax 65-735-6891
E-mail *inkworks@mbox2.singnet.com.sg*
Editor: (Ms) Tan Chung Lee
Art Director: (Ms) Juriah Banding
 This travel magazine is released every two months. Anything that would interest the outbound (from Asia) traveller will fit into the publication's lineup. Photographs go to the art director, or can be included as part of a text-photo package to the editor. Features run 2,000 words. Writing should be light, not verbose. Typical photography—color transparencies—includes people, landscapes, foods, and arts and crafts. Payment: S$120 per published page for images and text. Articles bring S$.20 per word and photos alone range from S$38 to S$50.

Parents and Computers
Media House
Adlington Park
Macclesfield SK10 4NP
United Kingdom
Tel. 44-1625-878888
Fax 44-1625-850652
E-mail *pamt@idg.co.uk*
Editor: Pam Turnbull
 Advice for parents looking to get the most out of their computer for their children is the theme of this publication. Take an aspect of computing—word processing, graphics, Web pages, etc.—and "teach" parents how to introduce these to their children. Topics also cover education and children's points of view. Length: 1,000 words. Color photos are used. Payment is negotiated with the editor. Query by e-mail.

PC Direct
Ziff-Davis U.K. Ltd.
Cottons Centre
Hay's Lane
London SE1 1QT
United Kingdom
Tel. 44-171-378-6800
Fax 44-171-378-1192
Editor: Karen Packham
 News, reviews, and features on technical aspects of computers and software are found in this monthly magazine. Readers are primarily buyers looking for the latest in software and hardware. Query first, as all articles are assigned. Also, be sure the publisher only buys first U.K. rights and not world rights, as Ziff-Davis is one of the USA's largest publishers in the United States. Length: 500–6,000 words. Photos: color slides. Payment: £180 per 1,000 words; photos are paid according to use.

The Peak
C. Cheney and Associates
Twelfth Floor, Sun House
90 Connaught Road
Central Hong Kong
Tel. 90-541-91-33
Fax 90-541-70-12
Deputy Editor: Jane Steer

Published in English for an upscale Asian market, the *Peak* covers travel, fashion, cuisine, sports, and anything that is "sophisticated." Length: 1,000–2,000 words. Photos: color slides. Payment (upon publication) is between $200 and $350 for articles and $350 for 3–5 color images. This same publisher puts out *Regent* magazine, which is distributed in Regent hotels in the United States, Europe, and Asia. Areas of interest for this latter publication are similar to those of *Peak* with a wider geographical outlook. Payment is also the same.

People Magazine
54 Park Street
Sydney NSW 2000
Australia
Tel. 61-2-282-8743
Fax 61-2-267-4365
Editor: D. Naylor

The title tells it all—95 percent of the stories in this magazine are about people: celebrities, political leaders, individuals with unique jobs or stories to tell. There is no set length, but there are sections for short (200–500 words) stories and features (1,000–1,500 words). Photos are purchased individually with captions or with articles. Payment: $300 per page of text and/or photos.

Personal Computing World
VNU House
32-34 Broadwick Street
London W1A 2HG
United Kingdom
Tel. 44-171-396-9000
Fax 44-171-396-9301
E-mail *ben@compulink.co.uk*
Editor: Ben Tisdall

This magazine runs features on computers, product reviews, and new technology. Length: 800–5,000 words. Photos: color and black and white. Payment: £130 for 1,000 words; photo fees are based on printed size, but good rates reported.

Personal Finance
Charterhouse Communications Ltd.

4 Tabernacle Street
London EC2A 4LU
United Kingdom
Tel. 44-171-638-1916
Fax 44-171-638-3128
Editor: Sarah Burnett

This monthly focuses on family financial matters: savings, investments, trends, and easy-to-understand advice and news. The editor assigns all features, so query first. Length: 1,500–3,000 words. Photos: color and black and white. Payment: £150–£200 per 1,000 words; £50–£150 for photos.

Photo Answers
EMAP Apex Publications Ltd.
Apex House
Oundle Road
Peterborough PE2 9NP
United Kingdom
Tel. 44-1733-898100
Fax 44-1733-894472
Editor: Roger Payne

A general-interest monthly magazine for photographers of all levels. The editor says that most features are produced by staff writers, but photographers are welcome to submit photo-essays and quality single images that tell a story. Color and black-and-white photos are used. Payment: £25 minimum per published page.

Photo Technique
IPC Magazines Ltd.
King's Reach Tower
Stamford Street
London SE1 9LS
United Kingdom
Tel. 44-171-261-5323
Fax 44-171-261-5404
Editor: Liz Walker

This monthly publication is aimed at amateur photographers. Features on techniques, equipment, and film are used. Most articles run 700–900 words. Both prints and slides are used for illustrations. Payment: £100 per 1,000 words and £90 per full-page photo.

Pilot
The Clock House
28 Old Town, Clapham
London SW4 0LB
United Kingdom

Tel. 44-171-498-2506

Fax 44-171-498-6920

E-mail *100126.563@compuserve.com*

Editor: James Gilbert

This monthly magazine covers both private and business aviation. Most features are general interest—new planes, equipment, personalities, routes, the business of flying, and safety. Length: 1,000–3,000 words. Photos: color and black and white. Payment (made upon acceptance): £100–£800 per article; £25 per photo.

The Pink Paper

72 Holloway Road

London N7 8NZ

United Kingdom

Tel. 44-171-296-6000

Fax 44-171-296-0026

E-mail *positivetimes@postnet.co.uk*

Editor: Andrew Saxton

This weekly has a national distribution and is read by lesbians and gay men. Most features relate in some fashion to the lifestyles of these individuals. News, book and music reviews, interviews, and general-interest stories are all used. Length: 100–500 words for short items, up to 1,500 for features. Photos: color and black and white. Payment: £40–£100 for articles; £45–£75 for photos.

Planet

P.O. Box 44

Aberystwyth, Dyfed SY23 5BS

United Kingdom

Tel. 44-1970-611255

Fax 44-1970-623311

Editor: April Joyce

This six-issue-a-year publication focuses on Welsh current affairs, politics, social issues, news, personalities, and minorities around the world. Short stories and poems are also used. Length: 1,000–3,500 words. Photos: black and white. Payment: £25–£40 for articles; £5 for images.

Poetry London Newsletter

26 Clacton Road

London E17 8AR

United Kingdom

Tel. 44-181-520-6693

Fax 44-181-404-3598

E-mail *pdaniels@easynet.co.uk*

Editor: Peter Daniels

This publication focuses on the study of contemporary poetry. Articles, interviews,

reviews, and poems are used. According to the editor, only the highest quality writing is required. No limits on length. No photos used. Payment is £20 plus four copies of the publication.

Poetry Review
22 Betterton Street
London WC2H 9BU
United Kingdom
Tel. 44-171-240-4810
Fax 44-171-240-4818
Editor: Peter Forbes
This quarterly is dedicated to modern poetry. There are also reviews and features on artists, poetry style, and the teaching of poetry. The editor stresses that one must study the publication prior to submitting material. Payment: £25–£30 per published poem.

Pony
Haslemere House
Lower Street, Haslemere
Surrey GU27 2PE
United Kingdom
Tel. 44-1428-651551
Fax 44-1428-653888
Send to submissions to the editor.
Readers of this monthly are eight to sixteen years old. Features cover aspects of horses, riding, stables, and animal care. Length: 700–900 words. Color photographs are preferred. Images should contain people as well as ponies. Payment: £65 per 1,000 words; £20–£60 per color image.

Post Magazine
Timothy Benn Publishing Ltd.
58 Fleet Street
London EC4Y 1JU
United Kingdom
Tel. 44-171-353-1107
Fax 44-171-583-6069
Editor: Stephen Womack
Published weekly for insurance professionals, most articles in this publication are commissioned. It is therefore suggested that you query first. News on the international insurance industry, trends, investments, and company and personality profiles are desired. Length: 1,700–2,000 words. Photos: color and black and white. Payment: £150–£200 per 1,000 words; £30–£60 for photos.

PR Week
Haymarket Marketing Publications
174 Hammersmith Road
London W6 7JP
United Kingdom
Tel. 44-171-413-4520
Fax 44-171-413-4509
Editor: Stephen Ferish
A weekly publication for the public relations (PR) industry. Articles cover world trends, news, interviews, company profiles, strategies, and other aspects of the PR business. Length: 800–3,000. Photos: color and black and white. Payment: £170 per 1,000 words; photos purchased with article or negotiated with photographer.

Practical Caravan
60 Waldegrave Road
Teddinton
Middlesex TW11 8LG
United Kingdom
Tel. 44-181-943-5629
Editor: Rob McCabe
The editor desires human-interest stories with caravanning angles as well as consumer features and travelogs—but no typical travel. Average length is 1,200 words. Color photos are used: 35mm or larger-format transparencies. Payment: £120 per 1,000 words; extra for images.

Practical Parenting
IPC Magazines Ltd.
King's Reach Tower
Stamford Street
London SE1 9LS
United Kingdom
Tel. 44-171-261-5058
Fax 44-171-261-5366
Editor: Jayne Marsden
Articles cover child care, parenting, health, education, psychology, newborns, activities for young children, and related topics. Length: 700–2,500 words. The editor requests a detailed query letter. Photos: color slides. Payment: £100–£150 for 1,000 words; photo rates are negotiated.

Practical Photography
Apex House
Oundle Road
Peterborough PE2 9NP
United Kingdom

Tel. 44-1733-898100
Fax 44-1733-894472
Editor: Martyn Moore
 All aspects of photography—from techniques and equipment to business and environ-
mental effects—are covered. Most articles are written in-house, but the editor will
consider queries. Length: 600–1,500. Photos: color and black and white. Payment: £50
for 1,000 words; Rates start at £10 for black-and-white photos and go upward.

Practical Woodworking
Nexus House
Azalea Drive
Swanley, Kent BR8 8HU
United Kingdom
Tel. 44-1322-660070
Fax 44-1322-667633/615636
Editor: Peter Roper
 This monthly is for the professional and amateur wood craftsperson. Projects, tools,
materials, and techniques of woodworking are all covered. Length: 600–1,000 words.
Most articles are illustrated. Photos: color and black and white. Payment: £50 per
published page for text and images.

The Practitioner
30 Calderwood Street
London SE18 6QH
United Kingdom
Tel. 44-181-855-7777
Fax 44-181-855-2406
Editor: Howard Griffiths
 Published monthly for general practitioners, the topics covered include business
aspects of the medical field as well as working with trainees, new developments,
products, and techniques. Length: 200–500 words for news items; 100–2,000 for
features. Photos: color and black and white. Payment: £150 for 1,000 words; photo
rates are negotiated.

Pride
55 Battersea Bridge Road
London SW11 3AX
United Kingdom
Tel. 44-171-228-3110
Fax 44-171-228-3130
Editor: Clare Gorham
 Subtitled "The Magazine for Women of Colour," this monthly runs interviews of
prominent women from around the world. There are also regular features on fash-
ion, beauty, health, lifestyle, and the arts. Articles run 1,000–3,000 words. Payment:
£1 per word; £75 for each photo (color slides).

Prize Preview
Lead Edge Media Ltd.
Unit 31
28/29 Maxwell Road
Woodston, Peterborough
Cambridgeshire PE2 7JE
United Kingdom
Tel. 44-1733-232-261
Editor: Thomas Jones

Prize offerings to consumers is the theme of this glossy publication. Short articles listing new competitions, drawings, prizes, and winning entries are run, along with features on companies offering prizes. You may want to try international or state lotteries. Keep in mind that this is a U.K. publication and you will probably be telling readers how to enter competitions as foreigners. Lengths: 500 to 1,000 words. Rates were not revealed.

Professional Photographer
MLP Ltd.
Market Link House
Tye Green, Elsenham
Bishop's Stortford CM22 6DY
United Kingdom
Tel. 44-1279-647555
Fax 44-1279-815300
Editor: Steve Hynes

Published for the professional photographer, this monthly magazine covers techniques, equipment, profiles of top photographers, and industry news. Length: 1,000–2,000 words. Photos: color slides and black-and-white prints. Payment: for both articles and photos, £75 per page.

Property Week
The Builder Group
1 Millharbour
London E14 9RA
United Kingdom
Tel. 44-171-560-4000
Fax 44-171-560-4012
Editor: Penny Guest
Art Director: Peter Smith

A weekly news publication that covers commercial property, management, and related issues, including financial affairs. Length: 600–2,000 words. Photo-essays also wanted. Payment: £170 per 1,000 words; photos are negotiated by the art director.

Pulse
Miller Freeman Professional Ltd.
30 Calderwood Street
Woolwich
London SE18 6QH
United Kingdom
Tel. 44-181-855-7777
Fax 44-181-855-2406
Editor: Howard Griffiths
General practitioners read this weekly publication to obtain information on clinical studies, research, and developments that affect their occupation. Authors should be experts. Length: 100–750 words. Photos: color slides and black-and-white prints. Payment: £150 per article, average; photo rates according to usage.

Q Magazine
EMAP Metro
Mappin House
4 Winsley Street
London W1N 7AR
United Kingdom
Tel. 44-171-436-1515
Fax 44-171-323-0680
Editor: Andrew Collins
Glossy, full-color monthly, which covers rock music—from personalities to the charts. Query first, as all articles and photos are commissioned. Length: 1,200–2,500 words. Photos: color and black and white. Payment: £180 per 1,000 words; photos by arrangement.

Quadrant
P.O. Box 1495
Collingwood
Victoria 3066
Australia
Tel. 61-3-9417-6855
Fax 61-3-9416-2980
Editor: Robert Manne
General-interest pieces and short stories make up the core of this monthly magazine. There are also poems and art reviews. Length of articles is 2,000–5,000 words. Payment (in U.S. dollars): $90 for articles; $60 for reviews; $40 for poems; illustration fees are negotiated.

Quote Magazine
12 Wingadee Street
Lane Cove
Sydney NSW 2066
Australia
E-mail *duggo@magna.com.au*
Editor: Tim Duggan
This monthly is aimed at a young adult audience (twelve to thirty years old). The main feature is an interview with an up-and-coming young star or celebrity. The editor is also looking for columns. Send queries by e-mail or post. Payment: $A200 for interviews/features, $A150 for columns, which cover fashions, technology, and youth trends.

R&R Shopper News

Kolpingstrabe 1	Editorial office:
D-69181 Leimen	1910 Villa Road
Germany	Birmingham, MI 43009
Tel. 49-6224-70662	Tel. 248-723-9884
Fax 49-6224-70616	Fax 248-723-9966
E-mail *rrmagazine@t-online.de*	E-mail *rrcom@ameritech.net*

Editor: Marji Hess
This monthly magazine targets the U.S. military stationed in Europe. The publisher has altered the magazine's focus in recent years, becoming more like a TV guide for satellite viewing, with fewer articles. However, it still covers travel, entertainment, interviews, and sports. Articles run 600–1,200 words. The publication does accept reprinted material, as long as it has not appeared in a major consumer magazine in the United States or in a military market publication. Payment has decreased: approximately $50 for articles and $25 for photos. Query first.

RA Magazine
Royal Academy of Arts
Burlington House, Piccadilly
London W1V 0DS
United Kingdom
Tel. 44-171-494-5657
Fax 44-171-287-9023
Editor: Nick Tite
This quarterly is dedicated to the Royal Academy of Arts. Common topics include history, exhibits, and personalities. Length: 500–1,500 words. Articles of 1,000 words bring £100. Photographers should contact the editor with stock or assignment request.

Radio Control Models and Electronics
Nexus Special Interests
Nexus House
Azalea Drive
Swanley, Kent BR8 8HU
United Kingdom
Tel. 44-1322-660070
Fax 44-1322-667633/615636Editor: Kevin Crozier
The editor of this monthly desires well-illustrated articles related to radio control and electronics. Images are black-and-white or line drawings. There is no specified length for features. Payment for images and/or text is £35 per published page. Query first.

RCI Asia
101 Thomson Road
#26-03 United Square
Singapore 307591
Tel. 65-251-2551
Fax 65-251-1200
E-mail *rcisin@singnet.com.sg*
Editor: Luna Ho
Published and distributed to Resort Condominium International (RCI) members, this magazine uses travel with focus on time-share ownership. Personalities are sometimes used, as well as general travel news. Length: 500–1,000 words. Photos: color and black and white. Payment: negotiated for text and images.

Reader's Digest (Australia and New Zealand)
26-32 Waterloo Street
Surry Hill NSW 2010
Australia
Tel. 61-2-690-6111
Fax 61-2-699-8165
Editor: Bruce Heibuth
This monthly uses articles on Australian or New Zealand subjects, or those with tie-ins to these countries. All features are by assignment only, so query first. Length is 2,500–5,000 words. Payment is about $1 per word. Fillers are also used and bring $50–$250.

Reader's Digest (U.K.)
11 Westferry Circus
Canary Wharf
London E14 4HE
United Kingdom
Tel. 44-171-629-8144

E-mail *excerpts@readersdigest.co.uk*
Director: Russell Twisk

True-life tales, anecdotes, humor, medicine, food, and animal features are used in this monthly. Length: from 500–4,000 words. Payment: £1 per word.

Retail Week
EMAP Business Communications
Maclaren House
19 Scarbrook Road
Croydon, Surrey CR9 1QH
United Kingdom
Tel. 44-181-277-5331
Fax 44-181-277-5344
Editor: Ian McGarrigle

If you can write or provide images relating to retail management, this is a potential market for you. Published weekly and distributed to business retailers throughout the U.K., *Retail Week* uses articles up to 1,000 words on news, personalities, and management ideas for selling. Color and black-and-white photos are used. Payment: £120 per 1,000 words; and National Union of Journalists rates for images.

Ritz Newspaper
Ritz Frazer Magazines Ltd.
57-63 Old Church Street
Chelsea, London SW3 5BS
United Kingdom
Tel. 44-171-468-0230
Fax 44-171-351-7516
Editor: Helen Cuddigan

This newspaper, aimed at twenty- to forty-year-olds, has a circulation of 40,000. It is highly illustrated with color images and covers such topics as food, short stories, reviews, and general-interest features. Articles run 200–1,000 words. Payment: £100 for 600 words; photo prices are negotiated.

Royal Flyer and **Aero Zambia**
Jumbo Publications
R.O. Hussey and Company (Pty) Ltd.
Emafini House, Malagwane Hill
P.O. Box A225
Swai Place, Mbabane
Kingdom of Swaziland
Editor: Hazel Hussey

According to recent reports, opportunities are very good at these in-flight magazines of Royal Swazi Airways. Articles on travel, business, and topics dealing with international interests and technology are used. Average length is 2,000 words and each

feature includes 2–3 color images. Hussey prefers articles to be submitted in hard copy and on 3½" floppy disk. Payment: £65 per feature (rather low, but it might make a good resale market).

Rugby World
IPC Magazines Ltd.
King's Reach Tower
Stamford Street
London SE1 9LS
United Kingdom
Tel. 44-171-261-6830
Fax 44-171-261-5419
Editor: Alison Kervin

Features and news stories on rugby and the personalities of this sport are wanted by the editor of this monthly. Length: 1,200 words. Photos: color slides. Payment: £120 per article; photo rates a negotiated.

Saga
The Saga Building
Middleberg Square
Folkestone, Kent CT20 1ASZ
United Kingdom
Tel. 44-1303-711523
Fax 44-1303-220391
Editor: Paul Bach

More than 600,000 readers make this monthly one of the United Kingdom's top publications for men over fifty. Payment for stories, up to 1,800 words, is £250 per 1,000 words. Topics covered include celebrities, finance, cuisine, travel, health and nutrition, fitness, and social issues in the United Kingdom as well as matters that affect the world.

Sainsbury's: The Magazine
New Crane Publishing
20 Upper Ground
London SE1 9PD
United Kingdom
Tel. 44-171-633-0266
Fax 44-171-401-9423
Editor: Michael Wynn Jones

This general-interest magazine, published monthly, covers food and wine, health, travel, personalities, and humor. Query first, as all material is commissioned. Length: 1,500 words. Photos: color slides and black-and-white prints. Payment: varies, but averages £400 per page for articles and/or images.

Sawasdee
Travel and Trade Publishing (Asia) Ltd.
23/F Right Emperor Commercial Building
122–126 Wellington Street
Central Hong Kong
Tel. 852-545-1618
Fax 852-805-1809
Editor: David Keen
Only time will tell whether recent political changes in Hong Kong will affect this monthly in-flight publication for Thai Airlines (many publishers based here in the past have moved to locations like Singapore). This slick magazine uses a lot of articles on travel, culture, sports, celebrities, business, science, technology, and cuisine. Anywhere Thai Airlines flies—the United States, Europe, Asia—there is a potential story. Rates were not provided.

Scale Models International
Nexus Special Interests
Nexus House
Azalea Drive
Swanley, Kent BR8 8HU
United Kingdom
Tel. 44-1322-660070
Fax 44-1322-667633/615636Editor: Kelvin Barber
The editor of this monthly magazine wants articles up to 2,500 words on scale models. Illustrations can be color slides or black-and-white prints. Payment: £25–£30 per page of text and/or photos.

The Scots Magazine
2 Albert Square
Dundee DD1 9QJ
United Kingdom
Tel. 44-1382-223131 ext. 4119
Fax 44-1382-322214
Send queries to D. C. Thompson and Company
For more than 250 years, this monthly has covered people, events, and places in Scotland. Articles run 1,000–2,500 words. Payment: £22 per 1,000 words; and £12 per photo.

Scuba World
Freestyle Publications Ltd.
Alexander House
Ling Road, Tower Park
Poole, Dorset BH12 4NZ
United Kingdom

Tel. 44-1202-735090
Fax 44-1202-733969
Editor: Richard Chumbley
This monthly magazine uses up-to-date travel articles dealing with diving. Features should include general information for the traveller/diver, including airline connections from the United Kingdom, hotels, tourist offices, and essentials for scuba buffs. Length: 1,500–2,000 words. Both color and black-and-white photos are used. Payment: £40–£100 per article; more for photos. Query first.

Sea Breezes
Units 28-30
Spring Valley Industrial Estate
Braddon
Isle of Man IM2 2QS
United Kingdom
Tel. 44-1624-626018
Fax 44-1624-661655
Editor: Capt. A. C. Douglas
This publication includes factual articles covering ships, seamen, the Royal or Merchant Navy, and oceangoing history. Length: 1,000–4,000 words. Photos: black and white and color. Payments were not revealed.

Select Magazine
EMAP Metro
Mappin House
4 Winsley Street
London W1N 5AR
United Kingdom
Tel. 44-171-436-1515
Fax 44-171-312-8250
Editor: John Harris
Readers of *Select* are eighteen- to twenty-five-year-olds with an interest in music and youth culture: personalities, trends, fashions, etc. Images of rock/pop stars are always welcome. Both writers and photographers should query first as editors commission all work. Payment: £120 per 1,000 words; £110 per page of illustrations.

She Magazine
National Magazine House
72 Broadwick Street
London W1V 2BP
United Kingdom
Tel. 44-171-439-5000
Fax 44-171-439-5350
Editor: Alison Pylkkanen

A monthly magazine for women, *She* is heavy on health, relationships, childcare, careers, and personalities. Payment is according to the National Union of Journalists (U.K. standards). Query first.

The Short Wave Magazine
G8VFH Arrowsmith Court
Station Approach
Broadstone, Dorset BH18 8PW
United Kingdom
Tel. 44-1202-659910
Fax 44-1202-659950
Editor: Dick Ganderton

This monthly magazine covers the technical and nontechnical aspects of short-wave radio operation. Topics include the design and construction of radios as well as new equipment and personalities behind the gear. Photo-essays are always welcome. Article length is 500–5,000 words. Payment: £55 per page.

Silver Kris
MPH Magazines (S) Pte Ltd.
12 Tagore Drive
Singapore 787621
Tel. 65-453-8200
Fax 65-457-0313
E-mail *SilKris@mph.com.sg*
Editor: Steve Thompson

Steve Thompson uses a lot of articles in this monthly in-flight magazine of Singapore Airlines. A recent issue carried sixteen features (1,200–2,000 words) and several short pieces (500 words). There were also two photo-essays (500 words and 10 images). Topics cover travel, nature, science, business, interviews, culture, history, and the arts. Payment is based on the Singapore dollar, but checks are issued in the currency of one's choice: S$1,000 for four pages; S$1,250 for six pages, S$1,500 for eight pages. While *Silver Kris* has e-mail, Thompson prefers to work by nonelectronic means.

The Skier and Snowboarder
48 London Road
Sevenoaks
Kent TN13 1AS
United Kingdom
Tel. 44-1732-743644
Fax 44-1732-743647
Editor: Frank Baldwin

This magazine uses features and stories covering all aspects of snowboarding and skiing, including personal adventure, travels, techniques, and interviews of people in the industry or sport. "What I don't want" says Baldwin, "are features which we

call 'Oh what a lovely time I had in . . .'" Articles run 1,000–2,000 words. Color slides are preferred. A contact sheet can be sent for consideration. Payment: £100 per 1,000 words; photos based on published size. Query first.

Slimmer Magazine
Turret Group plc
177 Hagden Lane
Watford
Herts WD1 8LN
United Kingdom
Tel. 44-1923-228577
Fax 44-1923-221346
Editor: Claire Crowther
Fitness, health, nutrition, and staying trim are the themes covered in this bimonthly. The editor especially wants personal weight-loss stories. Length: 500–1,500 words. Payment is £10 per 100 words. Mention photos in query. Photographer should contact the editor with regard to stock or photo assignments. All topics are contemporary, including exhibits and book reviews. Articles ranging from 1,000–2,000 words are commissioned and illustrated with black-and-white photography. Payment: £100-£150 per editorial package. Query first.

South African Yachting
P.O. Box 3473
Cape Town 8000
South Africa
Tel. 27-21-461-7472
Fax 27-21-461-3758
Editor: Neil Rusch
Covering all aspects of yachting—racing, boats, equipment, techniques, travel, personalities—this monthly runs features up to 2,000 words. Black-and-white images illustrate articles, with a color cover. Payment (in rands): R12 per 100 words; photos are negotiated based on use.

Southern Cross
P.O. Box 2372
Cape Town 8000
South Africa
Tel. 27-21-455-007
Fax 27-21-453-850
Address all correspondence to the managing editor.
This national English-language weekly reports news and features relating to the Catholic faith and South Africa. Articles run up to 1,000 words. Payment is 87.5¢ per cm/column. Illustrations bring (in rands) R6 per column.

Speak Up
De Agostini-Rizzoli
Via Gaspare Gozzi 17A
20129 Milan, Italy
Tel. 39-02-380781
Fax 39-02-70023309
Editor: Mark Worden

A monthly English-language publication for Italian students of all ages. Articles are relatively short (200–900) words and cover a wide range of topics—from computers and travel to entertainment and media. A recent issue highlighted London nightlife; Internet addiction; dating; the American film industry; The Academy Awards; Hollywood billboard queen, Angelyne; Napa Valley wines and cuisine; and a travelog on the Trace Parkway. This is reported to be a good reprint market. Though payment is negotiated, the De Agostini-Rizzoli group is known for being among Italy's best payers. Writers and photographers often submit material, making the editor an offer.

Sport
The Sport Council
16 Upper Woburn Place
London WV1H 0QP
United Kingdom
Tel. 44-171-388-1277
Fax 44-171-383-5740
Editor: Louise Fyfe

A bimonthly magazine dedicated to sports policies, development, physical education, training, athletic facilities, and personalities. Length: 500–1,000 words. Images: color slides. Photographers should query with stock list or ideas. Payments: £120 for 1,000 words; £50 per half page.

The Squash Player
460 Bath Road
Longford, Middlesex UB7 0EB
United Kingdom
Tel. 44-1753-775511
Fax 44-1753-775512
Editor: Ian McKenzie

All aspects of the game of squash are covered in this monthly publication. Length: 1,000–1,500 words. Photos: color slides. Payment: £75 per 1,000 words; £25–£40 for illustrations.

The Stage
Stage House
47 Bermondsey Street

London SE1 3XT
United Kingdom
Tel. 44-171-403-1818
Fax 44-171-357-9287
Editor: Brian Attwood

This weekly, covering professional broadcasting and stage topics, includes pieces on performers, directors, shows, and lighting. Length: 500–800 words. Photos: color slides. Payment: £1 per word; image fees are negotiated.

Stand By
1 Vester Farimagsgade
DK-1606 Copenhagen V
Denmark
Tel. 45-33-918-400
Fax 45-33-918-401
Publisher: Carsten Elsted

A monthly travel publication begun in 1982, *Stand By*'s readers are airline employees, travel agents, tour operators, hotel workers, and foreign tourists. Editorial content covers industry news, profiles, lifestyle, and world travel—though a large percentage of these latter articles focus on Scandinavian countries. Color photography is used throughout. Length: 700–1,200 words. Payment information was not available.

Straits Times Singapore
Singapore Press Holdings Ltd.
New Center, 82 Genting Lane
Singapore 349567
Tel. 65-743-8800
Fax 65-742-7226
E-mail *stlife@cyberway.com.sg*
Editor: Paul Zacu

This national newspaper is published daily and has a circulation of 367,000. Among the topics used are news, personality profiles, and travel. Color and black-and-white images used. Rates are negotiated.

Sunday Express
Ludgate House
245 Blackfriars Road
London SE1 9UX
United Kingdom
Tel. 44-171-928-8000
Fax 44-171-620-1656
Editor: Sue Douglas

This weekly seeks exclusive news features and images. Of particular interest are

celebrities and controversial topics. For its *Sunday Express Magazine* insert, edited by Jean Carr, subjects include gardening, cooking, and general interest. Length: 1,000 words. Payment: £250 for 1,000 words. Photos: both color and black and white bring top rates.

Sunday Review
1 Canada Square
Canary Wharf
London E14 5DL
United Kingdom
Tel. 44-171-293-2000
Fax 44-171-293-2027
Editor: Richard Askwith

This weekly publication is distributed free with the *Independent* newspaper on Sunday. Highly illustrated general-interest subjects, including personality profiles, are used. Length: 1,000–5,000 words. Photos: color. Payment: £150 per 1,000 words; photo rates are negotiated according to use. Query first.

Sunday Times (Johannesburg)
P.O. Box 1090
Johannesburg 2000
South Africa
Tel. 27-11-497-2300
Fax 27-11-497-2623
Editor: K. F. Owen

This illustrated Sunday newspaper uses features of 1,000 words (maximum) as well as essays and general-interest pieces of 500–750 words. Both color and black-and-white photographs are used. Topics of interest include world events and politics, human-interest stories, and anything with a South African slant. Payment: £100 per article; photo prices are negotiated.

Sunday Times (London)
1 Pennington Street
London E1 9XW
United Kingdom
Tel. 44-171-782-5000
Editor: John Witherow

Top newspaper rates—£100 for features; £50 for illustrations—are offered for authoritative articles in the areas of art, entertainment, science, politics, and current issues. Also part of this edition is the *Sunday Times Magazine* (general-interest articles on people, travel, and tabloid-type news), *Style* (fashion, art, upscale profiles, and travel); and *Culture* (education, people, music, entertainment, and television). The supplements are also good markets for photographs.

189

The Sydney Morning Herald
P.O. Box 506
Sydney NSW 2001
Australia
Tel. 61-2-282-2858
Editor: John Alexander
 Though published daily, the Saturday edition offers the best opportunities for freelancers, as it also includes a magazine with glossy images. General-interest articles, many in tabloid style, are used. People seem to be a main theme, along with travel, current affairs, beauty, and fashion. Length: 600–4,000 words. Payment: $100 minimum for 1,000 words; photo rates are negotiated.

That's Life!
Second Floor, 1-5 Maple Place
London W1 5FX
United Kingdom
Tel. 44-171-462-4700
Fax 44-171-636-1824
Editor: Janice Turner
Fiction Editor: Emma Fabian
 True-life stories with women as the main characters is the general theme of this weekly. Articles average 1,000 words and bring £650. Illustrations are in color and black and white and are paid as part of the package or by arrangement. Also publishes fiction (1,000 words) at £300 per piece.

The Third Alternative
TTA Press
5 Martins Lane
Witcham Ely
Cambs CB6 2LB
United Kingdom
Editor: Andy Cox
 This quarterly is frequently called Britain's most innovative magazine for fiction. Much of what Cox uses is fantasy, with elegant graphics. Short stories in the science fiction and horror categories are also considered. Any length is considered. Payment: £5–£20 per 1,000 words.

This Caring Business
1 Saint Thomas' Road
Hastings, East Sussex TN34 3LG
United Kingdom
Tel. 44-1424-718406
Fax 44-1424-718460

Editor: Michael J. Monk

Hospital, nursing, and residential care are covered in this monthly. The editor prefers experts as authors. Articles are illustrated with black-and-white images. Length: 1,000–1,500 words. Payment: £75 per 1,000 words.

Today's Horse

Peenhill Ltd.
64 Great Eastern Street
London EC2A 3QR
United Kingdom
Tel. 44-171-739-5052
Fax 44-171-739-5053
Editor: Toni Cadden

This monthly publication for riding enthusiasts features all aspects of horse care, riding, and training and takes photo-essays on related topics. Length: 500–1,500 words. Photos: color slides. Payment: £60 per 1,000 words; £5–50 per photo, depending on use.

Top of the Pops Magazine

BBC Worldwide
80 Wood Lane
London W12 0TT
United Kingdom
Tel. 44-181-576-3254
Fax 44-181-576-3267
Editor: Peter Loraine

A young (twelve- to seventeen-year-olds) market that enjoys music, humor, television, and the latest pop stars is the readership for this monthly. Most articles, which run 700–1,000 words, are commissioned. Color photos of celebrities are used. Payment: £200 per 1,000 words; photo rates are negotiated depending on subject.

Top Santé Health and Beauty

Presse Publishing Ltd.
17 Radley Mews
Kensington, London W8 6JP
United Kingdom
Tel. 44-171-938-3033
Fax 44-171-938-5464
Editor: Sharon Parsons

Established in 1993, this monthly covers all areas of beauty and health. Features run 500–1,500 words. Color photos are used. Payment: £200 per 1,000 words. Try something on fitness or eating habits. Query first.

Trade and Travel
Edicom Corp.
Citibank Centre, Fifteenth Floor
8741 Paseo de Roxas
1226 Makati City
Philippines
Tel. 632-814-1457
Fax 632-817-9143
E-mail *jetm@asiansources.com*
Editor in Chief: Jet Magsaysay
Covering the travel industry in the Pacific Rim, *Trade and Travel* uses articles of 500–1,500 words. Color photography illustrates most features. News items run shorter in length. Payment: negotiated. Query first.

Trail Blazer
Gelt Mill House
Castle Carrock
Carlisle CA4 9NQ
United Kingdom
Tel. 44-1228-70403
Editor: Tony Thornton
This is a bimonthly dedicated to American West activities such as country music and line dancing. The editor is looking for features and news items in this genre. Article lengths and compensation are negotiated between the writer and Thornton after he reviews a query. Phone queries are also accepted.

Travel Away
22 Buckingham Street
Surry Hills 2010
Australia
Tel. 61-2-9310-4105
Fax 61-2-9310-2810
E-mail *travelaway@comcen.com.au*
Editor: Mathew Mopherson
A bimonthly magazine covering travel. The editor suggests that writers query first. Once an assignment is agreed upon, length and payment will be negotiated. Photographers should send ideas for photo features to Mopherson. E-mail queries are also accepted.

Travel Indonesia
P.O. Box 3651
Jakarta 10310, Java
Indonesia
Tel. 62-21-230-1008

Fax 62-21-392-1909
Editor: Daisy Hadmoko
 As the title suggests, this English-language magazine covers travel, tourism, lodging, restaurants, and unique aspects of Indonesia. Articles are illustrated with color transparencies. Length: 500–1,500 words. Payments are negotiated with writers and photographers. Query first.

Travel Talk
P.O. Box 1035
West Perth, Western 6872
Australia
Tel. 61-8-9328-3711
Fax 61-8-9328-3986
E-mail *impact@highway1.com.au*
Editor: Chris Hurd
Art Director: Sofia Hurd
 This company publishes three magazines—two monthly and one quarterly—covering travel, tourism, air freight, and airport developments. Articles begin at 300 words and move upwards depending on the topic. The editor prefers to work with writers on ideas, and also negotiates length and fees. Query first. Photographers should send their works to the art director.

Travel Trade
Level 12 North Tower
1-5 Railway Street
Chatswood NSW 2067
Australia
Tel. 61-2-372-5222
Fax 61-2-419-7533/7264
Editor: Ben Sandilands
 With a circulation of 10,000, *Travel Trade* is read by airline executives, tourist operators, hotel managers, and those interested in selling package excursions. Industry news, profiles, trends, and travel as it relates to new package ideas and tourist establishments are used. Color photography illustrates articles. Length: 200–400 for news items, 100–1,500 for features. Payment: negotiated. Query first.

Traveller
45-49 Brompton Road
Knightsbridge, London SW3 1DE
United Kingdom
Tel. 44-171-581-4130
Fax 44-171-581-1357
E-mail *mship@wexas.com*
Editor: Maranda Haines

Called the "U.K.–style *National Geographic*" by some, this quarterly covers offbeat destinations, adventure, and exotic cultures—with an emphasis on cultural and anthropological angles. Length: 1,000–2,000 words. Good color transparencies are a must. Payment: £125 per 1,000 words; £25 for photos, £50 for covers. Query first.

TravelNews Asia
Far East Trade Press
Block C 10/F Seaview Estate
2-8 Watson Road
Hong Kong
Tel. 852-2566-8381
Fax 852-2508-0255
Editor: Andrea Ripper

News, travel, profiles, and industry happenings are the mainstay of *TravelNews Asia's* editorial content. Running 350–1,700 words, articles are illustrated with color photography. Query the editor with ideas, both text and photographs. Payment is arranged according to the assignment and topic.

Ulysses 2000
Linee Aerea Italiana SpA
Via della Magliana 886
00148 Rome, Italy
Tel. 39-6-6562-2526
Fax 39-6-6562-6166
Editorial Director: Marco Zamichelli

Alitalia's in-flight magazine, while an excellent and colorful display, is oftentimes a political showcase for "famous" Italian journalists, celebrities, and political figures. Highly illustrated travel features, culture, art, history, and interviews of business, political, and entertainment personalities are used. Payment, reported to be among the best in Italy, is negotiated between the editor and freelancer.

Vanity Fair
Condé Nast Publications Ltd.
Vogue House, Hanover Square
London W1R 0AD
United Kingdom
Tel. 44-171-221-6228
Fax 44-171-221-6269
Editor: Henry Porter

Monthly lifestyle, entertainment, fashion, and political magazine for British women. Payments are negotiated for each feature purchased. All articles must first be assigned—i.e., send only queries. Length also varies depending on the topic.

Video Camera
W.V. Publications and Exhibitions Ltd.
57–59 Rochester Place
London NW1 9JU
United Kingdom
Tel. 44-171-485-0011
Fax 44-171-482-6249
Editor: Philip Lattimore

Tips, tricks, and the video camera and camcorder trade are the lifeline of this monthly magazine. Technique articles are particularly desired by the editor. Most articles and images are commissioned, so query first. Length: 800–1,000 words. Photos: color slides. Payment: £90 for 1,000 words; £90 per page of illustration.

The Voice
370 Coldharbour Lane
London SW9 8PL
United Kingdom
Tel. 44-171-737-7377
Fax 44-171-274-8994
Editor: Annie Stewart

A weekly news publication, covering current affairs, personalities, general interest, and the arts. The key is that articles appeal to black readers. Illustrations are color and black and white. Length: 500–2,000 words. Payment: £100 per 100 words; photos £20–£35 per image.

Vogue
Vogue House, Hanover Square
London W1R 0AD
United Kingdom
Tel. 44-171-499-9080
Fax 44-171-408-0559
Editor: Alexandra Shulman

This popular monthly magazine covers a little of everything: health, fashion, beauty, fitness, home decor, art, theater, television, movies, music, travel, profiles, and food. Length: 1,000–3,000 words. Photos: top-quality slides—send stock list. Payment: negotiated, but reportedly excellent.

What's On in Manila
Suite 403, Pacific Bank Building
Ayala Avenue, Makati, Metro Manila
Philippines
Tel. 632-810-2106
Fax 632-810-3707
Editor and Publishing Consultant: Murray Hertz

If it is happening in Manila, you'll find it in this publication. Editor Murray Hertiz—whom I met many years ago in one of the city's new, ritzy hotels—maintains a lively mix of entertainment, tourist happenings, and shopping. Features on local travel, retail outlets, and Philippine culture are all used. Length: 200–1,000 words. Both color and black-and-white photography is used. Payment: negotiated.

When Saturday Comes

When Saturday Comes Ltd.
Fourth Floor, 2 Pear Tree Court
London EC1R 0DS
United Kingdom
Tel. 44-171-251-8595
Fax 44-171-490-1598
Editor: Andy Lyons

If you can write about or provide images of soccer, this may be a good outlet for you. Take a fan's perspective and think European or global. Length: 500–2,000 words. Illustrations: color slides. Payment: £50–£100 for articles; £50–£75 for photos.

Winds

Aoyama Si Bldg
1-1-11 Shibuya Shibuya-ku
Tokyo 150, Japan
Tel. 03-5467-4630
Fax 03-5467-4635
E-mail *steveforster@twics.com*
Editor: Stephen Forster

This is the in-flight magazine for Japan Airlines (JAL). Editor Steve Forster says that he never assigns an article or photograph until he sees clips of previously published work. Most articles, in English, run 1,500–1,800 words. Features, with top-quality color images, must be linked to JAL routes in Asia, North America, and Europe. Payment is made after publication at about 40¢ per word. Photos are paid for according to use.

Wingspan

McEdit, c/o Davis Associates, Inc.
5-22-5-403 Higashi-Gotanda
Shinagawa-ku
Tokyo 141, Japan
Tel. 03-3592-3352
Fax 03-3592-6188
E-mail *mcdavis@gol.com*
Editor: Dominic Giovannangeli

This monthly in-flight magazine of All Nippon Airlines (ANA) is distributed free (150,000 copies) aboard all ANA flights. Text is in both Japanese and English. Travel,

business, culture, fashion, profiles, sports, and general-interest topics are covered in this full-color publication. Length for features: 2,000–3,000 words. The editor uses about ten images per article. Query with ideas. Payment for text is about 45¢ per word, paid after publication. Photo rates are negotiated.

Woman Alive
Herald House Ltd.
96 Dominion Road
Worthing, West Sussex BN14 8JP
United Kingdom
Tel. 44-1903-821082
Fax 44-1903-821081
E-mail *media@heraldhouse.co.uk*
Editor: Liz Proctor

Woman Alive is Britain's only Christian magazine aimed at women. It covers all denominations and discusses issues that are particularly relevant to active Christians. Features of general interest to women (e.g., contemporary issues, celebrity profiles, cookery, fashion, and health) are also included. The magazine is aimed at women of all ages, whether married, single, divorced, or widowed. Freelance articles generally fall into the following categories: interviews, testimony, travel, crafts, home, gardening, and cooking. Articles run 750–2,000 words. Payment is £50 per 1,000 words, paid upon publication.

Woman Spirit
P.O. Box 146
Highbury
South Australia 5089
Address all inquiries to the managing editor.

This quarterly has a 40,000 print run and pays (in U.S. dollars) $100 per article—a good option for reprint articles. According to the guidelines, "this target market is the growing body of women who desire to explore their female energy, their place in society, as well as their need for personal development." Articles of 1,000–2,000 words cover astrology, fashion, gardening, health, women in the workplace, relationships, and fine food and wine. Submit articles in hard copy as well as on an IBM-compatible disk.

Woman's Journal
IPC Magazines Ltd.
King's Reach Tower
Stamford Street
London SE1 9LS
United Kingdom
Editor: Marcelle D'Argy Smith

A monthly devoted to the contemporary woman over thirty. Features run 1,000–

2,000 words and cover interviews, fashion, beauty, health, food, and home. Illustrations are very important (color only). The staff warns: "Articles often fail because people try to put too much in. Not all the pieces we publish will feature new topics or ideas. We're also interested in new ways to look at issues/emotions/relationships." Query first. Rates: in accordance with National Union of Journalists standards.

The World of Interiors
Condé Nast Publications Ltd.
Vogue House, Hanover Square
London W1R 0AD
United Kingdom
Tel. 44-171-499-9080
Fax 44-171-493-4013
Editor: Min Hogg
 All articles and photos are assigned for this monthly, so query with a synopsis and/or clips of images. Home design and interiors are the main theme of the publication. Good photo-essays of homes are desired. Articles run 1,000–1,500 words. Color images throughout. Payment: £400 for text; £100 and up for images.

Yachting World
King's Reach Tower
Stamford Street
London SE1 9LS
United Kingdom
Tel. 44-171-261-6979
Fax 44-171-261-6818
Editor: Elaine Thompson
 Sailing as a sport as well as racing are covered in this slick monthly. Though focus is on U.K. waterways, the most exotic ports in the world are also included in text. Thompson prefers text-photo packages, with color slides, maps, charts, and practical information such as addresses, telephone and fax numbers of ports, and clubs. Features run 2,500–3,000 words, whereas columns, such as "Cruising Log," which includes news, experiences, and information on marinas, run 250–300 words. Query the editor before sending articles. Payments are negotiated based on topic, length, and illustrations provided.

Your Cat Magazine
EMAP Apex Publications Ltd.
Apex House
Oundle Road
Peterborough PE2 9NP
United Kingdom
Tel. 44-1733-898100
Fax 44-1733-898487

Address all queries to the submissions editor.

Offbeat, true-life stories about cat owners and their pets are sought by the editor of this monthly. Fiction is also used, with a cat theme, naturally. Articles and stories run 600–1,500 words. Payment, made upon publication, is £60. Photos, both color and black and white, are purchased—all rates are negotiated with photographer.

Your Dog Magazine
EMAP Apex Publications Ltd.
Apex House
Oundle Road
Peterborough PE2 9NP
United Kingdom
Tel. 44-1733-898100
Fax 44-1733-898487
Editor: Sarah Wright

Features of interest to dog lovers fill this bimonthly publication, including many step-by-step articles with illustrations. In fact, Wright prefers text-photo packages. Readers are everyday dog owners, with little or no interest in technical articles and shows. Some ideas might be sports with your dog, a new pet, or dealing with daily problems of dog ownership. Length: 1,000–1,500 words. Color transparencies are desired. Payment: £60 per 1,000 words. Fees for photographs are negotiated.

Your Garden
32 Welsh Street
Melbourne, Victoria 3003
Australia
Address all queries to the managing editor.

This monthly magazine is dedicated to providing practical ways to improve gardens and is read by amateurs as well as professional growers (e.g., nursery owners). Techniques in growing, new products, and interviews with noted experts are featured. Payment is varied based on the topic, length, and illustrations offered. Query first.

Your Garden (U.K.)
IPC Magazines Ltd.
Westover House
West Quay Road, Poole
Dorset BH15 1JG
United Kingdom
Tel. 44-1202-680603
Fax 44-1202-674335
Editor: Michael T. Pilcher

This magazine covers practical information on gardening for amateurs. Query first. Length: 800–2,000 words. Photos: color and black and white. Payment: £1 per word; photo prices are negotiated.

Your Home
Australian Consolidated Press (New Zealand) Ltd.
Private Bag 92512
Wellesley Street
Auckland
New Zealand
Tel. 64-9-373-5408
Fax 64-9-377-6725
Editor: Sharon Newey

Home-keeping advice, tips, projects, and ideas are desired by the editor. Readers of this monthly publication are keen gardeners and interior decorating enthusiasts. Quality color slides are used for illustrations. Article length: 1,000 words. Payment (in U.S. dollars): 30¢ per word; $50 per photo.

Yours
EMAP Apex Publications Ltd.
Apex House
Oundle Road
Peterborough PE2 9NP
United Kingdom
Tel. 44-1733-55123
Editor: Neil Patrick

A monthly for the elderly (over sixty). General-interest articles and short stories of 1,000–1,500 words are used. Query with ideas and stock photo lists. Payments are negotiated with the freelancer.

Zest: The Health and Beauty Magazine
National Magazine Company Ltd.
72 Broadwick Street
London W1V 2BP
United Kingdom
Tel. 44-171-439-5000
Fax 44-171-437-6886
Editor: Linda Bird

A publication for the general public covering health and beauty, *Zest*'s regular topics include allergies, nutrition, fitness, and beauty. Length: 500–2,000 words. Color photography is used throughout. Payments are negotiated, but are reportedly in accordance with National Union of Journalists standards.

200

Books

Selling Books Abroad

IN ADDITION TO SELLING ARTICLES, YOU CAN ALSO SELL YOUR BOOKS abroad, though this requires greater patience and more business skill. Some literary agents thrive on foreign book sales, as do some publishers. A good example of this was the foreign sales, a few years back, of Trevanian's novel *The Summer of Katya*; in Britain it was purchased for $85,000; in Germany $10,000, in Spain, $30,000; and in France, $15,000. The Dutch paid $10,000 for Dutch-language rights, and the Finnish paid the equivalent of $750. All this purchasing action occurred four months before the book even appeared in U.S. bookstores. As is obvious from this and the thousands of other overseas book transactions that take place every month, foreign publishers are eager to find talented writers on the opposite side of the Pacific and Atlantic. You should, therefore, seriously consider these markets in your book-selling strategy.

Peter Straub, author of such best-selling titles as *Floating Dragons, Ghost Story,* and *Shadowland,* found a home for his first novel in London, after numerous unsuccessful attempts to be published in New York, as have many other American authors. In addition to the personal and financial satisfaction an author receives from placing a book manuscript with a foreign publisher, he or she also has the advantage of a completed—edited, typeset, and bound—work to offer U.S. publishing houses.

Many authors find that doors open much wider—even after previous rejection—for a book that has already been released abroad. So could you.

Handling Your Own Foreign Book Rights

As a newcomer to the book-selling game, you should probably stick with English-language countries when submitting manuscripts. This will make the business aspects easier. As was the case with articles, you must keep your rights. If a publisher in London wants your book, sell U.K. rights only. A good literary lawyer can help with book contracts and negotiations.

There are several ways to locate acquisitions editors at foreign publishing houses. Perhaps the best source is the *International Literary Market Place* (ILMP), published by R. R. Bowker (see appendix B). This is a standard resource for the book industry, issued annually and containing data on publishers in 160 countries. The information covers the type of books they produce, names of editors and—very important—the person in charge of foreign language purchases. Remember, in most countries, English is a foreign language. The directory also provides telephone and fax numbers as well as postal and e-mail addresses. Unfortunately, *ILMP* is thick, heavy, and expensive—over $100. Many libraries, however, carry it in their reference sections. If you do decide to purchase your own copy of *ILMP*, you can do so by calling (800) 521-8110 or (908) 464-6800.

Because I enjoy the book industry and the thrill of selling my work, I attend lots of international book fairs. Most foreign rights sales, in fact, take place at the Frankfurt Book Fair, the London International Book Fair, or the ABA (American Booksellers Association) Book Fair, which is held each year in the United States. The annual directory of the Frankfurt Book Fair (available from Ausstellungs- und Messe GmbH des Börsenvereins des Deutschen Buchhandels, Reineckstraße 3, D-60313 Frankfurt am Main, Germany) provides a good listing of publishers around the world, their current book lines, addresses, phone numbers, and other useful information.

If you discover, as I did, that you become seriously involved in foreign book marketing, you may find it helpful to join the Publishers Marketing Association, (see appendix C). They can provide advice,

support, and offer cooperative marketing and display at many book fairs and trade shows. If you do not want to do all the work yourself, you can send your manuscript to foreign agents listed in the ILMP.

Don't get the impression that selling books overseas is any easier than placing them at home. It never is. Marketing, I feel, is the name of the game. As individuals, we might consider ourselves unique. But let's face it, there are many writers out there as good or better than you or I. Few, however, know how to market their work successfully worldwide.

Expanding your book sales, for example, to London, Sydney, or Frankfurt opens more doors for you, providing greater opportunities to place your book. Foreign markets also follow different trends than, say, New York. Let's imagine, for instance, that you are trying to sell horror. This genre may be experiencing a slump in the North American market. At the same time, however, it could be on the rise in the United Kingdom.

To get you started on your book marketing efforts, chapter 18 provides some of the more popular publishing houses outside North America, their current lines, editors, addresses, and phone and fax numbers.

SPOTLIGHT
Toni Lopopolo, International Literary Agent

Toni Lopopolo was one of New York's top fiction editors for many years, working for Bantam Books, Harcourt Brace, Houghton Mifflin, Macmillan, and St. Martin's Press. With the experience gathered from over twenty years in the publishing industry, she turned to agenting in 1990. Frequently travelling between her offices in Los Angeles and Bisceglie, a resort town on the southeastern coast of Italy, I caught up with Lopopolo on a sunny June day to discuss international book sales over a seafood meal and fine white wine.

During our lunch, Toni pointed out that many publishers in North America try to sell foreign rights to titles they have contracted as a means of offsetting author advances—that is, they can cut deals abroad and obtain money from, say, European publishers that equal or exceed their own investments. She also indicated that while there are a lot of publishers around the world, the job of selling a book in today's

global industry is difficult everywhere. Nonetheless, Lopopolo is quick to add that the international situation is no more difficult than trying to sell one's work in a place like New York, where there is "an overabundance of novels" and "publishers who are behaving conservatively." She advises anyone thinking about making a living selling books overseas to "have a lot of travel money."

Writers who have the time and energy should try their hands at selling their own books overseas. Otherwise, according to Lopopolo, they should "have a U.S. (or Canadian) agent who works with overseas agents in Europe or Asia."

Have you sold many books overseas?
Yes, many times.

What type of books are better accepted in the foreign marketplace?
Bestselling nonfiction. Rarely fiction, though they often show interest.

Are there advantages, in your view, for writers trying to sell their books to overseas publishers, such as those in the United Kingdom?
Only that the money goes directly to the authors—not to the publisher to help earn off advances paid—nor to the agent who takes 10–15 percent.

Is it easier to sell a book overseas?
No. Too broad a market.

What types of books are easier to sell abroad?
[Basically, works that have] plots concerned to the particular country or has been a bestseller in the United States like *Men are from Mars* . . .

What contractual difficulties might a writer run into when selling to overseas book publishers?
No one to protect them from crooked publishers.

Where might an author obtain information on publishing houses overseas and their editors?
The *International Literary Market Place.*

Publishing Houses

LIKE THEIR NORTH AMERICAN COUNTERPARTS, EDITORS AT PUBLISHING houses around the world change jobs frequently. I therefore suggest that you invest in a telephone call prior to sending any proposals or manuscripts to obtain the specific name of the editor in charge of acquisitions. My experience is that editors in Australia and England tend to answer much faster than those in, say, New York. Ensuring that your submission is addressed to a specific individual will make the response even faster.

The following is not intended to be a comprehensive list of all global book publishers—that would require a book in itself. It is a good representation, however, of the mainstream publishers and includes the larger houses, which, in many cases, have several imprints. Keep in mind that while publishers generally have an editorial director, there is also at least one editor responsible for each imprint. When making your inquiry as to whom should receive your submission, be sure you know not only which company you are dealing with, but which imprint of that company.

Last week, for instance, I called Macmillan General Books in London. While Peter Straus is the editor in chief, I realized that this company is a giant in the publishing industry, with several imprints. What I was interested in was the person in charge of fiction paperbacks under the Pan label. After telling this to the person manning Macmillan's

switchboard, she was able to look in the directory and advise me that "Peter Lavery is the publisher and editor of that line." Armed with this information, off went my proposal to Lavery. While he ultimately refused the idea, his personal letter, which came back within three weeks, indicated that he studied my submission in some detail. As such, I would not hesitate to submit to him in the future.

While there are thousands of publishers that buy English-language books around the world, I have included only the larger houses that maintain numerous imprints and offer the best opportunities for North American writers.

AA Publishing
Automobile Association Developments Ltd.
Fanum House
Basingstoke, Hampshire RG21 4EA
United Kingdom
Tel. 44-1256-21573
Fax 44-1256-491974
Editorial Manager: Michael Buttler
> Travel, atlases, maps, and leisure. The company handles the Baedeker, Essential, and Thomas Cook travel series as well as Explorer Travel Guides.

ABC, All Books for Children
33 Museum Street
London WC1A 1LD
United Kingdom
Tel. 44-171-436-6300
Fax 44-171-240-6923
Publishing Director: Susan Tarsky
> Children's books.

Absolute Press
Scarborough House
29 James Street West
Bath BA1 2BT
United Kingdom
Tel. 44-1225-316013
Fax 44-1225-445836
E-mail *sales@absolutepress.demon.co.uk*
Editor: Bronwen Douglas
> General nonfiction, cooking, wine, and travel books.
> Imprint: **Absolute Classic** *Translated European drama and theater books.*

Allison and Busby
114 New Cavendish Street
London W1M 7FD
United Kingdom
Tel. 44-171-636-2942
Fax 44-171-833-1044
Managing Director: Peter Day
Crime, literary fiction, and books for writers.

Asia 2000 Ltd.
1101 Seabird House
22-28 Wyndham Street
Central Hong Kong
Tel. 00852-2530-1409
Fax 00852-2526-1107
E-mail *info@asia2000.com.hk*
Web site *www.asia2000.com.hk*
Editor: Alan Sargent
Asia 2000 publishes nonfiction and fiction titles that are linked to aspects of Hong Kong and China. Author's guidelines are available from its Web site.

Black Ace Books
Ellemford FarmHouse, Duns
Berwickshire TD11 3SG
United Kingdom
Tel. 44-1361-890370
Fax 44-1361-890287
Publisher: Hunter Steele
Scottish and general new fiction, and historical nonfiction.

Bloomsbury Publishing
38 Soho Square
London W1V 5DF
United Kingdom
Tel. 44-171-494-2111
Fax 44-171-434-0151
E-mail *alan@bloombry.sonnet.co.uk*
Web site *www.bloomsbury.com*
Publishing Director: Alan Wherry
Trade and mass-market paperbacks, hardcover and paperback travel, and biographies.

Calder Publications Ltd
126 Cornwall Road

London SE1 8TQ
Tel. 44-171-633-0599
Director: John Calder
European, international, and British fiction, art, music, biography, and science.

Cassell
Wellington House
125 Strand
London WC2R 0BB
United Kingdom
Tel. 44-171-420-5555
Fax 44-171-240-7261
Director: Rod Dymott
Imprints/Contact/Subjects:
- **Arms and Armour Press** *Rod Dymott* Military history, reference, defense
- **Blandford Press** *Rod Dymott* Hobbies, sports, music, fitness
- **Cassell** *Alison Goff* General nonfiction, academic reference, science, current affairs
- **Geoffrey Chapman** *Gillian Paterson* Religion and theology
- **Victor Gollancz** *Jane Blackstock* Popular fiction and general nonfiction
- **Gollancz Witherby** *Liz Knights* Sports
- **Indigo** *Mike Petty* Literary fiction and general nonfiction
- **Leicester University Press** *Janet Joyce* Academic books
- **Mansell Publishing** *Janet Joyce* Biographies, history
- **Mowbray** *Gillian Paterson* Religion and theology
- **New Orchard Editions** *Kevin Briston* General nonfiction and illustrated titles
- **Pinter** *Janet Joyce* Politics, economics, technology, religious study
- **Studio Vista** *Barry Holmes* Art, architecture, design
- **Vista** *Humphrey Price* Mass-market fiction and general nonfiction
- **Ward Lock** *Alison Goff* Reference books, health, outdoors
- **Wisley Handbooks** *Barry Holmes* Gardening

Constable and Company
3 The Lanchesters
162 Fulham Palace Road
London W6 9ER
United Kingdom
Tel. 44-181-741-3663
Fax 44-181-748-7562
Director: Richard Dodman
General fiction, crime and suspense, and nonfiction: biographies, politics, current affairs, food, travel, guidebooks, and mass-market reference.

Creation Books
83 Clerkenwell Road

London EC1M 5RJ
United Kingdom
Tel. 44-171-430-9878
Fax 44-171-242-5527
Director: James Williamson
 Horror, science fiction, erotic, surreal, and cult fiction.
Imprint: **Velvet** *Erotic fiction*

Faber and Faber
3 Queen Square
London WC1N 3AU
United Kingdom
Tel. 44-171-465-0045
Fax 44-171-465-0034
Web site *www.faber.co.uk*
Director: John Bodley
 High-quality general fiction and nonfiction.

Fourth Estate
6 Salem Road
London W2 4BU
United Kingdom
Tel. 44-171-727-8993
Fax 44-171-792-3176
E-mail *general@4thestate.co.uk*
Publishing Director: Christopher Potter
 High-quality fiction, business, politics, current affairs, and TV tie-ins.
Imprints:
- **Fourth Estate Paperbacks** *Paperback versions of hardcover bestsellers*
- **Guardian Books** *Titles generated from the Guardian newspaper*

Granta Publications
2/3 Hanover Yard, Noel Road
London N1 8BE
United Kingdom
Tel. 44-171-704-9776
Fax 44-171-354-3469
Publisher: Frances Coady
Editor: Antonella Caruaro
 General fiction, politics, and autobiographies.

Robert Hale
Clerkenwell House
45-47 Clerkenwell Green

London EC1R 0HT
United Kingdom
Tel. 44-171-251-2661
Fax 44-171-490-4958
Director: John Hale
 General adult fiction and nonfiction.

Harlequin Mills and Boon
Eton House
18–24 Paradise Road
Richmond, Surrey TW9 1SR
United Kingdom
Tel. 44-181-948-0444
Fax 44-181-288-2899
Editorial Director: K. Stoecher
Imprints/Contact/Subjects:
- **Mills and Boon** *S. Hodgson* Hardcover and paperback romance
- **Mira Books** *L. Fildew* Women's fiction
- **Medical and Historical** *E. Johnson* Romance fiction
- **Silhouette** *L. Stonehouse* Popular romance fiction

HarperCollins Publishers
77–85 Fulham Palace Road
London W6 8JB
United Kingdom
Tel. 44-181-741-7070
Fax 44-181-307-4440
Web site *www.harpercollins.co.uk*
Trade Director: Adrian Bourne
Reference Director: Robin Wood
Education Director: Kate Harris
Children's Director: Ian Craig
Imprints/Contacts/Subjects:
- **Access Press** *(Query the appropriate director given above)* Travel guides
- **Bartholomew** *(Query the appropriate director given above)* Atlases and maps
- **Birnbaum** *(Query the appropriate director given above)* Travel
- **Collins** *(Query the appropriate director given above)* Fiction, education, directories, general nonfiction, children's books
- **Collins Children's Non-Fiction** *David Howgrave* Graham illustrated titles
- **Collins Picture Lion** *Gail Penston* Children's illustrated paperbacks
- **Collins Tracks** *Gail Penston* Young adult
- **Flamingo** *Jonathan Butler* Literary fiction
- **Fontana Press** *Philip Gwyn Jones* Sophisticated nonfiction paperback
- **Fount** *Eileen Campbell* religion

- **HarperCollins** Paperback and hardcover adult fiction and nonfiction for mass market
- **HarperCollins Electronic Products** *Kate Harris* CD-ROM and other electronic reference, children's, and interactive fiction
- **HarperCollins World** *Henrietta Silver* Imported general adult trade
- **Lions** *Gail Penston* Children's books
- **Marshall Pickering** *Eileen Campbell* Theology, children's illustrated titles, music, Christian titles
- **Nicholson** *Jeremyu Westwood* Maps, atlases, guides
- **Pandora Press** *Eileen Campbell* General nonfiction
- **Thorsons** *Eileen Campbell* Medicine, health, nutrition, parenting, astrology, mythology, psychic activities
- **Times Books** *Jeremy Westwood* maps, atlases, reference
- **Tolkien** *David Brawn* General nonfiction
- **Voyager** *Jane Johnson* Science fiction and fantasy fiction

HarperCollins Publishers (Australia) Pty Ltd. Group
25–31 Ryde Road
Pymble NSW 2073
Australia
Tel. 61-2-9952-5000
Fax 61-2-9952-5555
Managing Director: Barrie Hitchon
 Adult fiction and nonfiction with mass-market appeal. Biographies, current affairs, sports, health, true crime, and travel are all considered.

HarperCollins Publishers (New Zealand) Ltd.
P.O. Box 1
Auckland
New Zealand
Tel. 64-9-443-9400
Fax 64-9-443-9403
Address all proposals to the acquisitions editor.
 General fiction and nonfiction with global appeal to adult readers including reference books and trade paperbacks.

Hodder Headline
338 Euston Road
London NW1 3BH
United Kingdom
Tel. 44-171-873-6000
Fax 44-171-873-6024
Web site *www.headline.co.uk*

Imprints/Contact/Subjects:

- **Edward Arnold** *Richard Stileman* Academic and reference
- **Brockhampton Press** *John Maxwell* Nonfiction and promotion books
- **Headline Book Publishing** *Amanda Ridout* Adult fiction and nonfiction
- **Headline Feature/Headline Review** *Alan Brooke* Commercial fiction and nonfiction
- **Headline Delta** *Mike Bailey* General erotica
- **Headline Liaison** *Mike Bailey* Erotica
- **Hodder Children's Books** *Mary Tapissier* Picture fiction and nonfiction
 - Under this division are: **Hodder and Stoughton, Knight, Picture Knight, Hodder Dargaud, Headstart, Test Your Child,** and **Signature** *All follow the children's book theme*
- **Hodder and Stoughton Educational** *Brian Steven* General text books
 - Under this division are: **Educational, Teach Yourself,** and *Headway* Textbooks for *all levels of education*
- **Hodder and Stoughton General** *Martin Nield* Nonfiction and fiction for the mass market
 - This division includes the **Coronet** imprint for mass-market fiction.
- **Hodder and Stoughton Religions** *Emma Sealey* Bible studies and Christian literature
- **New English Library, Sceptre** Literary fiction, commercial nonfiction, travel, general interest

Hodder Headline Australia Pty Ltd.
10–16 South Street
Rydalmere NSW 2116
Australia
Tel. 61-2-9841-2800
Fax 61-2-9841-2810
E-mail *hsales@hha.com.au*
Managing Director: Malcolm Edwards
General nonfiction, religion, educational, and children's books.

Hodder Moa Beckett Publishers Ltd.
P.O. Box 100-749
North Shore Mail Centre
Auckland 1330
New Zealand
Tel. 64-9-478-1000
Fax 64-9-478-1010
Managing Director: Neil Aston
General fiction and nonfiction in the areas of sports, gardening, and travel. Children's books are also considered.

214

Little, Brown and Company
Brettenham House, Lancaster Place
London WC2E 7EN
United Kingdom
Tel. 44-171-911-8000
Fax 44-171-911-8100
Editorial Director: Alan Samson
Film and TV Tie-in Editor: Jo O'Neill
Imprints/Contact/Subjects:
- **Abacus** *Richard Beswick* Trade paperback
- **Illustrated** *Vivien Bowler* Tabletop art and photo books
- **Orbit** *Colin Murray* Science fiction and fantasy
- **Virago** *Lennie Goodings* General fiction and nonfiction
- **Warner-Futura** *Barbara Boote* Crime fiction and original paperbacks
- **X Libris** *Helen Goodwin* Erotica

Loki Books
38 Chalcot Crescent
London NW1 8YD
United Kingdom
Tel./Fax 44-171-722-6718
A new press specializing in exciting modern fiction translated into English.

Lonely Planet Book Company Ltd.
P.O. Box 617
Hawthorn, Victoria 3122
Australia
Tel. 61-3-9819-1877
Fax 61-3-9819-6459
E-mail *talk2us@lonelyplanet.com.au*
Web site *www.lonelyplanet.com*
Publisher: Tony Wheeler
Travel guides with adventure and/or outdoor slant.

The Lutterworth Press
P.O. Box 60
Cambridge CB1 2NT
United Kingdom
Tel. 44-1223-350865
Fax 44-1223-366951
E-mail *lutterworth.pr@dial.pipex.com*
Web site *dialspace.dial.pipex.com/lutterworth.pr/*
Editorial Assistant: Jeremy Young

Part of the James Clarke and Company, this publisher produces quality fiction and nonfiction covering art, biography, history, environmental, science, and current affairs.

Macmillan Publishers Ltd.
25 Eccleston Place
London SW1W 9NF
United Kingdom
Tel. 44-171-881-8000
Fax 44-171-881-8001
Director: R. Barker
Imprints/Contact/Subjects:

- **Macmillan Children's Books Ltd.** *Susan Gibbs* Picture books, fiction, poetry, and nonfiction on general topics
- **Macmillan General Books** *Peter Lavery* General fiction, sci-fi, fantasy, horror, detective, and nonfiction in the areas of business, biography, and history. Also beauty, health, travel, philosophy, world affairs
- **Pan** *Tanya Stobbs* Detective fiction, fantasy, as well as sports, the arts, travel, gardening, cooking
- **Papermac** *Jon Riley* Nonfiction series, science, history, politics, culture, art history
- **Sidgwick and Jackson** *Georgina Morley* Military affairs, war, music

Orion Books
Orion House
5 Upper St. Martin's Lane
London WC2H 9EA
United Kingdom
Tel. 44-171-240-3444
Fax 44-171-240-4823
Managing Director: Peter Roche
Imprints/Contact/Subjects:

- **Illustrated** *Michael Dover* All categories of illustrated nonfiction
- **Mass Market** *Susan Lamb* Mass-market fiction and nonfiction
- **Millennium** *Caroline Oakley* Science fiction and fantasy
- **Orion** *Rosemary Cheetham* Hardcover fiction and nonfiction
- **Orion Children's Books** *Judith Elliott* Fiction and nonfiction for children
- **Phoenix House** *Maggie McKernan* Literary fiction
- **Weidenfeld and Nicholson** *Ion Trewin* General nonfiction

Penguin Books Ltd.
27 Wrights Lane
London W8 5TZ
United Kingdom
Tel. 44-171-416-3000

Fax 44-171-416-3274
Web site *www.penguin.co.uk*
Publishing Director: Juliet Annan
Assistant Editor: Hannah Robson
Imprints/Editorial Director/Subject:

- **Allen Lane/The Penguin Press** *Alistair Rolfe* Academic interests for hardcover titles
- **Dutton Children's Books** *Rosemary Stones* Picture books, poetry, fiction for children
- **Hamish Hamilton Ltd.** *Kate Jones* Fiction, biography, history, literature, limited travel (Query first)
- **Hamish Hamilton Children's Books** *Jane Nissen* Fiction and picture books for children
- **Penguin** *Tony Lacey* Nonfiction and fiction originals in paperback (Most often there is a TV or movie tie-in to titles in this line)
- **Puffin** *Philippa Milnes-Smith* Paperback originals for children, fiction, and limited nonfiction
- **RoC/Creed** *Luigi Bonomi* Synopses and queries welcome for this science fiction and fantasy line
- **Signet** *Luigi Bonomi* Paperback fiction and nonfiction for mass market
- **Viking** *Clare Alexander* Fiction, nonfiction, biographies, science, travel (Queries only)
- **Viking Children's Books** *Rosemary Stones* Picture books and fiction

Penguin Books Australia Ltd.
487 Maroondah Highway
Ringwood, Victoria 3134
Australia
Tel. 61-3-9871-2400
Fax 61-3-9870-9618
Director: R. P. Sessions
 Fiction and popular adult nonfiction including travel, social issues, current events, biography, and health.

David Philip Publishers (Pty) Ltd.
P.O. Box 23408
Claremont 7735
Western Cape
South Africa
Tel. 27-21-644-136
Fax 27-21-643-358
E-mail *dpp@iafrica.com*
Managing Director: Mair Philip
 Quality nonfiction including history, social issues, science, biography, reference books, and children's books. Also limited fiction.

Piatkus Books
Judy Piatkus (Publishers) Ltd.
5 Windmill Street
London W1P 1HF
United Kingdom
Tel. 44-171-631-0710
Fax 44-171-436-7137
E-mail *piatkus.books@dial.pipex.com*
Commissioning Editor: Elenore Lawson
Commercial fiction and nonfiction.

Quartet Books
27 Goodge Street
London W1P 1FD
United Kingdom
Tel. 44-171-636-3992
Fax 44-171-637-1866
Managing Director: Jeremy Beale
General fiction and nonfiction, including crafts, cooking, gardening, and other mass-market topics.

Random House
20 Vauxhall Bridge Road
London SW1V 2SA
United Kingdom
Tel. 44-171-973-9000
Fax 44-171-931-7672
Publishing Director: Simon King
Imprints/Contact/Subjects:
- **Arrow** *Carol Manderson* Science fiction, fantasy, crime, humor
- **Barrie and Jenkins** *Julian Shuckburgh* Art, antiques, collecting
- **Jonathan Cape** *Dan Franklin* Archaeology, biography, history, current affairs
- **Century** *Carol Manderson* Fiction, historical, romance
- **Chatto and Windus** *Jonathan Burnham* Hardcover and paperback thrillers, history, biography, general adult nonfiction
- **Condé Nast Books** *Julian Shuckburgh* Illustrated titles on fashion, beauty, cooking
- **Hutchinson** *Carol Manderson* Crime, general adult fiction, thriller, movie tie-ins
- **Methuen** *Michael Early* General fiction, drama, arts
- **Random House Children's Books** *Ian Hudson* Illustrated fiction and nonfiction for children
- **Stanley Paul** *Julian Shuckburgh* Sports, games, hobbies
- **Pimlico** *Will Sulkin* History and biographies
- **Secker and Warburg** *Geoff Mulligan* Literary fiction and adult nonfiction

- **Sinclair-Stevenson** *Penny Hoare* General fiction and nonfiction
- **Vintage** *Will Sulkin* Quality fiction and nonfiction

Random House Australia Pty Ltd.
20 Alfred Street
Milsons Point NSW 2061
Australia
Tel. 61-2-9954-9966
Fax 61-2-9954-4562
E-mail *random@randomhouse.com.au*
Managing Director: E. F. Mason
General fiction and nonfiction, as well as children's books.

Random House New Zealand Ltd.
Private Bag 102950
North Shore Mail Centre
Auckland 10
New Zealand
Tel. 64-9-444-7197
Fax 64-9-444-7524
Managing Director: J. Rogers
Fiction and general nonfiction including health and business.

Reed International Books
Michelin House
81 Fulham Road
London SW3 6RB
United Kingdom
Tel. 44-171-581-9393
Fax 44-171-225-9424
E-mail: *cd49@dial.pipex.com*
Web site *www.reedbooks.co.uk*
Imprints/Contact/Subjects:

- **Bounty** *Laura Bamford* Children's and adult's special editions
- **Hamlyn** *Laura Bamford* Popular nonfiction, crafts, sports, music
- **Hamlyn Children** *Jane Winterbotham* Illustrated fiction and nonfiction
- **Heinemann Young Books** *Jane Winterbotham* Children's novels and picture books
- **Mammoth** *Jane Winterbotham* Children's paperbacks
- **Methuen Children's Books** *Jane Winterbotham* Fiction and picture books
- **Mitchell Beazley** *Jane Aspden* Illustrated nonfiction
- **Osprey** *Jonathan Parker* Nonfiction, military, cars, aviation
- **Philips** *John Gaisford* Maps, atlases, reference books

Robinson Publishing
7 Kensington Church Court
London W8 4SP
United Kingdom
Tel. 44-171-938-3830
Fax 44-171-938-4214
E-mail: *100560.3511@compuserve.com*
Publisher: Nicholas Robinson
General, horror, fantasy, science fiction, and historical crime/mystery fiction. Also adult nonfiction.
Imprint/Contact/Subjects:
- **Scarlet Books** *Sue Curran* Women's romantic fiction

Scholastic Ltd.
Commonwealth House
1–19 New Oxford Street
London WC1A 1NU
United Kingdom
Tel. 44-171-421-9000
Fax 44-171-421-9001
Editor: Kirsten Skidmore
Publishers of quality books for children, both fiction and nonfiction. Most popular series are the Point Horror and Point Horror Unleashed titles.

Serpent's Tail
4 Blackstock Mews
London N4 2BT
United Kingdom
Tel. 44-171-354-1949
Fax 44-171-704-6467
E-mail *info@serpentstail.com*
Web site *www.serpentstail.com*
Director: Peter Ayrton
Editor: Barbara Lyon
Contemporary fiction and literary and experimental work.

Severn House Publishers
9-15 High Street
Sutton, Surrey SM1 1DF
United Kingdom
Tel. 44-181-770-3930
Fax 44-181-770-3850
Senior Editor: Sara Short
Submissions Editor: S. Brown
All forms of adult fiction: thrillers, detective, science fiction, romance.

Simon and Schuster
West Garden Place
Kendal Street
London W2 2AQ
United Kingdom
Tel. 44-171-316-1900
Fax 44-171-402-0639
Fiction Editor: Jo Frank
Mass-Market Editor: Martin Fletcher
Touchstone Editor: Diane Spivey
Nonfiction Editor: Helen Gummer
 All forms of adult publishing: fiction, nonfiction, and mass-market paperbacks.

Titan Books
42–44 Dolbern Street
London SE1 0UP
United Kingdom
Tel. 44-171-620-0200
Fax 44-171-620-0032
E-mail *101447.2455@compuserve.com*
Editorial Director: Katy Wild
 Novels and film tie-ins.

Transworld Publishers Ltd.
61–63 Uxbridge Road
London W5 5SA
United Kingdom
Tel. 44-181-579-2652
Fax 44-181-579-5479
Paperback Editor: Tony Mott
Hardback Editor: Ursula Mackenzie
Adult Trade Editor: Patrick Janson-Smith
 Perhaps the United Kingdom's largest publishing conglomeration with imprints from many of the finest companies around the world, including Bantam and Doubleday. Transworld itself releases both hardback and paperback fiction and nonfiction. You can also address your queries to the following imprint editors.
Imprints/Contact/Subjects:
- **Anchor** *John Saddler* Contemporary fiction and nonfiction
- **Bantam** *Francesca Liversidge* Paperback fiction and nonfiction
- **Bantam Press** *Sally Gaminara* Limited fiction, cooking, business, health, diet, history, military, science, travel, biographies
- **Bantam Children's Books** *Philippa Dickinson* Paperbacks for young readers
- **Black Swan** *Bill Scott-Kerr* paperback fiction
- **Corgi** *Bill Scott-Kerr* Paperback fiction and nonfiction
- **Corgi Children's Books** *Philippa Dickinson* Picture books, fiction, poetry for children

- **Doubleday** *Marianne Velmans* Fiction and nonfiction adult titles
- **Doubleday Children's Books** *Philippa Dickinson* Picture books and fiction in hardback
- **Freeway** *Philippa Dickinson* Young adult paperbacks
- **Partridge Press** *Alison Barrow* Sports and leisure

Transworld Publishers (Australia) Pty Ltd.

Gound Floor, 40 Yeo Street
Neutral Bay NSW 2089
Australia
Tel. 61-3-9908-4366
Fax 61-3-9953-8563
Managing Director: Geoffrey Rumpf

Popular fiction and nonfiction in the areas of biography, parenting, sports, current events, and culture.

Virgin Publishing Ltd.

332 Ladbroke Grove
London W10 5AH
United Kingdom
Tel. 44-181-968-7554
Fax 44-181-968-0929
Editorial Assistant: James Marriott
Science Fiction Editor: Will Mackie
Assistant Editor: Simon Winstone

Books on popular culture, entertainment, celebrities, TV tie-ins, biographies, the arts, character-based novels, and erotica. The recently added Virgin World imprint represents a new direction in the company. The books will include strong character-led fiction. Examples of strong fiction imprints already being published are Doctor Who, Black Lace, and Cracker lines. Contact editor Kerri Sharp with queries for brands (i.e., imprints) Black Lace and Nexus.

William Waterman Publications Pty Ltd.

P.O. Box 5091
Rivonia 2128
South Africa
Tel. 27-11-882-1408
Fax 27-11-882-1559
Director: Murray J. Bolton

Mass-market nonfiction, including military history, educational, and literature.

International Media E-mail Addresses

MOST OF THIS LIST WAS PROVIDED BY PETER GUGERELL, AN AUSTRIAN pilot whose passion for information led him to begin a Web site of media contact. My personal thanks go out to Peter for providing this valuable resource.

There was some indecision on my part as to whether to include this listing in the book or to simply refer Internet users to Peter's Web page at *www.ping.at/gugerell/media*. Writer friends had mixed opinions as well. Some said definitely include it, others said not to. In the end, the first group won.

The reason for my doubt was, like market listings, this information is subject to change. As a test, I sent 150 messages to addresses from the following list. Within ten hours, 16 had returns. A couple of these were due to typing errors, others, on follow-up attempts, made it through. In the end, only a handful were undeliverable. I reported these to Peter by e-mail, as he is constantly updating the lists of his Internet Web page. You should, in fact, refer to his Update page for any changes or additions at *www.ping.at/gugerell/e2news.html*. About once a quarter Peter transfers the updated information to the master listings. Because Peter is always looking for new media contacts, you can send any e-mail addresses that are not already on his list, as well as the publication, to *gugerell@ping.at*.

I will also be maintaining and updating the list for future editions

of this book, so please also send any new e-mail addresses and updates to me at *pp10013@cybernet.it.*

AUSTRALIA

The Age (Melbourne)	editorial@theage.com.au
Altair	altair@senet.com.au
AMIDA	amida@coombs.anu.edu.au
Architecture Australia	publisher@archmedia.com.au
Area Magazine	pwilken@peg.apc.org
Augusta Margaret River Mail	amrmail@rpl.com.au
The Australian	
Arts	ausarts@newscorp.com.au
The Australian Magazine	auswkend@newscorp.com.au
Business	ausbuss@newscorp.com.au
Computers	auscomp@newscorp.com.au
Features	ausfeat@newscorp.com.au
Foreign Desk	ausforgn@newscorp.com.au
Higher Education	aushied@newscorp.com.au
Letters to the Editor	ausletr@newscorp.com.au
Motoring Desk	ausmotor@newscorp.com.au
Sport and Racing Desk	ausport@newscorp.com.au
The Weekend Australian	auswkend@newscorp.com.au
Australian Book Review	abr@vicnet.net.au
Australian Broadcasting Corporation	
Classic FM	cfm@classic.abc.net.au
Frank Crook's Living Memories	crook@your.abc.net.au
Radio Australia English Service	raelp@radioaus.abc.net.au
Radio Australia N Asia Services	ratx@radioaus.abc.net.au
Radio Australia Pacific Services	rapac@radioaus.abc.net.au
Radio Australia S and SE Asia Services	rasea@radioaus.abc.net.au
Radio Australia Transmission Manager	ratx@radioaus.abc.net.au
Radio National	editor@rn.abc.net.au
Rural Radio	rural@your.abc.net.au

Television	ryan.peter@a2.abc.net.au
Triple J Radio	mail@triplej.abc.net.au
2BL Radio Sydney	2bl@your.abc.net.au
Australian Buildings News	editor@abn.com.au
Australian Classic Car Monthly	acmp@ozemail.com.au
Australian Journal of Grape and Wine Research	ajgwr@waite.adelaide.edu.au
Australian Financial Review	afr@afr.com.au
Australian Net Guide	neted@netguide.aust.com
Australian Observer	info@aobserver.com.au
Australian PC User	pcuser@acp.com.au
Australian PC World	pcworld@idg.com.au
Australian Personal Computer	
Editor	jwhite@acp.com.au
Australia's Exotic News	aen@light.iinet.net.au
Beat Magazine	beat@ozonline.com.au
Bright Lights Film Journal	gmm@slip.net
Broadcast Engineering News	bengnews@magna.com.au
Brother Sister Newspaper	leto@rabbit.com.au
Bush Telegraph	damor@qdlgp.qld.gov.au
Business Sydney	editor@businesssydney.com.au
Buzz Magazine	editfeedback@buzzmag.com
Byron Shire Echo	editor@echo.net.au
Campus Review	info@camrev.com.au
Canberra Times	letters.editor@canbtimes.com.au
Channel 9 Radio Adelaide (NWS9)	angusr@nws9.com.au
Channel 9 Radio Queensland (BTQ9)	qtq_pub@ninenet.com.au
Click Multimedia Magazine	editor@click.com.au
Community Radio 3CR	
Careering Arts Australia	vincent@journalism.ss.rmit.oz.au
Computer Week	
Editor	bdawes@apnpc.com.au
Press Releases	cw@apnpc.com.au
Daily Commercial News	farynski@world.net

Daily Telegraph dtmletr@ozemail.com.au

Desktop Magazine kinta@werple.net.au

Dutch Courier hadeg@connexus.apana.org.au

Engineers Australia Magazine engineer@australis.net.au

Fairfax Community Newspapers talktous@fairfax.com.au

Geek Girl gg@geekgirl.com.au

Herald Sun saburke@newscorp.com.au

Hodder Headline Australia hsales@hha.com.au

Hyper freakscene@hyper.com.au

Illawarra Mercury

 Editor nhartgerink@illnews.com.au

internet.au

 Letters to the Editor letters@ia.com.au

 News Releases news@ia.com.au

Life Australia lifeedit@life.timeinc.com

Lonely Planet Book Company talk2us@lonelyplanet.com

Look! look@ion.com.au

MacUser macuser@niche.com.au

MacWorld macworld@geko.com.au

Matilda in Cyberspace Tony.Barry@library.anu.edu.au

Medical Journal of Australia mja@library.usyd.edu.au

Music Teacher Magazine rkp@warehouse.net

National Outlook rocket@zip.com.au

Network World david_benyon@idg.com

Offshore Yachting offshore@merlin.com.au

Online World online.world@idg.com.au

On the Street Magazine ots@real.com.au

Practical Hydroponics and Greenhouses casper@hydroponics.com.au

Quote duggo@magna.au

Radio and Records mailroom@rronline.com

Random House Australia random@randomhouse.com.au

Reseller News Paul_Zucker@idg.com

Resort News Magazine dwresort@oz.com.au

Rolling Stone	letters@rstone.com.au
Search	search@control.com.au
Seven Network Australia	
Today Tonight	todaytonight@seven.com.au
Witness	witness@seven.com.au
Shepparton News Online	webmaster@www.sheppnews.com.au
Sunday Telegraph	suntel@newscorp.com.au
The Sun-Herald	letters@sunherald.fairfax.com.au
Sydney Business Review	sbr@geko.net.au
Sydney Morning Herald	news@smh.com.au
Letters to the Editor	letters@smh.com.au
Tharunka	tharunka@UNSW.edu.au
Time	time.letters@time.com.au
Travel Away	travelaway@comcen.com.au
Travel Talk	impact@highway1.com.au
Traveltrade	editor@traveltrade.com.au
Victorian Computer News	amjadali@oz.com.au
The Weekend Independent	jrgdobin@dingo.cc.uq.oz.au
Who Weekly	who.letters@time.com.au
Windows Sources Australia	
Editor	nsudbury@apnpc.com.au
Press Releases	wsa@apnpc.com.au

NEW ZEALAND

AntePodium (Victoria University Wellington)	antepodium@vuw.ac.nz
Editor	kosuke.shimizu@vuw.ac.nz
Auckland University Law Review	seanm@ccu1.auckland.ac.nz
Bits and Bytes	
Editor	jbaker@iconz.co.nz
City Voice	city@voice.wgtn.planet.co.nz
Coastline FM Radio	cfm@enternet.co.nz
Country FM Radio	countryfm@rockhouse.com
Craccum Magazine	craccumed@auckland.ac.nz

Deep South Journal (University of Otago)	dsouth@elwing.otago.ac.nz
Discover New Zealand	editor@discovernz.co.nz
Dive Log New Zealand	
Assistant Editor	tanyag@divelognz.co.nz
Editor	davem@divelognz.co.nz
Subscriptions	petalm@divelognz.co.nz
Education Television (eTV)	etv@wp.tvnz.co.nz
Feminist Studies in Aotearoa	l.c.alice@massey.ac.nz
Geyser Television (GTV)	cblenews@iconz.co.nz
HillsAM Radio	hillsam@earthlight.co.nz
IceTV	icetv@iconz.co.nz
Independent Newspapers Limited	pat.churchill@inl.co.nz
Inform	inform@diatp.dia.govt.nz
InfoTech Weekly	manager@infotech.co.nz
Interstices (University of Auckland)	m.linzey@auckland.ac.nz
The Maori Law Review	bennion@actrix.gen.nz
National Business Review	nevil@eworld.com
The Net	brucep@www.chch.planet.org.nz
New Zealand Doctor	
Editor	carmelw@iprolink.co.nz
New Zealand Engineering	peter@nzeipenz.co.nz
Alternate Address	peter@ipenz.org.nz
New Zealand Science Monthly	nzsm@spis.co.nz
New Zealand Skeptic	nzsm@spis.co.nz
NZPA Newswire	george@nzpa.co.nz
Omniscient Honeycomb Media Service	abulafia@sans.vuw.ac.nz
Plains FM Radio	plainsfm@bcast1.chchp.ac.nz
Post	ahi_cstuart@hsblab.auckland.ac.nz
The Press	
Letters to the Editor	editorial@press.co.nz
Radio New Zealand International	rnzi@actrix.gen.nz
RDU Radio	rdu@rdu.org.nz
News Editor	news@rdu.org.nz

Shortland Street TV	shorters@chch.planet.co.nz
Sixty Minutes TV	producer@sixtymin.co.nz
Small World Television	swtv@smallworld.co.nz
Social Behaviour and Personality Journal	stewart@journal.manawatu.planet.co.nz
Straight Thinking Magazine	omcshane@deepthnk.kiwi.gen.nz
Waikato Times	info@waikato-times.co.nz
The Weekly O'Press	opress@spis.co.nz
Worldwide Women's TV Network	pamela@central.co.nz

EUROPE: AUSTRIA

a3BAU (Das oest. Baumagazin)	a3bau@magnet.at
a3BOOM! (Magazin für Marketing)	a3boom@a3boom.co.at
a3 Umwelt	summera3@inmedias.ping.at
Aerzte Woche	aerzte@aerztewoche.co.at
akin (Aktuelle Informationen)	be.redl@link-atu.comlink.de
APA (Austria Presse Agentur): Marketing	marketing@apa.co.at
AppleTime (Zeitschrift)	appletime@magnet.at
Badener Rundschau	bar@noer.at
BAZAR Zeitungs—und Verlags GesmbH	bazar@bazar.co.at
Behinderte (Zeitschrift)	p.rudlof@magnet.at
Bestseller	best@manstein.co.at
Betrifft Integration	integration.oesterreich@magnet.at
bizeps (Zeitschrift f. Behinderte)	bizeps@magnet.at
Cogito	vsstoe.intern@amda.or.at
COM (Computerzeitschrift, Erb-Verlag)	com_redaktion@inmedias.ping.at
Comment (EDV-Zentrum, Uni Wien)	comment@cc.univie.ac.at
Computerwelt	computerwelt@cw.co.at
Courage (Graz)	courage.graz@demut.or.at
Das Gruene Haus	gruene.haus@net4you.co.at
Der Blaetterteig	bt@fgidec1.tuwien.ac.at
Der neue Grazer	grazer@sime.com
Der Standard (Tageszeitung)	documentation@standard.co.at
Der Takt	dertakt@ebWeb.tuwien.ac.at

DOMINO (Behindertenzeitschrift)	domino@magnet.at
EUROTEC	eurotec@inmedias.ping.at
explosiv (Jugendmagazin)	aks@blackbox.ping.at
factum est (Nachr. Agentur. f. Forschung)	factum_est@inmedias.ping.at
Falter (Wiener Stadtzeitschrift)	wienzeit@falter.co.at
Flex Digest (Zeitschrift)	a6213gqs@helios.edvz.univie.ac.at
Flugblatt (AUA-Firmenzeitung)	gugerell@ping.at
Freies Radio Wien	f.radio@link-atu.comlink.apc.org
Guernice (Friedenswerkstatt Linz)	friedenswerkst.linz@demut.or.at
HighTech Presse	pfm@hightech.presse.co.at
Jaensch Christian (Radio Steiermark)	cjaensch@sime.com
Journal Networks	networks@cw.telecom.at
Korrekt (Linzer Kleinanzeiger)	g.martello@mag.co.at
Kupf (Zeitung der Kultuplattform OOe)	kupf.ooe@demut.or.at
Kurier (Tageszeitung)	E-mail@kurier.co.at
LIBRA (Astronomical News and LIBRA Online)	libra@zlsm03.una.ac.at
Linz Entertainment (Kabarett, etc.)	digo@netzwerker.at
Live (Sportmagazin)	root@www.zika.co.at
LK-Handelszeitung (Lebensmittel-Fach)	w.friedrich@magnet.at
media biz	mediabiz@inmedias.ping.at
Neue Flieger Revue	flieger@via.at
NOE-Rundschau	office@noer.at
OEH-Courier (Zeitschrift, Uni Linz)	oeh-courier.abgabe@amda.or.at
Oekonomia	marina.ichikawa@telecom.at
Oesterreichische Hochschulzeitung (OeHZ)	oehz@apanet.apa.co.at
Oesterreichischer Journalisten Club	oejc@apanet.at
Oberoesterreichischer Presseclub	ooe.presseclub@amda.or.at
Alternate Address	pcl.@zika.co.at
Online (Das Magazin der Grünen)	a.grasl@demut.or.at
ORF (Oesterreichischer Rundfunk)	
Generalintendanz (General Correspondence)	gmp@orf.at
Kunstradio	kunstradio@thing.or.at
Kurzwelle (Radio Austria International)	kwp@rai.ping.at

230

Modern Times	modern.times@orf.via.at
Pleiten-, Pech- und Pannendienst	pleiten-pech-pannen@orf.at
Publikumsservice Anfragen	anfrage@orf.at
Publikumsservice Beschwerden	beschwerde@orf.at
Publikumsservice Wuensche	wunsch@orf.at
Radio Blue Danube Radio/News	bdr_news@orf.at
Radio Blue Danube Radio/Today at Six	bdr_tas@orf.at
Radio FM4	fm4@orf.at
Radio-PR (für Journalisten-Anfragen)	radio.pr@orf.at
Teletext	teletext@orf.at
Output (EDV-Magazin)	output@inmedias.ping.at
Ost-News	k.tumler@magnet.at
Ost West Info	ostwest.info@demut.or.at
pBlattform (Zeitung der OeH-BOKU)	pressereferat@oeh1.boku.ac.at
PC Austria	vdv@plus.at
PCNEWSedu	pcnews@pcnews.at
Pipeline (TU Wien)	husinsky@edvz.tuwien.ac.at
profil (Zeitschrift)	profil@inmedias.ping.at
Radio CD	radiocd@ping.at
Reuters Finanzdienst (Agentur)	t.straka@magnet.at
Schwarzataler Bezirksbote	sbb@noer.at
SOWI-News (Uni Innsbruck)	sowi-ca01@uibk.ac.at
SowiTimes (Zeitschrift, Uni Linz)	heidi.vitez@jk.uni-linz.ac.at
SPORT-aktiv (osterr. Behindertensportverb)	joachim.schwendtner@amda.or.at
Tatblatt (Zeitschrift)	tatblatt@link-atu.comlink.apc.org
Technopress GesmbH Fachzeitschr.Verlag	technopress@technopress.co.at
Testorello (PC-Tip)	testorello@cw.co.at
trend (Zeitschrift)	trend@profil-trend.co.at
UniKat (Zeitschrift, OeSU Linz)	martin.borger@jk.uni-linz.ac.at
unilibre (OeH Zentralausschuss)	uni_libre@oeh.ac.at
Unser St. Poelten	usp@noer.at
Viennaslide (Reportagen-u. Fotogr. Agentur)	viennaslide@magnet.at
Volksstimme	volksstimme@magnet.at

WCM (Wiener Computer Markt) zeitung@wcm.co.at

WebAnzeiger/Online-Inserate webanzeiger@netzwerker.at

Wiener Neustaedter Nachrichten wnn@noer.at

Wiener Zeitung

 Aussenpolitik (Christian Hoffmann) ch@email-wz.oesd.co.at

 Aussenpolitik (Ines Scholz) is@email-wz.oesd.co.at

 Chefredakteur (Heinz Fahnler) hf@email.oesd.co.at

 Chefredakteur (Peter Bochskanl) pb@email-wz.oesd.co.at

 Computer (Gerald Jatzek) jatzek@magnet.at Stv.

 Stv. Chefredakteur (Franz Zauner) fz@email-wz.oesd.co.at

 EDV (Anton Gunsam) gunsam@emailoesd.co.at

 EXTRA (Gerald Schmickl) gs@email-wz.oesd.co.at

 Foto (Willi Puchner) puchner@email.adis.at

 Innenpolitik (Gisela Vorrath) gv@email-wz.oesd.co.at

 Kommunales (Georg Friesenbichler) gf@email-wz.oesd.co.at

 Kultur (Edwin Baumgartner) eb@email-wz.oesd.co.at

 Sport, EXTRA (Francesco Campagner) fc@email-wz.oesd.co.at

 Wirtschaft (Christian Wojta) woj@email-wz.oesd.co.at

WirtschaftsBlatt wirtschaftsblatt@inmedias.ping.at

Wirtschaftswoche (Wirtschaftsmagazin) wirtschaftswoche@inmedias.ping.at

Wirtschaftswoche (Wirtschaftsmagazin) redaktion@wirtschaftswoche.co.at

Wuestenrot-Magazin wuestenrot-presse@mail.apanet.at

X-it (Falter-Beilage) x.it@blackbox.ping.at

EUROPE: BELARUS

Belarusski Predprinimatel bp@bp.belpak.minsk.by

Belorusski Rynok (Belarussian Market) root@belmarket.belpak.minsk.by

Compyuterniye Vesti (Computer News) kb@belhard.by.glas.apc.org

Ekonomicheskaya Gazeta (Economical News) econ@nenp.minsk.by

Tseny i Tovary Segodnya (Prices/Goods) PaulBuk@Magic.Belpak.Minsk.by

Vecherni Minsk (Minsk Tonight) omp@bm.belpak.minsk.by

EUROPE: BELGIUM

Data News	isybex@sybex.eunet.be
De Nar	de_nar@knooppunt.be
Knooppunt	knooppunt@knooppunt.be
Secret Magazine	secretmag@glo.be

EUROPE: THE CZECH REPUBLIC

European Information Network	deirdre@ein.cz
ITNS—IntelliTech News Service	sslatem@intellitech.cz
Press Releases	editorial@intellitech.cz
Subscriptions	admin@intellitech.cz
Prague Post	prgpost@traveller.cz
Zurnal UP (Palacky University)	veselovs@risc.upol.cz

EUROPE: FRANCE

E.M@ALE	e.mailmagazine@wanadoo.fr
Frank	david@paris-anglo.com
International Herald Tribune	iht@iht.com
Marquis	marquis@lagare.fr
Ozone	ozone@infonie.fr

EUROPE: GERMANY

Addison-Wesley Germany	info@addison-wesley.de
anitimilitarismus information	ami@zedat.fu-berlin.de
Bild Online/Leserbiefe	brief@bild.de
CHIP	100434.1303@compuserve.com
c't magazin für computertechnik	cp@ct.ix.de
DATA BECKER GmbH and Company KG	ruland@data-becker.de
Der Spiegel (Hamburg)	74431.736@compuserve.com
Deutsche Welle	dw@dw.gmd.de
Die Tageszeitung (Berlin)	briefe@taz.de
ELRAD (Magazin für Elektronik)	cs@elrad.ix.de
Focus (München)	100335.3131@compuserve.com

Franzis' Verlag	100102.1612@compuserve.com
Gateway (Magazin für Telekommunikation)	rh@gateway.ix.de
Germany Inc.	Healy@t-online.de
GEO	75410.1601@compuserve.com
Hamburger Morgenpost Online	paustian@mopo.de
Leserbriefe	leserbrief@mopo.de
Hannoversche Allgemeine Zeitung	haz@madsack.de
Holsteinischer Courier	redaktion@courier.de
Internet-Magazin	75162.3657@compuserve.com
Inter-Net-Report (IWT)	tim@cole.spacenet.de
iX Multiuser (Multitasking Magazin)	post@ix.de
MacWelt (Macintosh Magazin)	macwelt@applelink.apple.com
Mannheimer Morgen	mamo@zeno.franken.de
Marquis	marquis@t-online.de
Nürnberger Nachrichten and Nürnberger Zeitung	
Erich Heimann	hei@nordbayern.de
Michael Nordschild	mic@nordbayern.de
Nuernberger Nachrichten Online	
Erich Heimann	hei@nordbayern.de
Egbert M. Reinhold	emr@nn-online.de
Nuernberger Zeitung Online	
Thomas Gerlach	tg@nz-online.de
Michael Nordschild	mic@nordbayern.de
Off Duty Europe	Odutyedit@aol.com
Online ISDN	74431.515@compuserve.com
O'Reilly Germany	oitv@ora.de
PC Online	70007.5041@compuserve.com
PC Player	71333.2206@compuserve.com
PC Praxis	71333.2066@compuserve.com
PC Professionell	71154.1404@compuserve.com
PC WELT	70007.5263@compuserve.com
pl@net	planet@zd.com
P.M.	kontakt@pm.spacenet.de

R&R Shopper News	rrmagazine@t-online.de
Radio HUNDERT (Berlin)	edvorga@bbtt.de
Sonderforschungsbereich f. Bildschirmmedien	mattusch@sfb240.uni-siegen.d400.de
Spotlight Verlag	102404.367@compuserve.com
Springer Deutschland	orders@springer.de
Stern (Hamburg)	100125.1305@compuserve.com
Storisende Verlag	story@storisende.com
3D-Magazin (Stuttgart)	3d-magazin@stereo.s.bawue.de
Voll! (Stadtmagazin Burgdorf und Lehrte)	voll01@aol.com

EUROPE: GREAT BRITAIN

Absolute Press	sales@absolutepress.demon.co.uk
Albedoon One (Ireland)	bhry@iol.ie
Allscot News and Features Agency	101324.2142@compuserve.com
Amiga Computing	amigacomputing@cix.compulink.co.uk
Amiga Format	amformat@futurenet.co.uk
Amstrad Action	aa@futurenet.co.uk
AM/FM Magazine	james007@cix.compulink.co.uk
Arcane	sfaragher@futurenet.co.uk
AREL Press Agency	101324.2142@compuserve.com
Artists Newsletter	anpubs@gn.apc.org
Autocar	100020.2017@compuserve.com
Babycare and Your Pregnancy	baby@dcthomson.co.uk
Back Brain Recluse	bbr@fdgroup.co.uk
Balance Fitness	Howard.Jardine@hyperlink.com
BBC Aberdeen	jcowie@scot.bbc.co.uk
BBC (General)	
Bug Reports (BBC WWW Server)	bug-report@bbcnc.org.uk
Documentaries	documentaries@bbc.co.uk
East	lookeast@nc.bbc.co.uk
Education	bbc_education@bbcnc.org.uk
General Inquiries or Comments	correspondence@bbcnc.org.uk
Independents Commissioning Office	ice.fact@bbc.co.uk

Monit. Range of Commercial and Services	100431.2524@compuserve.com
Networking Club	info@bbcnc.org.uk
Networking Club Membership Application	auntreg@bbcnc.org.uk
Networking Club Software Support	askauntie@bbcnc.org.uk
Press and Publicity Office Birmingham	birmingham.press.office@bbc.co.uk
Top Gear Magazine	topgearmag@bbcnc.org.uk
Viewer and Listener Correspondence	VLC@bbc.co.uk
Wales Sports	bbcsport@wales.bbc.co.uk
Weather Centre	weather@bbc.co.uk
Webweaver	webweaver@bbcnc.org.uk
Youth and Entertainment Features	yef@bbcnc.org.uk
BBC Radio 1	radio1@bbc.co.uk
Bruce Dickinson	bruce.dickinson@bbc.co.uk
Mark Goodier	mark.goodier@bbc.co.uk
The Net	radio1.thenet@bbc.co.uk
Pete Tong	pete.tong@bbc.co.uk
BBC Radio 2	
DJ John Dunn	JohnDunn@bbc.co.uk
BBC Radio 3	
Impressions	gerladine.copp@bbc.co.uk
Mixing It	Mixing.It@bbc.co.uk
Open University	info@oupc.bbc.co.uk
Record Review	record.review@bbc.co.uk
BBC Radio 4	
Afternoon Shift	afternoon.shift@bbc.co.uk
The Big Byte	big-byte@bbcnc.org.uk
Costing the Earth	caspar.henderson@bbc.co.uk
Daily Arts Magazine	Kaleidoscope@bbc.co.uk
Diamonds, Rust, and a Handful of Sand	crystal@oupc.bbc.co.uk
The Network	the.network@bbc.co.uk
New Ideas	newideas@bbc-sci.demon.co.uk
Short Stories	short.stories@bbc.co.uk
The Theory Query	theory.query@bbc.co.uk

Today	today@bbcnc.org.uk
Woman's Hour	womanshour@bbc.co.uk
BBC Radio 5	
Canned News	colin.savage@bbc.co.uk
Collins Maconie	collins.maconie@bbc.co.uk
Crime Desk	lousie.shorter@nc.bbc.co.uk
Law in Action	colin.savage@bbc.co.uk
Special Assignment	colin.savage@bbc.co.uk
Stop Press	colin.savage@bbc.co.uk
BBC Radio Norfolk	norfolk@nc.bbc.co.uk
BBC Radio Northampton	northampton@nc.bbc.co.uk
BBC Television	
Blue Peter	BluePeter@bbc.co.uk
Ceefax Travel	travel@bbc.co.uk
Children's Television	childrens@bbc.co.uk
Clear Air	clear.air@bbc.co.uk
Crinkley Bottom	crinkley.bottom@bbc.co.uk
The Eye	the.eye@bbc.co.uk
Fist of Fun	fist.of.fun@bbc.co.uk
In Living Colour	in.living.colour@bbc.co.uk
The Net	the-net@bbcnc.org.uk
In the News	in.the.news@bbc.co.uk
New Ideas	newideas@bbc-sci.demon.co.uk
Noel's House Party	noels.house.party@bbc.co.uk
Open University	info@oupc.bbc.co.uk
Points of View	pov@bbcnc.org.uk
Reactive	reactive@bbc.co.uk
See Hear	bryn@cet.education.bbc.co.uk
The Sky at Night	the.sky.at.night@bbc.co.uk
Sunday Show	sunday@bbcnc.org.uk
The Steve Wright People Show	steve.wright.people.show@bbc.co.uk
The Terry Wogan Show	terry.wogan.show@bbc.co.uk
Travel Show	travel.show@bbc.co.uk

Tomorrows World	tworld@bbc.co.uk
Watch Out	watchout@bbcnc.org.uk
Westminster Online	westonline@bbc.co.uk
BBC World Service	iac@bbc-iabr.demon.co.uk
BBC World in Japan, Inquiries	JapanTV@bbc.co.uk
Letters	worldservice.letters@bbc.co.uk
Outlook Magazine	outlook@bbc.co.uk
Polish Section	polska.sekcja@bbcnc.org.uk
World Service Programme	Radio.International@bbc.co.uk
World Service Pop Programme	WS.Pop@bbc.co.uk
Bloomsbury Publishing	alan@bloomsbry.sonnet.co.uk
Boards Magazine	billdawes@compuserve.com
Brunel Radio B1000	brunel.radio.b1000@brunel.ac.uk
Building Power Scotland	101324.2142@compuserve.com
Business Life	business_life@premiermags.co.uk
Business Power Scotland	101324.2142@compuserve.com
Card Systems	satnews@cix.compulink.co.uk
CD-ROM Games	cdromgames@paragon.co.uk
CD-ROM Today	mrichards@futurenet.co.uk
Classic CD	rainsley@futurenet.co.uk
Classical Music	100546.1127@compuserve.com
Commodore Format	cf@futurenet.co.uk
Communications Networks	75300.243@compuserve.com
CompuServe	iballantyne@csi.compuserve.com
Computer Arts	mhigham@futurenet.co.uk
Computer Business Review	100537.2236@compuserve.com
Computer Buyer	feedback@comp-buyer.co.uk
Art Editor	art.buyer@dennis.co.uk
Editor	editor.buyer@dennis.co.uk
Deputy Editor	deputy_ed.buyer@dennis.co.uk
Computer Shopper	100034.1056@compuserve.com
Computer Weekly	comp_weekly@cix.compulink.co.uk
Computing	computed@cix.compulink.co.uk

Connected (Daily Telegraph)	connected@telegraph.co.uk
Cycling Plus	djoyce@futurenet.co.uk
Cycling and Mountain Biking Today	106003.3405@compuserve.com
Data Broadcasting News	satnews@cix.compulink.co.uk
Daily Record and Sunday Mail	dmill@record-mail.co.uk
The Daily Telegraph	editor@telegraph.co.uk
Desktop Publishing	webweaver@greened.demon.co.uk
Early Music	jnl.early-music@oup.co.uk
East Cambridgeshire	ecoln_editor@bjga.demon.co.uk
Edge (Interactive Entertainment)	jbrookes@futurenet.co.uk
EMBO Journal	jnl.info@oup.co.uk
The European	editor@the-european.com
Focus UK	focus@gjofuk.demon.co.uk
Football Heroes	footballheroes@paragon.co.uk
Foreign Service	mcockle@cruint.tcom.co.uk
Fourth Estate	general@4thestate.co.uk
France Magazine	francemag@btinternet.com
Future Music	mailto:ajones@futurenet.co.uk
Gair Rhydd (Cardiff University, Wales)	gairrhydd@cardiff.ac.uk
The Gown (Queens University, Belfast)	gown@athmail1.causeway.qub.ac.uk
The Guardian	
Computer Page	computerg@guardian.co.uk
Letters	letters@guardian.co.uk
Notes and Queries	nandq@guardian.co.uk
The Observer—Management (Business)	obsmanagement@guardian.co.uk
"Online"	online@guardian.co.uk
Questions	nandq@guardian.co.uk
Head Magazine	100344.1203@compuserve.com
High Life	high_life@premiermags.co.uk
IBM System User	andyl@power.globalnews.com
The Independent	network@independent.co.uk
International Herald Tribune	iht@eurokom.ie
Internet and Comms Today	davew@paragon.co.uk

The Irish Emigrant	ferrie@iol.ie
Irish Times	computimes@irish-times.ie
John Rogers Media	jrms@patrol.i-way.co.uk
Journal Publication (London)	dbailey@cix.compulink.co.uk
Journalist	the.journalist@mcr1.poptel.org.uk
Keyboard Review	kr@musicians-net.co.uk
Living Marxism	lm@camintl.org
Lutterworth Press	lutterworth.pr@dial.pipex.com
M2 News Agency (London)	satnews@cix.compulink.co.uk
MacFormat	macformat@futurenet.co.uk
Morning Star	morsta@geo2.poptel.org.uk
Mountain Biking U.K.	mbuk@futurenet.co.uk
MTB Pro (Mountain Biking)	mtbpro@futurenet.co.uk
MTV Europe	
Most Wanted	mostwanted@mtvne.com
Naturalist	m.r.d.seaward@bradford.ac.uk
Nature	nature@nature.com
Needlecraft	needlecraft@futurenet.co.uk
.net The Internet Magazine	rlonghurst@futurenet.co.uk
Alternate Address	netmag@futurenet.co.uk
.net directory	scrook@futurenet.co.uk
Netuser	seanc@uktv.co.uk
New Internationalist	newint@gn.apc.org
New Scientist	
"The Last Word"	lastword@newscientist.com
Net Editor	neteditor@newscientist.com
U.S. Bureau	newscidc@soho.ios.com
News, Satire	editor@walden.demon.co.uk
19	19@ipc.co.uk
O Magazine	
Editor in Chief (Ron Mayer)	ron@o-mag.com
Oil City News	101324.2142@compuserve.com
Oilnews and Gas International	101324.2142@compuserve.com

The Oxford Student (Oxford University)	theoxstu@black.ox.ac.uk
Parents and Computers	pam@idg.co.uk
PC Format	prichards@futurenet.co.uk
PC Gamer	jdavies@futurenet.co.uk
PC Guide	dslingsby@futurenet.co.uk
PC Labs U.K.	steve_browne@hades.zis.ziff.com
PC Magazine U.K.	tony_westbrook@hades.zis.ziff.com
PC Plus	dpearman@futurenet.co.uk
PC Plus U.K.	pcplus@cix.compulink.co.uk
PC Sports	edge@futurenet.co.uk
PCW Plus	pcwplus@futurenet.co.uk
Personal Computer World	editorial@pcw.ccmail.compuserve.com
Editor	ben@compulink.co.uk
Photon Magazine	davidkilpatrick@photon.scotborders.co.uk
Piatkus Books	piatkus.books@dial.pipex.com
Pilot	100126.563@compuserve.com
The Pink Paper	positivetimes@posnet.co.uk
Poetry London Newsletter	pdaniels@easynet.co.uk
Private Eye	strobes@cix.compulink.co.uk
Readers Digest U.K.	excerpts@readersdigest.co.uk
Redbrick (University of Birmingham)	redbrick@bham.ac.uk
Red Pepper	redpepper@online.rednet.co.uk
Reed International Books	cd49@dial.pipex.com
Robinson Publishing	100560.3511@compuserve.com
Satnews	satnews@cix.compulink.co.uk
Scallywag Magazine	scallywag@scandals.demon.co.uk
Scotsgay	scotsgay@drink.demon.co.uk
Second Nature Ltd.	Secondnature.co.uk@aol.com
SEGA Power	nmerritt@futurenet.co.uk
SEGA Pro	segapro@paragon.co.uk
Serpent's Tail	info@serpentstail.com
SFX	mattb@futurenet.co.uk
SIDES Magazine	t.bowden@qub.ac.uk

The South Bucks Star	systems@freepressgrp.co.uk
ST Format	klevell@futurenet.co.uk
Sunday Telegraph Magazine	sunmag@telegraph.co.uk
The Sunday Times (London)	
Innovation	innovation@delphi.com
Telecomworldwire (London)	satnews@cix.compulink.co.uk
3W Magazine	3W@ukartnet.demon.co.uk
Time Out	net@timeout.co.uk
Titan Books	101447.2455@compuserve.com
Total Football	gwhitta@futurenet.co.uk
Total Guitar	ttucker@futurenet.co.uk
Traveller	mship@wexas.com
Whatnet	74774.1357@compuserve.com
Woman Alive	media@heraldhouse.co.uk
X gen	xgenmag@paragon.co.uk
Xenos	xenos@xenos.demon.co.uk
Xephon	100325.3711@compuserve.com

EUROPE: ITALY

Colors (Rome)	colors.mag@agora.stm.it
Grazia	grazia@mondadori.it
Informer	j.murphy@agora.stm.it
Internazionale	r.internazionale@agora.stm.it
Nexus International Broadcasting Assn. (Milan)	100020.1013@compuserve.com
Panorama	panorama@mondadori.it
Qui Touring	qt.tci.96@iol.it
RAI 3—Tempo reale	tempo.reale@agora.stm.it
Where Rome	wherema@uni.net

EUROPE: NETHERLANDS

Activist Press Service (BBS)	aps@aps.nl
De Journalist (Journalism Magazine)	journalist@nvj.nl
Fahrenheit 451 (Radical Magazine)	schism@schism.aps.nl

Grafische Onrust (Radical Art Magazine)	vegu@iaehv.nl
Infinity (Digital Technology)	rkohl@xs4all.nl
Media Partners International	Ken_wilkie@rotonet.rsdb.nl
Nomen Nescio (Activist Newspaper)	nn@nnmag.aps.nl
Noticias (BBS, Latin America)	noticias@noticias.aps.nl
Promotor (Activist Magazine)	promotor@promotor.aps.nl
Radio Netherlands (Hilversum)	letters@rn-hilversum.nl

EUROPE: POLAND

Delta	delta@plearn.edu.pl
Europa Press News	webmaster@europapress.com
FilmNet, Europe	70671.1624@compuserve.com
Gazeta Wyborcza	gawyb@ikp.atm.com.pl
GMT Partner Wielkopolski	gmt@europapress.com
Katolicka Agencja Informacyjna	kai@ikp.atm.com.pl
Pocket Press Photo and News Agency	pocket@pocketpress.com
Polska Telewizja Kablowa	ptk@ikp.atm.com.pl
Polskie Radio Program I	radio1@ikp.atm.com.pl
Postepy Fizyki (Advances in Physics)	postepy@fuw.edu.pl
RAJ Eco	raj@europapress.com
Zielone Brygady	greenbri@alpin.glas.apc.org

EUROPE: SWEDEN

Aftonbladet	
Arts and literature	kultur@aftonbladet.se
News	nyheter@aftonbladet.se
Sports	sport@aftonbladet.se
Travel	resor@aftonbladet.se
Channel 2, "Rapport"	twonews@basys.svt.se
Ekot/Swedish Broadcasting Corp.	ekot@sr.se

EUROPE: SWITZERLAND

Der Brueckenbauer (Zürich)	bb@logon.ch

Facts (Zürich)	facts@dial.eunet.ch
Interface (Bern)	sfib@dial.eunet.ch
L'Hebdo Magazine (Lausanne)	info@hebdo.ch
Online-PC-Zeitung (Zürich)	72662.1134@compuserve.com
Sonntagszeitung (Zürich)	sonntagszeitung@access.ch
Tages Anzeiger (Zürich)	100673.1233@compuserve.com
Weltwoche (Zürich)	weltwoche@access.ch

OTHER EUROPEAN COUNTRIES

Baltics Online News Service (Estonia)	newsgw@cherry.viabalt.ee
Budapest Business Journal (Hungary)	100263.213@compuserve.com
Cornucopia (Turkey)	cornucopia@atlas.net.tr
Croatian Journalists Association (Zagreb)	mario.profaca@public.srce.hr
Ecologia (Lithuania)	root@jt.aiva.lt
FilmNet, Europe	70671.1624@compuserve.com
First World Bulletin (Spain)	gw8@correo.interlink.es
InfoLinja (Finland)	jlahti@infocrea.fi
Island Publications (Malta)	mirabell@maltanet.omnes.net
MikroPC (Finland)	mpcmagas@mikropc.fi
Morgenbladet (Oslo, Norway)	truls@telepost.no
Standby Travel (Denmark)	standby@inform.dk
TV3/Televisi de Catalunya (Spain)	msansa@servicom.es
Verslo Zinios (Business News) (Lithuania)	biznis@verslo_zinios.omnitel.net
Virus (Music, Bratislava/Slovakia)	virus@cenezu.sk

ASIA

Asahi Evening News	newsroom@mx.asahi-np-jp
Asia Diver Online	infor@asiadiver.com
Asia Travel Trade (Singapore)	eastern@mbox2.singnet.com.sg
Asia 2000 Ltd.	Info@asia2000.com.hk
Asian Hotelier	kevin@hk.super.net
Bali Echo (Indonesia)	baliecho@denpasar.wasantara.net.id
Hong Kong Life (Hong Kong)	hklife@hkstandard.com

Kem Chick's World (Indonesia) 76255.3012@compuserve.com

Mabuhay (Philippines) eastgate@skyinet.net

Magazines Inc. (Singapore) mag_inc@pacific.net.sg

Mercedes (Singapore) srutherford@pacific.net.sg

Mini-World (Japan) mworld@kozo.co.jp

New Straits Times (Malaysia) itp@pop.jaring.my

Outbound Travel (Singapore) inkworks@mbox2.singnet.com.sg

Outdoor Adventure Asia Pacific (Malaysia) azizmd@pc.jaring.my

RCI Asia Pacific (Singapore) malini@singnet.com.sg

Silver Kris (Singapore) silverkris@mph.com.sg

Straits Times (Singapore) stlife@cyberway.com.sg

Trade and Travel jetm@asiansources.com

TV ASIA (Bangkok, Thailand) tvasia@ksc.net.th

What's On in Manila (Philippines) mhertz@mozcom.com

Winds (Japan) steveforster@twics.com

WingSpan (Japan) mcdavis@gol.com

BRAZIL

Folha de S. Paulo folha@uol.com.br

Jornal do Brasil jb@ax.apc.org

O Globo editor@oglobo.com.br

ISRAEL

Ariga (Web Publication)

 Robert Rosenberg (Editor) robert@ariga.com

Globs (Financial Daily)

 Efi Landau (Communications Editor) 72662.1562@compuserve.com

Ha'arets Daily

 Avi Belizovski avibliz@netvision.net.il

Israeli TV—CLICK (Computer Show on Channel-1)

 Dalia Bornstein, Producer dala@netvision.net.il

LINK Magazine (Business Monthly) link@link2link.co.il

Ma'ariv Daily

David Gordon	gordon@elronet.co.il
People @ Computer	
Yehuda Konfortas, Editor	72662.1563@compuserve.com
Peli Peled, CEO and Editor in Chief	peli@netvision.net.il
Reshet Computer	
Shlomit Meiron, Editor	merav@trendline.co.il
Alternate Address	100274.1017@compuserve.com
Telegraph (Financial Daily)	
Roni Lifshits	100274.3306@compuserve.com

SOUTH AFRICA

Africa Mosaik	afrika@icon.co.za
Cosmopolitan	cosmoa@iafrica.com
David Philip Publishers	dpp@iafrica.com
Femina	femina@iafrica.com
Flying Springbox	lynne@flyingspringbox.co.za
House and Leisure	hleisure@iafrica.com
Jewish Affairs	071JOS@muse.arts.wits.ac.za
The Namibian (Windhoek, Namibia)	tom@namibian.com.na
Namibian Broadcasting Corporation	
Head Office	marietha@nbc_hq.nbc.com.na
Sunday Times (Johannesburg)	suntimes@tml.co.za
Metro Edition	kznmetro@tml.co.za
Weekly Mail and Guardian (Johannesburg)	wmail-info@wmail.misanet.za

OTHER COUNTRIES

Caribbean Beat (Trinidad)	mep@wow.net
Daily Dawn (Karachi, Pakistan)	editor@dawn.khi.imran.pk
El Mercurio (Santiago, Chile)	sigloxxi@huelen.reuna.cl
Golden Falcon (Bahrain)	fp7pub@batelco.com.bh
Khaleej Times (United Arab Emirates)	ktimes@emirates.net.ae
The Mexican Journal (Mexico)	fbuendia@campus.cem.itesm.mx

Middle East Times (Cairo, Egypt) met@ritsecl.com.eg

Radio Havana (Cuba)

 "DXers Unlimited" radiohc@tinored.cu

Tico Times (Costa Rica) ttimes@huracan.cr

Time of the Islands (British West Indies) timespub@caribsurf.com

Reference Materials

IF I TOLD YOU THAT THIS BOOK WAS THE ONLY SOURCE OF INFORMATION on foreign markets, I would not only be lying, but I would also not be doing my job as an author. There are many books—most published abroad—that offer additional information on selling overseas. There are also periodicals that will help you keep your marketing information up-to-date.

Some of these publications have been listed throughout the text of this book. Those, as well as others, can be found in this index. The prices of these books and periodicals have been left out intentionally because currency exchange, postal fees, and subscription rates change so rapidly. For current prices I suggest you fax or write the publisher directly. In the case of newsletters and magazines, you might also ask for a sample.

The Bookseller, J. Whitaker and Sons Ltd., 12 Dyott Street, London WC1A 1DF, United Kingdom. This weekly journal provides valuable insight into the U.K. publishing industry—e.g., who is buying what, moves by editors, new imprints.

Cassell Publishing, Cassell Place, Stanley House, 3 Fleet's Lane, Poole, Dorset BH15 3AJ, United Kingdom; Tel. 44-1202-670581, Fax 44-1202-666219. This publishing house releases numerous reference books each year, including the *Directory of Publishing.* Because there are various editions, such as *Continental Europe,* I suggest you request their current catalog, which will provide all volumes and prices.

The Directory of Writers' Circles, Jill Dick, Oldacre, Horderns Park Road, Chapel-en-le-Frith, Derbyshire SK12 6SY, United Kingdom; Tel. 44-1298-812305; E-mail *jillie@cix.compulink.co.uk.* This directory lists more than six hundred groups and circles of writers meeting regularly throughout the world.

Freelance Market News, the Association of Freelance Writers, Sevendale House, 7 Dale Street, Manchester M1 1JB, United Kingdom; Tel. 44-161-237-1827, Fax 44-161-228-3533. Six-issues-a-year newsletter, published in England, that provides up-to-date marketing information.

Freelance Writing and Photography, Weavers Press Publishing Ltd., Clarendon Court, Over Wallop, Stockbridge, Hants SO20 8HU, United Kingdom; Tel./Fax 44-1264-782298. Bimonthly magazine with features, market news, etc.

Freelance Writing for Newspapers, A and C Black Ltd., 35 Bedford Row, London WC1R 4JH, United Kingdom. Author Jill Dick provides advice and insight into the newspaper markets of the United Kingdom.

International Literary Market Place, R. R. Bowker, 121 Chanlon Road, New Providence, NJ 07974; Tel. (800) 521-8110 or (908) 464-6800. Annual directory covering world publishers.

Journalist, National Union of Journalists, Acorn House, 314 Gray's Inn Road, London WC1X 8DP, United Kingdom; Tel. 44-171-278-7916, Fax 44-171-837-8143; E-mail *the.journalist@mcr1.geonet.de.* The official publication of the National Union of Journalists provides information on the U.K. newspaper and magazine industry, as it relates to writers.

Markets Abroad, Michael Sedge Publications, 2733 Midland Road, Shelbyville, TN 37160; Fax 39-81-851-2210; E-mail *pp10013@cybernet.it.* Quarterly newsletter with market information for magazine and book publishers outside North America.

The New Writer, P.O. Box 60, Cranbrook, Kent TN17 2ZR, United Kingdom. Magazine for writers.

Travelwriter Marketletter, Robert Scott Milne, The Waldorf-Astoria, 301 Park Avenue, Suite 1850, New York, NY 10022. Excellent monthly newsletter with market information. While primarily North American, there are some overseas publications included.

Willings Press Guide, Hollis Directories, Harlequin House, 7 High Street, Teddington, Middlesex TW11 8EL, United Kingdom. Two-volume—United Kingdom and other countries—annual that looks almost like the New York City telephone book (five inches thick).

Writers' and Artists' Yearbook, A and C Black Ltd., 35 Bedford Row, London WC1R 4JH, United Kingdom. This annual has been published for more than ninety years and includes thousands of foreign markets.

Writer's Forum, 9/10 Roberts Close, Moxley, Wednesbury, West Midlands WS10 8SS, United Kingdom; Tel. 44-1902-497514. Quarterly on the business of writing.

Writer's Guide to Hollywood Producers, Directors, and Screenwriter's Agents, Primar Publishing, P.O. Box 1260, Rocklin, CA 95677; Tel. 916-632-4400. An excellent introduction to the film/television scriptwriting industry.

Writer's Monthly, 29 Turnpike Lane, London N8 0EP, United Kingdom; Tel. 44-181-342-8879, Fax 44-181-347-8847. This magazine covers markets and information for writers of articles, books, and plays. Information on foreign agents is also listed.

Writer's News, P.O. Box 4, Nairn IV12 4HU, United Kingdom; Tel. 44-1667-454441, Fax 44-1667-454401. Monthly publication listing competitions and opportunities in the U.K. marketplace.

Writing for Magazines, A and C Black Ltd., 35 Bedford Row, London WC1R 4JH, United Kingdom. For those seeking tips and advice on the British periodical market, Jill Dick provides the answers in this title.

Writing Magazine (produced by the same folks that put out *Writer's News*). Quarterly covering all aspects of freelance writing.

Clubs and Associations

The Association of Photographers, 9–10 Domingo Street, London EC1Y 01TA, United Kingdom; Tel. 44-171-336-8811, Fax 44-171-253-3007.

The Australian Society of Authors, P.O. Box 1566, Strawberry Hill NSW 2012, Australia; Tel. 61-2-9318-0877, Fax 61-2-9318-0530; E-mail *asauthors@peg.pegasus.oz.au.*

Australian Writers' Guild Ltd., 60 Kellett Street, Kings Cross NSW 2011, Australia; Tel. 61-2-357-7888, Fax 61-2-357-7776.

Australian Writing Online, P.O. Box 333, Concord NSW 2137, Australia; Web site *www.ozemail.com.au/~awol.*

Authors' Club, 40 Dover Street, London W1X 3RB, United Kingdom; Tel. 44-171-499-8581, Fax 44-171-409-0913.

The British Fantasy Society, 2 Harwood Street, Heaton Norris, Stockport SK4 1JJ, United Kingdom; Tel. 44-161-476-5368.

The British Guild of Travel Writers, 90 Corringway, London W5 3HA, United Kingdom; Tel. 44-181-998-2223.

Crime Writers' Association, P.O. Box 10772, London N6 4SD, United Kingdom.

Foreign Press Association (London), 11 Carlton House Terrace, London SW1Y 5AJ, United Kingdom; Tel. 44-171-930-0445, Fax 44-171-925-0469.

Irish Writers' Union, Irish Writers' Centre, 19 Parnell Square, Dublin 1, Ireland; Tel. 353-1-872-1302, Fax 353-1-872-6282.

London Screenwriters' Workshop, 64 Church Crescent, London N10 3NE, United Kingdom; Tel. 44-171-833-7218; E-mail *jhobson@cix.compulink.co.uk;* Web site *www.lsw.org.uk.*

Medical Journalists Association, 185 High Street, Stony Stratford, Milton Keynes MK11 1AP, United Kingdom; Tel. 44-1908-564623.

Medical Writers Group, 84 Drayton Gardens, London SW10 9SB, United Kingdom; Tel. 44-171-373-6642.

National Union of Journalists, Acorn House, 314 Gray's Inn Road, London WC1X 8DP, United Kingdom; Tel. 44-171-278-7916, Fax 44-171-837-8143; E-mail *NUJ@mcr1.poptel.org.uk.*

Outdoor Writers' Guild, P.O. Box 520, Bamber Bridge, Preston, Lancs PR5 8LF, United Kingdom; Tel./Fax 44-1772-696732.

P.E.N. International, 9/10 Charterhouse Buildings, Goswell Road, London EC1M 7AT, United Kingdom; Tel. 44-171-235-4308, Fax 44-171-253-5711.

The Picture Research Association, 455 Finchley Road, London NW3 6HN, United Kingdom; E-mail *pra@pictures.demon.co.uk.* Contact Emma Krikler.

Publishers Marketing Association, 2401 Pacific Coast Highway, Suite 206, Hermosa Beach, CA 90254.

The Society of Authors, 84 Drayton Gardens, London SW10 9 SB, United Kingdom; Tel. 44-171-373-6642.

Society of Women Writers and Journalists, 110 Whitehall Road, Chingford, London E4 6DW, United Kingdom; Tel. 44-181-529-0886.

South African Writers' Circle, P.O. Box 10558, Marine Parade, Durban 4056, South Africa; Tel. 27-31-307-5668.

Theatre Writers' Union, c/o GFTU, Central House, Upper Woburn Place, London WC1H 0HY, United Kingdom; Tel. 44-181-673-6636.

Women Writers Network, c/o Susan Kerr, 55 Burlington Lane, London W4 3ET, United Kingdom; Tel. 44-181-994-0598.

The Writers' Guild of Great Britain, 430 Edgware Road, London W2 1EH, United Kingdom; Tel. 44-171-723-8074, Fax 44-171-706-2413; E-mail *postie@wggb. demon.co.uk;* Web site *www.writers.org.ul/guild/.*

Foreign Agencies

THERE ARE TIMES WHEN YOU SHOULD TURN TO AN AGENCY TO SELL YOUR articles around the world. For example, when your workload becomes so time-consuming that you no longer have enough hours in the day for foreign marketing. Or perhaps you simply lose interest in pushing a particular article. This has happened to me several times. I like to call this the "squeezing the sponge" system. When an article is fresh and I can peddle it to a number of regular clients, it's like water dripping from a sponge. After a few sales, I squeeze a little and get more sales. I then may tighten my grip a bit for one or two more sales. Once my hand gets tired, though, I'll let up. At that point, I send the article to an agency with a list of countries where rights are still available.

When working with an agency, keep in mind that it only sells the rights you specify. If, for instance, you've sold the article in Spain, be sure the agency does not include the article in its weekly offering to Spanish publications. Otherwise, it may be damaging to the agency as well as to you.

If you can work out an arrangement whereby you can pull back certain rights if you later find a market, it is recommended. This has happened to me a number of times. After I have submitted a story to an agency and the agency has attempted to sell it, one of my customers may ask for something similar. In such instances, I simply ask whether the agency has had a buyer in that particular market. If it

hasn't, I inform the agency that I have found a buyer and the particular rights I need to sell the story on my own are deleted from the agency's list.

It is highly recommended that you inquire into an agency's policies before submitting your work. If possible, try to speak with other writers that have worked with the agency.

The following is a list of some foreign agencies along with the areas in which they specialize and people to contact. As with the previous lists, keep in mind that contacts, phone numbers, and even addresses change frequently, so keep your information updated.

Academic File, Acre House 69-76 Long Acre, London WC2E 9JH, United Kingdom; Tel. 44-181-329-1122, Fax 44-181-392-1422. Features on developing nations. Contact: Sajid Rizvi.

Advance Features, Clarendon House, Judges Terrace, East Grinstead, West Sussex RH19 3AD, United Kingdom; Tel. 44-1342-328-562. Celebrities, breaking news, nature, and educational. Contact: Peter Norman.

A.L.I. Press Agency Ltd., Boulevard Anspach 111-115, Bte 9, B9-1000, Brussels, Belgium; Tel. 32-2-512-7394, Fax 32-2-512-0330. People, general interest, and photo features. Contact: George Lans.

Bernsen's International Press Service Ltd. (BIPS), 9 Paradise Close, Eastbourne, East Sussex BN20 8BT, United Kingdom; Tel. 44-1323-728-760. Human interest and the unusual. Contact: Harry Gresty.

Bulls Presstjänst AB, Tulegatan 39, Box 6519, S-11383 Stockholm, Sweden; Tel. 46-8-23-4020, Fax 46-8-15-8010. In cooperation with Bull Press offices in Germany, Norway, Denmark, Finland, and Poland, this agency sells features on everything from science and celebrities to travel and tragedies. It covers all of northern Europe. Contact: Managing Editor.

Capital Press Service, 2 Long Cottage, Church Street, Leatherhead, Surrey KT22 8EJ, United Kingdom; Tel. 44-1372-377-451. Business travel, transportation, and air cargo. Contact: M. Stone.

Central Press Features, 20 Spectrum House, 32/34 Gordon House Road, London NW5 1LP, United Kingdom; Tel. 44-171-284-1433, Fax 44-171-284-4494. Anything dealing with human interest, women's issues, sports, medicine, and science. Contact: Managing Editor.

Europa-Press, Saltmätargatan 8, First Floor, Box 6410, S-11382 Stockholm, Sweden; Tel. 46-8-349-435, Fax 46-8-348-079. Crime, human interest, features with international appeal, science, and celebrities. Contact: Sven Berlin.

Europress Features (U.K.), 18 St. Chads Road, Didsbury, Manchester M20 9WH, United Kingdom; Tel. 44-161-445-2945. Personality features, Hollywood scene, and celebrities. Contact: Managing Editor.

Features International, Tolland, Lydeard St. Lawrence, Taunton TA4 3PS, United Kingdom; Tel. 44-1984-623-014, Fax 44-1984-623-901. Features for women and weekly columns. Contact: Anthony Sharrock.

Gemini News Service, 9 White Lion Street, London N1 9PD, United Kingdom; Tel. 44-171-833-4141, Fax 44-171-837-5118. E-mail *Gemini@gn.apc.org.* News features of international interest. Contact: Daniel Nelson.

India-International News Service, Jute House, 12 India Exchange Place, Calcutta 700001, India; Tel. 91-220-9563/4791009. Industrial and technical news. Contact: H. Kothari.

International Fashion Press Agency, Mumford House, Mottram Road, Alderley Edge, Cheshire SK9 7JF, United Kingdom; Tel. 44-1625-583537, Fax 44-1625-584344. Health, fitness, medicine, science, beauty, and personalities. Contact: P. Bentham.

International Features Service, 104 rue de Laeken, 1000 Brussels, Belgium; Tel./Fax 32-217-03-42. Feature articles of general interest and books. Contact: Max S. Kleiter.

International Press Agency, P.O. Box 67, Howard Place 7450, South Africa; Tel. 27-21-531-1926, Fax 27-21-531-8789. Features, short stories, serials, and photos. Contact: T. Temple.

Maharaha Features Pvt., 5/226 Sion Road East, Bombay 400022, India; Tel. 91-22-409-7951, Fax 91-22-409-7801. Features of interest to the Asian market, with images. Contact: K. R. N. Swamy.

News Blitz International, Via Guido Banti 34, 00191 Rome, Italy; Tel. 39-6-333-26-41, Fax 39-6-333-26-51. Features and photo-essays covering celebrities, environmental issues, and travel. Contact: Vinicio Congiu.

Chandra S. Perera Cinetra, 437 Pethiyagoda, Kelaniya-11600, Sri Lanka; Tel. 94-1-911885, Fax 94-1-541414/332867. Breaking news. Contact: Chandra Perera.

Solo Syndication Ltd., 49-53 Kensington High Street, London W8 5ED, United Kingdom; Tel. 44-171-376-2166, Fax 44-171-938-3165. Newspaper features. Contact: Don Short.

Southern Media Services, P.O. Box 268, Springwood NSW 2777, Australia; Tel. 61-47-514-967, Fax 61-47-515-545. News and feature stories for newspapers. Contact: Nic van Oudtshoorn.

Swedish Features, Görwellsgatan 28B, 112 88 Stockholm, Sweden; Tel. 46-8-738-3274, Fax 46-8-618-2872. Newspaper and magazine features with human-interest appeal. Contact: Herborg Ericson.

Syndicated International Network, Second Floor, 208-209 Upper Street, Islington, London N1 1RL, United Kingdom; Tel. 44-171-359-0200, Fax 44-171-3359-2228. Celebrities of music and cinema. Contact: Marianne Lassen.

TEXT Syndication, 26 Ingelow Road, London SW8 3QA, United Kingdom; Tel. 44-171-978-2116, Fax 44-171-627-0746. Features with human interest, health, relationships, fashion/beauty, and celebrities. Contact: Amanda McKee.

Yaffa Newspaper Service of New Zealand, 29 Queens Avenue, Balmoral, Auckland 4, New Zealand; Tel. 64-9-631-5225, Fax 64-9-631-0040. Newspaper features. Contact: Managing Editor.

Stock Photo Agencies

Academic File News Photos
Eastern Art Publishing Group
27 Wallorton Gardens
London SW14 8DX
United Kingdom
Tel. 44-181-392-1122
Fax 44-181-392-1422
E-mail *easternart@compuserve.com*

Ace Photo Agency
Satellite House
2 Salisbury Road
London SW19 4EZ
United Kingdom
Tel. 44-181-944-9944
Fax 44-181-944-9940

Action Plus
54-58 Tanner Street
London SE1 3PH
United Kingdom
Tel. 44-171-403-1526

Aereofilms
Hunting Aerofilms Ltd
Gate Studios, Station Road
Borehamwood, Herts. WD6 1EJ
United Kingdom
Tel. 44-181-207-0666
Fax 44-181-207-5433
E-mail *aerofilms@compuserve.com*

AKG London
(Arts and History Picture Library)
10 Plato Place
72-74 St. Dionis Road
London SW6 4TU
United Kingdom
Tel. 44-171-610-6103
Fax 44-171-610-6125

Allied Artists Ltd
31 Harcourt Street
London W1H 1DT
United Kingdom
Tel. 44-171-724-8809
Fax 44-171-262-8526

Allsport Photographic Ltd.
3 Greenlea Park
Prince George's Road
London SW19 2JD
United Kingdom
Tel. 44-181-685-1010
Fax 44-181-648-5240

Andalucia Slide Library
Apto 499, Estepona
Malaga 29680
Spain
Tel./Fax 34-52-793647
E-mail *library@andalucia.com*
Web site *www.andalucia.com*

Andes Press Agency
26 Padbury Court
London E2 7EH
United Kingdom
Tel. 44-171-613-5417
Fax 44-171-739-3159
E-mail *photos@andespress.demon.co.uk*

Animal Photography
4 Marylebone Mews
New Cavendish Street
London W1M 7LF
United Kingdom
Tel. 44-171-935-0503
Fax 44-171-487-3038

Aquarius Picture Library
P.O. Box 5, Hasting
East Sussex TN34 1HR
United Kingdom
Tel. 44-1424-721196
Fax 44-1424-717704

Aquila Photographics
P.O. Box 1
Studley, Warks B80 7JG
United Kingdom
E-mail *interbirdnet@dial.pipex.com*

B. and B. Photographs
Prospect House
Clifford Chambers
Stratford-upon-Avon
Warks CV37 8HX
United Kingdom
Tel. 44-1789-298106
Fax 44-1789-292450

Barnardo's Photographic Archive
Tanners Lane
Barkingside, Ilford
Essex IG6 1QG
United Kingdom
Tel. 44-181-550-8822
Fax 44-181-550-0429

John Blake Picture Library
74 South Ealing Road
London W5 4QB
United Kingdom
Tel. 44-181-840-4141
Fax 44-181-566-2568

**Blitz International News
 and Photo Agency**
Stubcroft Studios, Stubcroft Farm
Stubcroft Lane
East Wittering, Nr Chichester
West Sussex PO20 8PJ
United Kingdom
Tel. 44-1243-671469

Bridgeman Art Library
17-19 Garway Road
London W2 4PH
United Kingdom
Tel. 44-171-727-4065
Fax 44-171-792-8509
E-mail *info@bridgeman.co.uk*

Camera Press Ltd.
21 Queen Elizabeth Street
London SE1 2PD
United Kingdom
Tel. 44-171-378-1300
Fax 44-171-278-5126

J. Allan Cash Photolibrary
74 South Ealing Road
London W5 4QB
United Kingdom
Tel. 44-181-840-4141
Fax 44-181-566-2568

Bruce Coleman Collection
16 Chiltern Business Village
Arundel Road, Uxbridge
Middlesex UB8 2SN
United Kingdom
Tel. 44-1895-257094
Fax 44-1895-272357

Contrasto
Via Pergolesi 2
20124 Milan, Italy
Tel. 39-2-669-88050
Fax 39-2-669-86857
Contact: General Manager

Sue Cunningham Photographic
56 Chathman Road
Kingston-upon-Thames
Surrey KT1 3AA
United Kingdom
Tel. 44-181-541-3024
Fax 44-181-541-5388
E-mail *scphotographic@btinternet*

Das Photo
Chalet le Pin
Domaine de Bellevue 181
6940 Septon
Belgium
Tel./Fax 32-86-322426

James Davis Travel Photography
65 Brighton Road, Shoreham
West Sussex BN43 6RE
United Kingdom
Tel. 44-1273-452252
Fax 44-1273-440116

Editrice del Vascello
Lungo Dora Collette 129
10153, Turin, Italy
Tel. 39-11-247-6058
Fax 39-11-247-4307
E-mail *EdV@ape.apenet.it*

Environmental Investigation Agency
15 Bowling Green Lane
London EC1R 0BD
United Kingdom
Tel. 44-171-490-7040
Fax 44-171-490-0436
E-mail *eiauk@gn.apc.org*

Excalibur
Via Salsomaggiore 12
20159 Milan, Italy
Tel. 39-2-607-1200
Contact: Giovanna Mazzoni

Farabolafoto
Via dei Valtorta 48
20100 Milan, Italy
Tel. 39-2-268-28949
Contact: Angelo Sacchi

Freelance Focus
7 King Edward Terrace, Brough
East Yorkshire HU15 1EE
United Kingdom
Tel./Fax 44-1482-666036

Frontline Photo Press Agency
P.O. Box 162
Kent Town
Australia 5071
Tel. 61-8-8333-2691
Fax 61-8-8364-0604
E-mail *fppa@tne.net.au*
Web site *www.tne.net.au/fppa*

Brian Gadsby Picture Library
Route des Pyrenees
Labatut-Riviere
65700 Hautes Pyrenees
France
Tel. 33-5-6296-3844

Geo Science Features
6 Orchard Drive
Wye, Kent TN25 5AU
United Kingdom
Tel./Fax 44-1233-812707
E-mail *gsf@geoscience.demon.co.uk*
Web site *www.geoscience.demon.co.uk*

International Press Agency (Pty) Ltd.
P.O. Box 67
Howard Place 7450
South Africa
Tel. 27-21-531-1926
Fax 27-21-531-8789
E-mail *inpra@iafrica.com*

New Blitz International
Via Guido Banti 34
00191 Rome, Italy
Tel. 39-6-333-2641
Fax 39-6-333-2651

Orion Press
1/13 Kanda Jimbocho
Chiyoda-ku
Tokyo 101, Japan
Tel. 81-3-295-1400
Fax 81-3-295-0227
E-mail *orionprs@po.iijnet.or.jp*

Chandra S. Perera Cinetra
437 Pethiyagoda
Kelaniya-11600
Sri-Lanka
Tel. 94-1-911885
Fax 94-1-541414/332867

Profile Photo Library
2b Winner Commercial Building
401-403 Lockhart Road
Hong Kong
Tel. 852-2574-7788
Fax 852-2574-8884
E-mail *profile@hk.linkage.net*
Web site *www.Profilephoto.com.hk*

Singapore Office:
62a Smith Street
Chinatown, Singapore 058964
Tel. 65-324-3747
Fax 65-324-3748
E-mail *profile@singnet.comsg*

Thailand Office:
Room 406, Fourth Floor Kitpanit Building
18 Patpong Soi 1 Suriwonges Road
Bangkok 10500, Thailand
Tel. 66-2-634-3065
Fax 66-2-634-3066
E-mail *winyou@ksc9.th.com*

Publifoto
Via Vico 16
20123 Milan, Italy
Tel. 39-2-481-5184
Contact: Giulia Carrese

Raleigh International Picture Library
Raleigh House
27 Parson's Green Lane
London SW6 4HS
United Kingdom
Tel. 44-171-371-8585
Fax 44-171-371-5116

Tony Stone Images
101 Bayham Street
London NW1 0AG
United Kingdom
Tel. 44-171-267-8988
Fax 44-171-722-9305

About the Author

MICHAEL H. SEDGE IS OWNER OF THE STRAWBERRY MEDIA AGENCY IN Naples, Italy. His byline has appeared on more than 2,600 articles around the world and in several books. In addition to selling freelance articles and photographs globally, Sedge publishes the quarterly *Markets Abroad* newsletter, where he shares his knowledge and experience with international newspapers, magazines, and book publishers.

Sedge is currently working on a number of book and article projects, including ones for Discovery Channel and *Newsweek International, Diplomat,* and Internet.com.

Index

Books from Allworth Press

Writing for Interactive Media: The Complete Guide
by Jon Samsel and Darryl Wimberley (hardcover, 6 × 9, 320 pages, $19.95)

The Writer's Internet Handbook
by Timothy K. Maloy (softcover, 6 × 9, 192 pages, $18.95)

This Business of Publishing: An Insider's View of Current Trends and Tactics
by Richard Curtis (softcover, 6 × 9, 224 pages, $18.95)

Mastering the Business of Writing: A Leading Literary Agent Reveals the Secrets of Success *by Richard Curtis* (softcover, 6 × 9, 272 pages, $18.95)

Photography for Writers: Using Photography to Increase Your Writing Income
by Michael Havelin (softcover, 6 × 9, 224 pages, $18.95)

The Writer's Legal Guide, Revised Edition
by Tad Crawford and Tony Lyons (softcover, 6 × 9, 304 pages, $19.95)

Business and Legal Forms for Authors and Self-Publishers
by Tad Crawford (softcover, 8½ × 11, 192 pages, $19.95)

Business and Legal Forms for Photographers, Revised Edition
by Tad Crawford (softcover, includes CD-ROM, 8½ × 11, 224 pages, $24.95)

The Writer's Resource Handbook
by Daniel Grant (softcover, 6 × 9, 272 pages, $19.95)

The Photographer's Internet Handbook
by Joe Farace (softcover, 6 × 9, 224 pages, $18.95)

The Writer's Guide to Corporate Communications
by Mary Moreno (softcover, 6 × 9, 192 pages, $18.95)

ASMP Professional Business Practices in Photography, Fifth Edition *by the American Society of Media Photographers* (softcover, 6¾ × 10, 416 pages, $24.95)

The Copyright Guide: A Friendly Guide for Protecting and Profiting from Copyrights *by Lee Wilson* (softcover, 6 × 9, 192 pages, $18.95)

The Photographer's Guide to Marketing and Self-Promotion: How to Find and Keep Good Paying Clients, Second Edition *by Maria Piscopo* (softcover, 6¾ × 10, 176 pages, $18.95)

Pricing Photography: The Complete Guide to Assignment and Stock Prices, Second Edition *by Michal Heron and David MacTavish* (softcover, 8½ × 11, 152 pages, $24.95)

Please write to request our free catalog. To order by credit card, call 1-800-491-2808 or send a check or money order to Allworth Press, 10 East 23rd Street, Suite 210, New York, NY 10010. Include $5 for shipping and handling for the first book ordered and $1 for each additional book. Ten dollars plus $1 for each additional book if ordering from Canada. New York State residents must add sales tax.

If you would like to see our complete catalog on the World Wide Web, you can find us at *www.allworth.com*